Christchurch Earthquake Images

Photographic Account of Devastation and Recovery

Debbie Roome

© Debbie Roome 2017

Photography by Debbie Roome

Foreword

On the morning of the 4th September 2010, I awoke to find our double storey home in the grips of a major earthquake. The bed was jumping and shaking and the house groaned as it stretched to its limits. I tried repeatedly to run to the doorway but the force of the quake flung me against the window, over and over again. I was convinced the wall was going to give way and I would end up in the garden below.

An hour later with the electricity off, the family huddled over our car radio listening to news reports of the major 7.1 earthquake that had torn Canterbury apart. I'd been a keen photographer for years and realised this was an event that needed to be recorded. "I'm going into town," I announced, "is anyone coming with me?" It was the beginning of a journey that has continued until today. I've been shouted at, chased, bullied, misunderstood and shamed as I've captured scenes of devastation, but have also had people thank me for photos of their work place, city and dearly loved landmarks such as Christchurch Cathedral.

In the two years after the earthquakes, access to the city centre's red zone was very tightly controlled. As a freelance journalist with a press pass, I had access to a couple of media tours and was also part of the deconsecration of Christchurch Cathedral. I initially used my photos in freelance articles for various online news sites. It was a tough year for Canterbury and although our house was relatively unscathed, thousands of people lost their homes, businesses and loved ones through the ongoing quakes. I decided to also use my photos to raise funds for the Red Cross who were doing a great job of supporting those in need. For a year, I created and sold a range of photographic products including books, fridge magnets, photo canvases, cards and calendars.

This book contains minimal text as I believe the pictures tell the story. I want you to gain an overview of the destruction and emotion of the seismic events we've lived through without the clutter of facts and figures. My photos reflect the journey we're on as we move steadily away from devastation to a new stronger city with an amazing future!

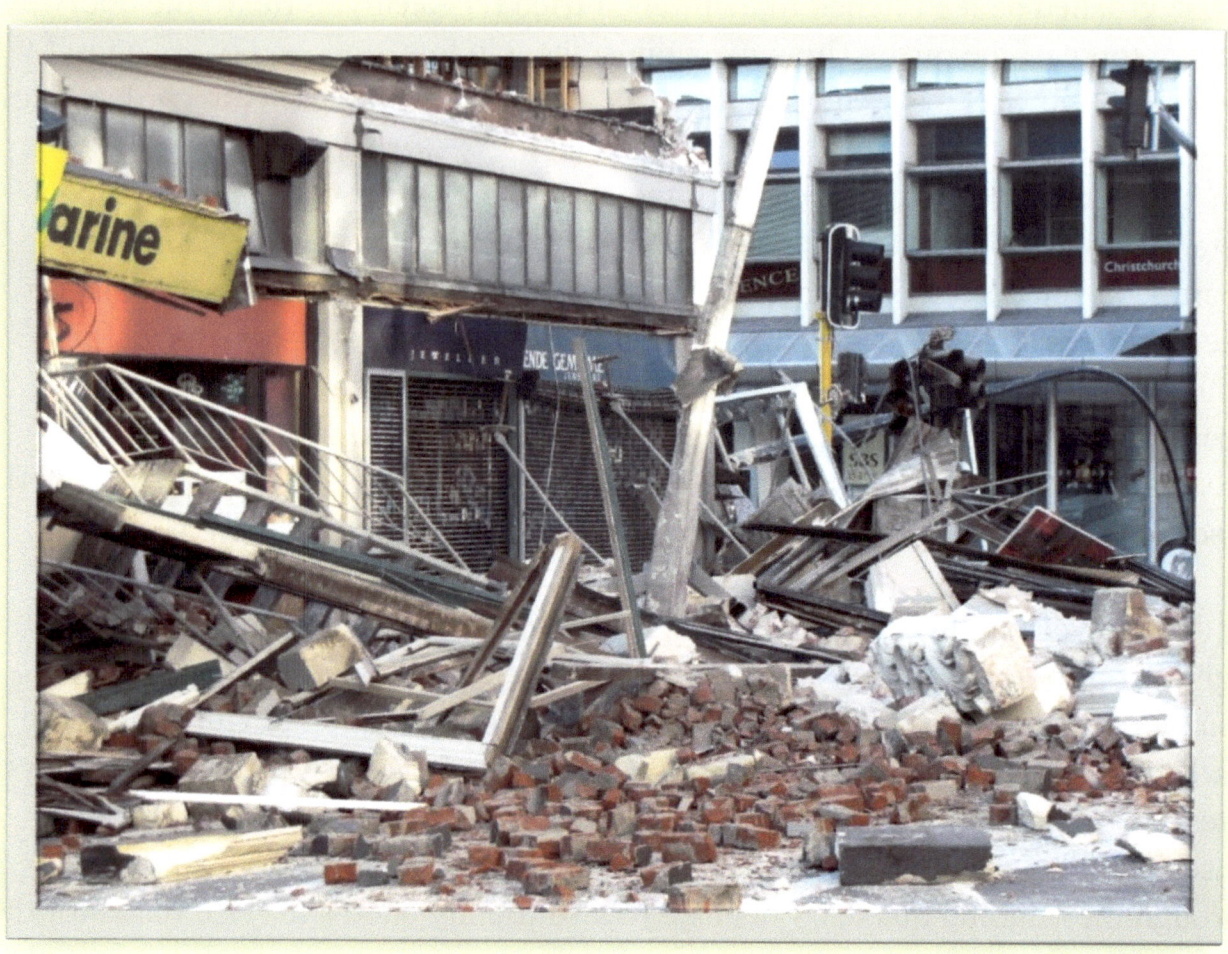

Contents

Before and After	1- 4
Christchurch on and after the 4th September 2010	5-10
Christchurch on and after the 22nd February 2011	11-32
Inside the Red Zone	33-38
Aerial views of Christchurch	39-48
Christchurch Cathedral	49-63

Chapter One
Before and After

Driving into Christchurch central the morning of the 4th September 2010 quake was a strange experience. The power was off and the sun balanced just above the horizon. Broken buildings were edged in gold, their facades lay crushed in the streets and their secrets were laid bare for the world to see. It was like looking into a doll house until you realised this was big and real. People milled around taking photos, shock reflected in their faces as they compared experiences. Less than six months later I drove the same route the morning after the massive 22nd February 2011 shake. The damage was more severe this time round and many familiar buildings lay in ruins. The photos below show the four corners of the intersection of Bealey Avenue, Victoria Road and Papanui Road. I returned to this spot in June 2017 to take a new set of photos. Two of the buildings have been completely rebuilt, one has been restored, and the Knox Church was resurrected around its original frame. These pictures remind me that there is hope and although Christchurch has suffered immense loss, a bright and beautiful new city is emerging from the rubble.

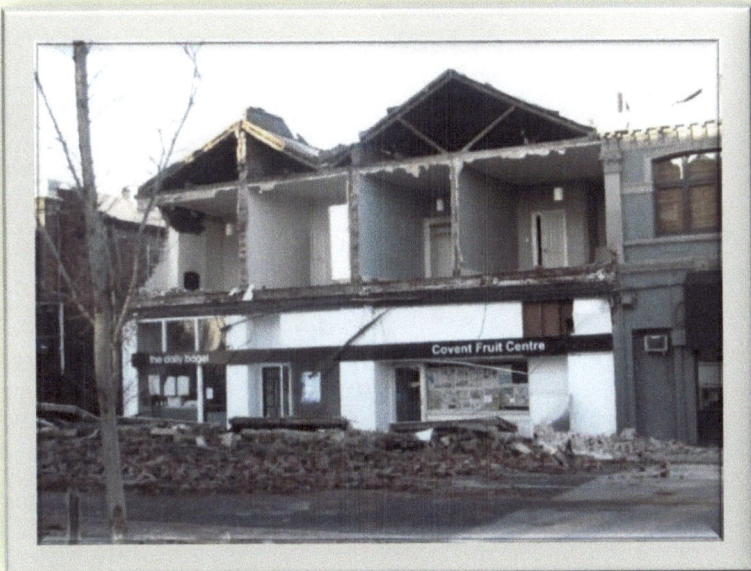 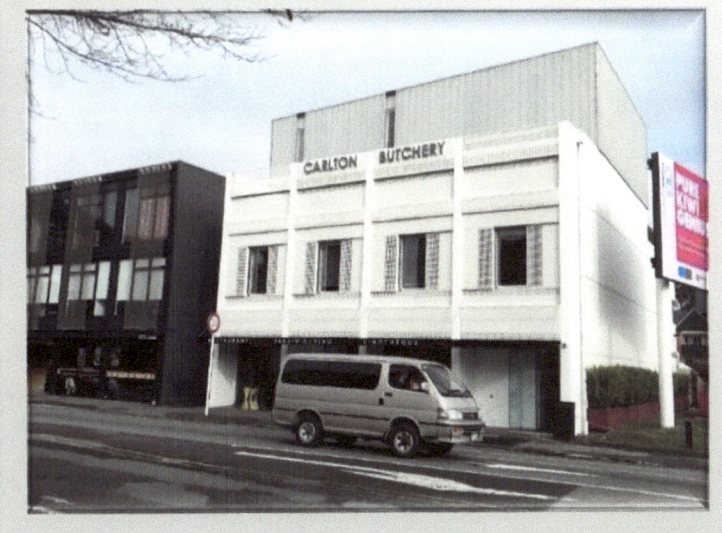

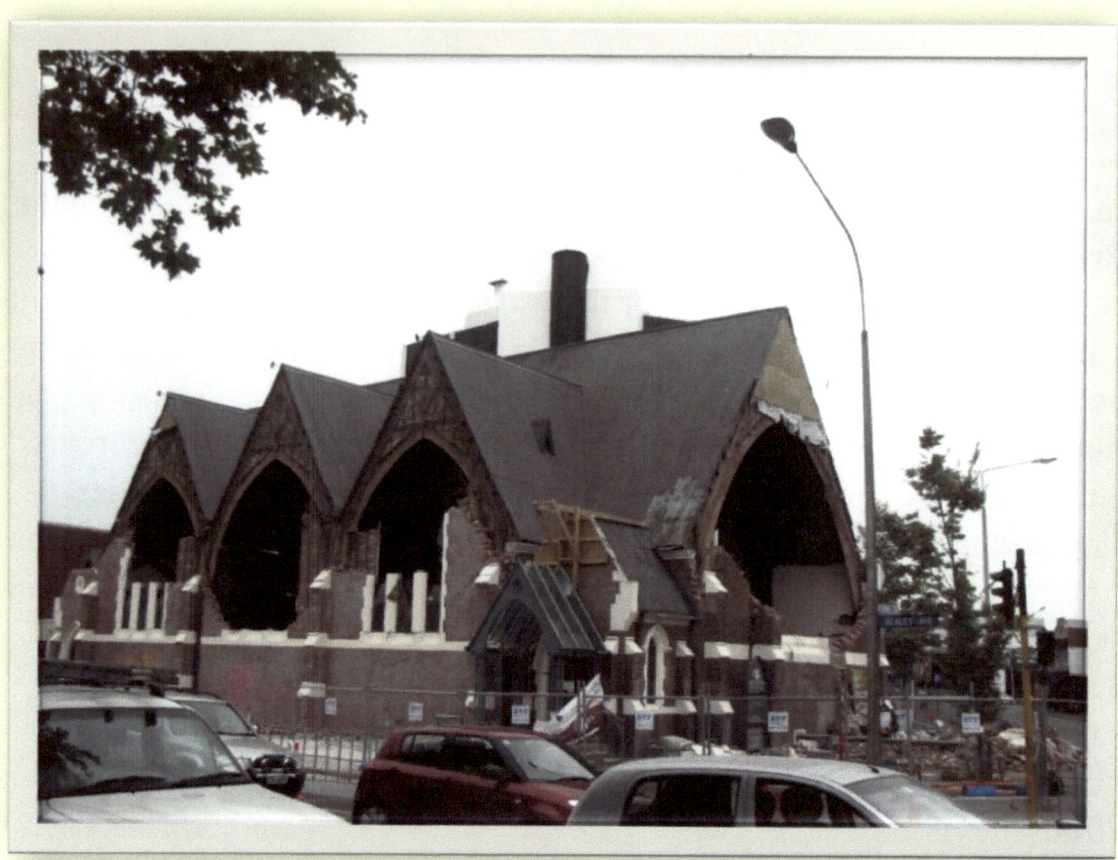
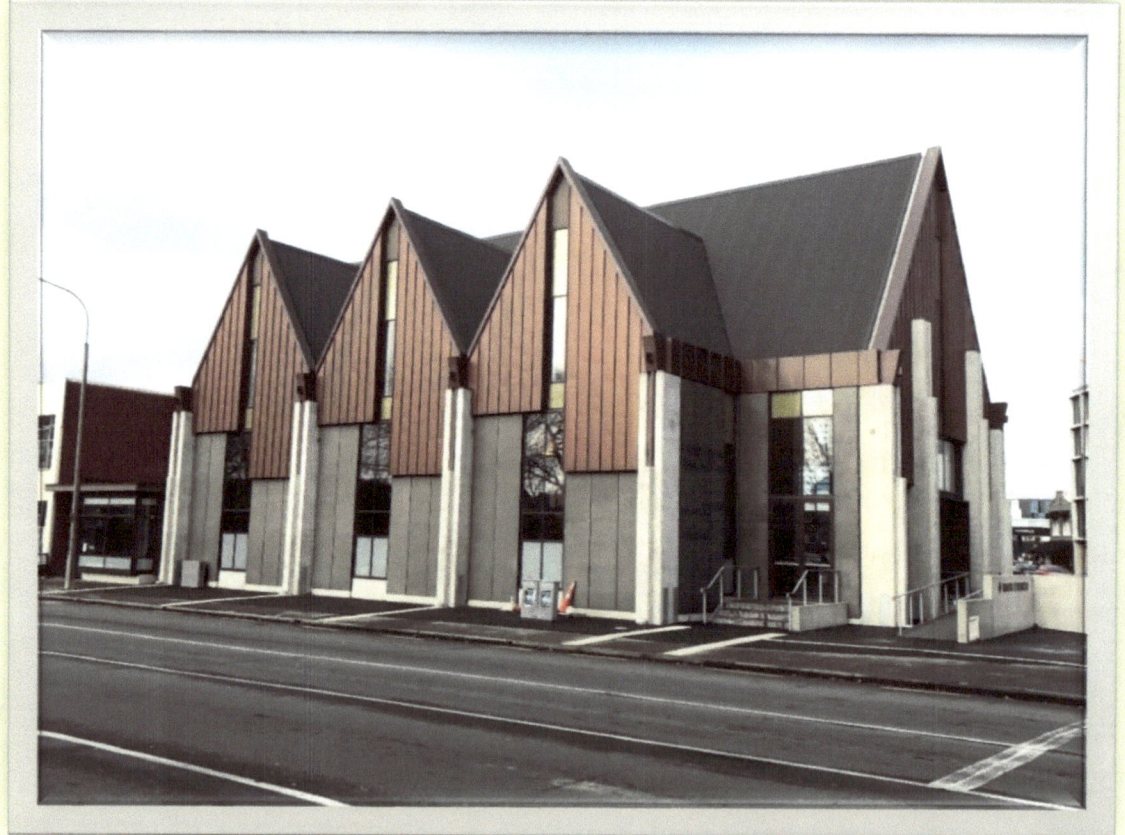

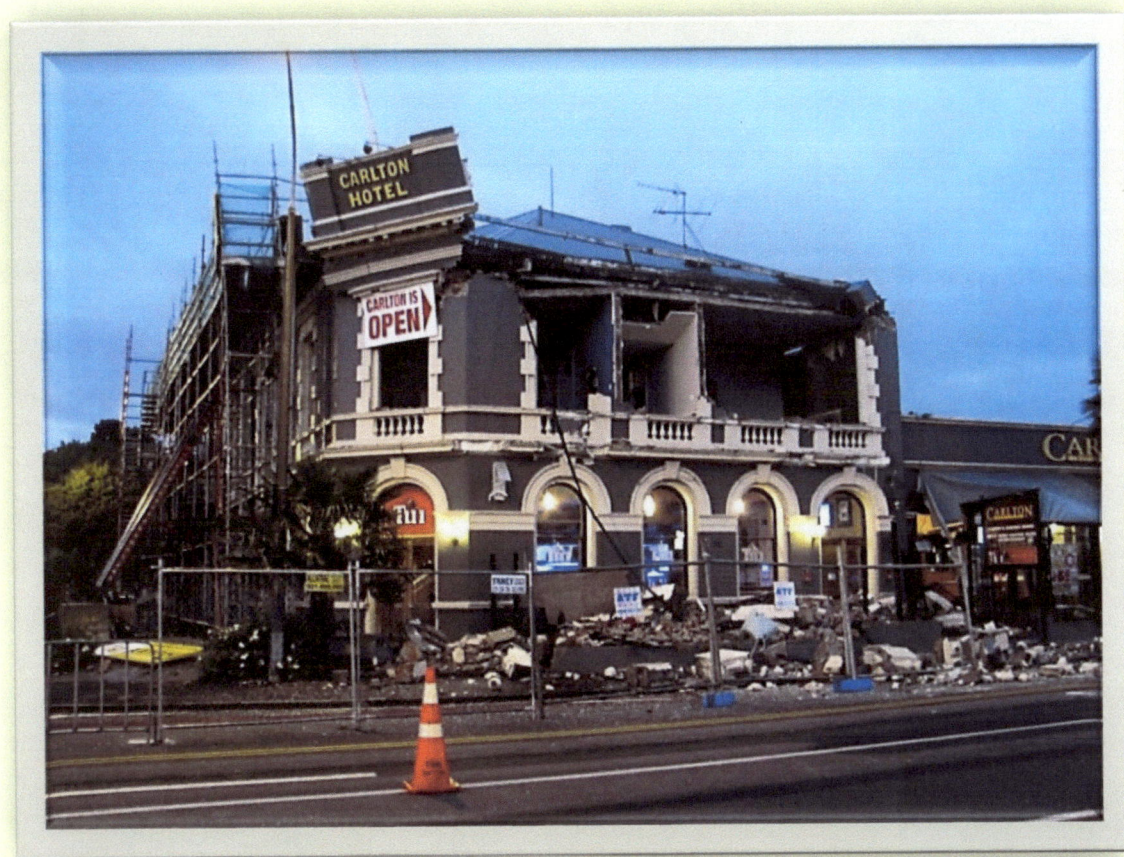
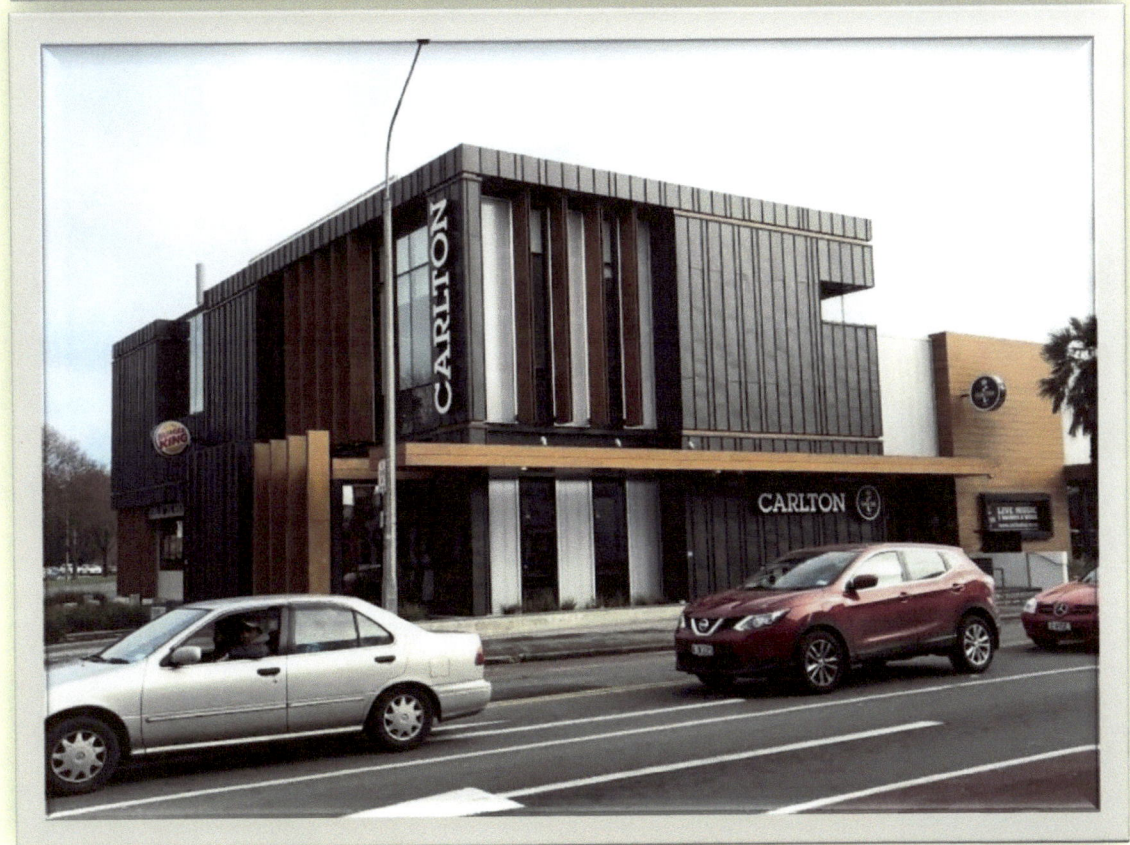

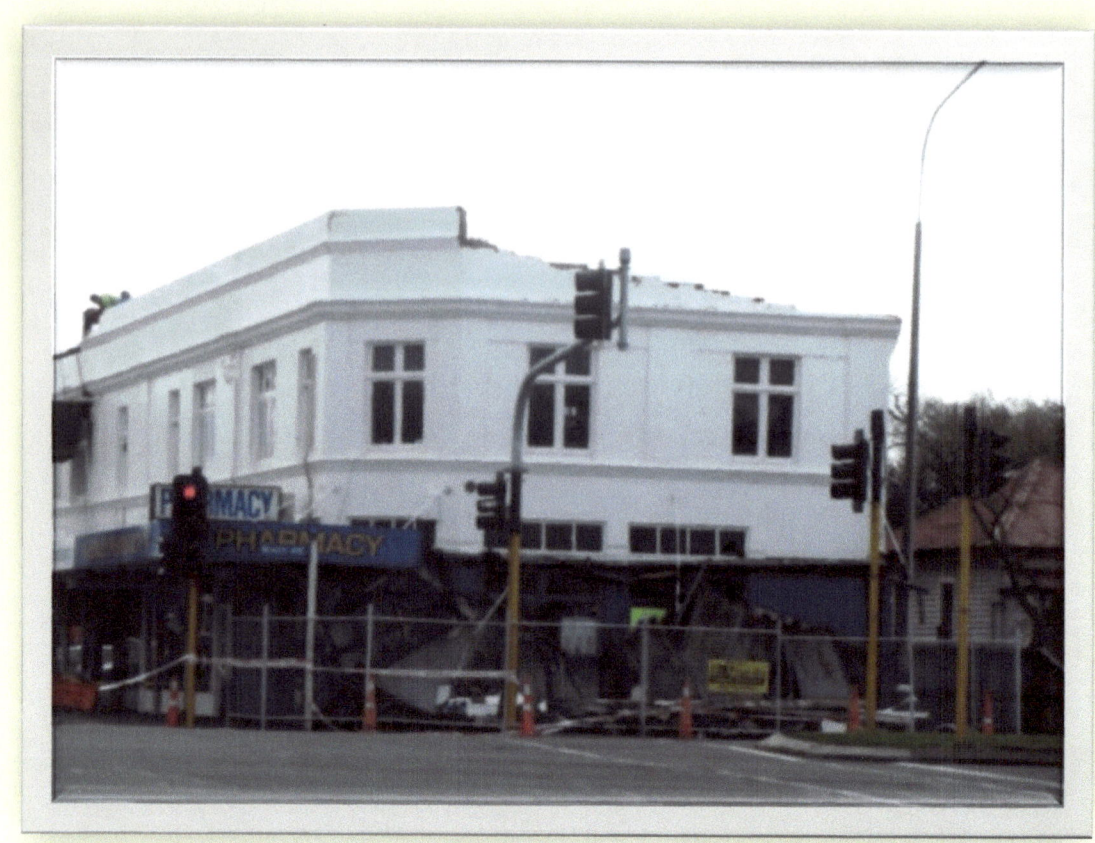

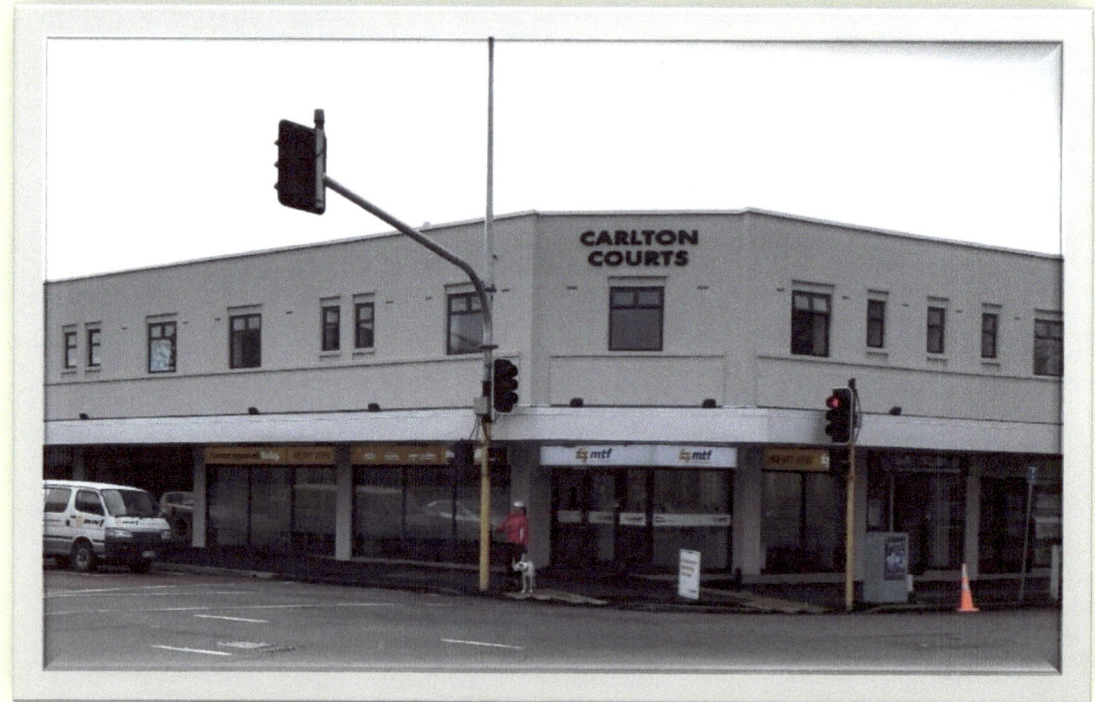

Chapter Two
Christchurch on and after the 4ᵗʰ September 2010

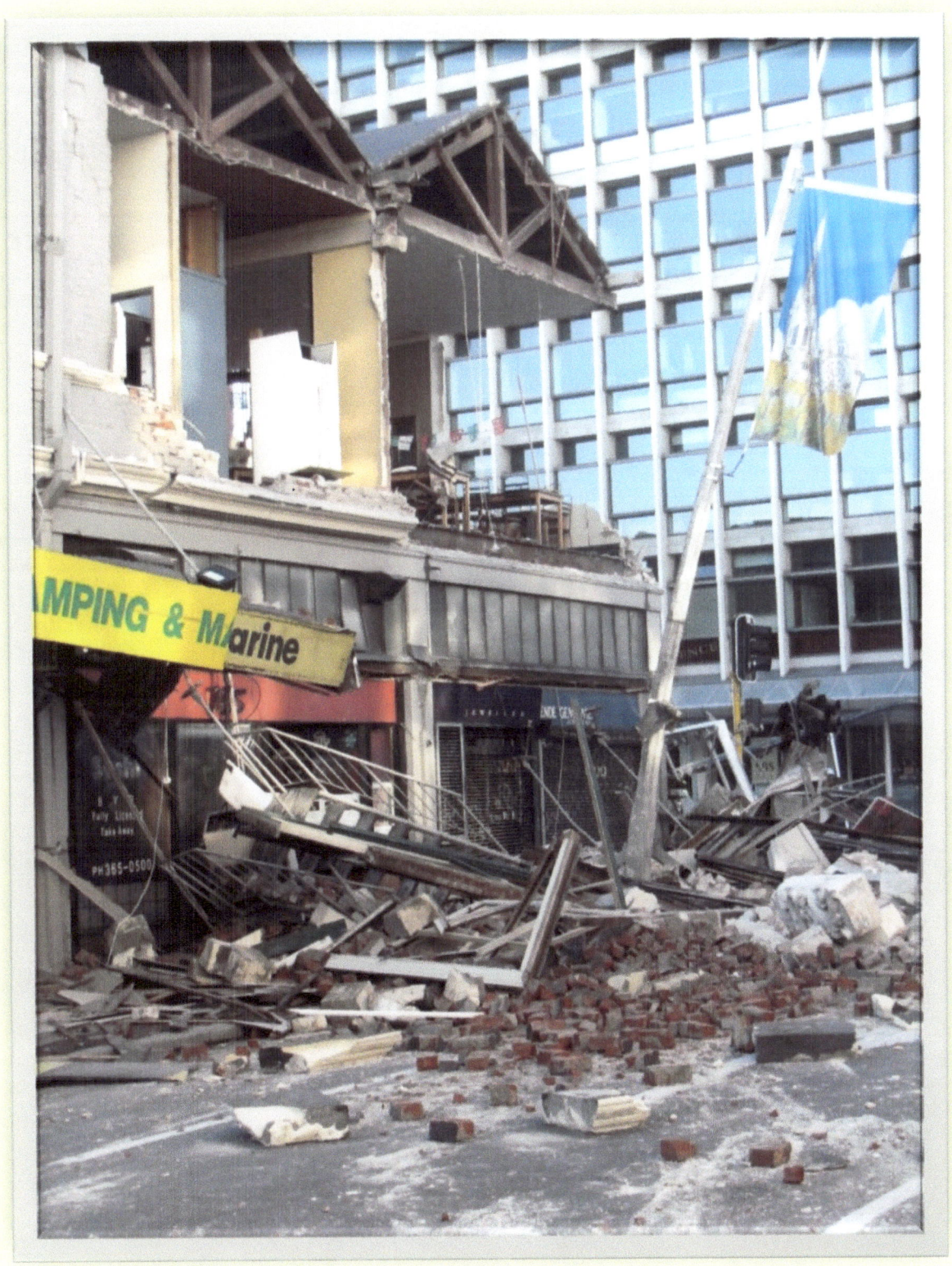

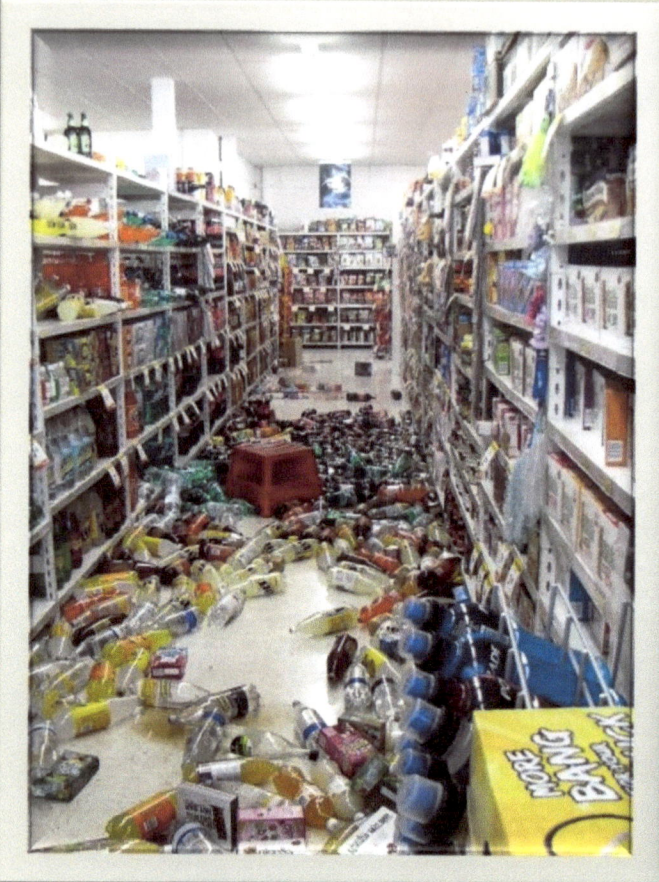
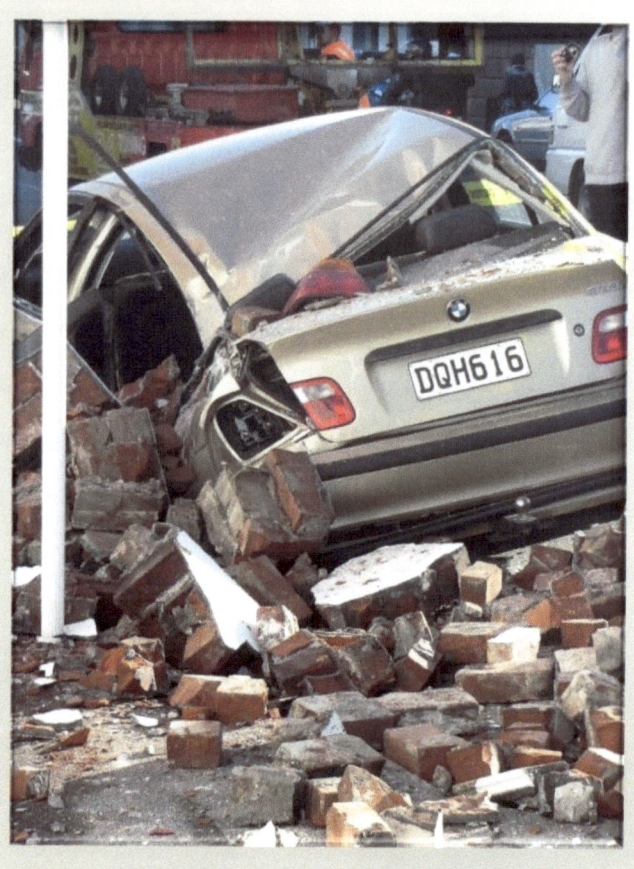
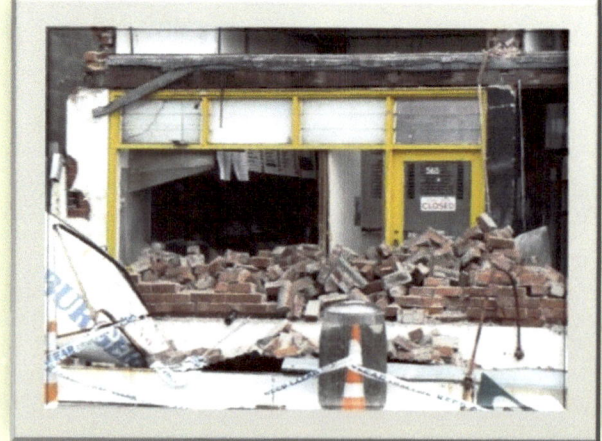
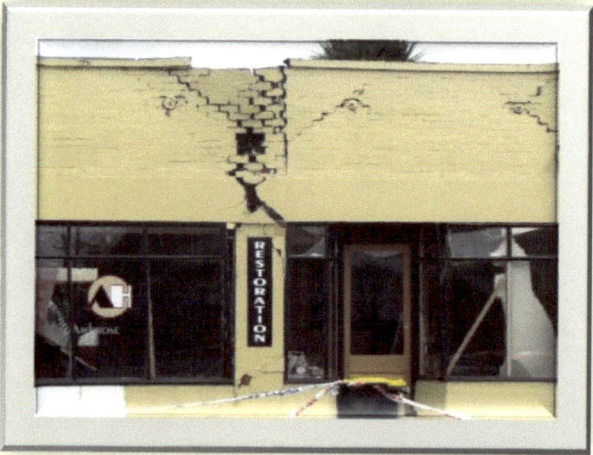

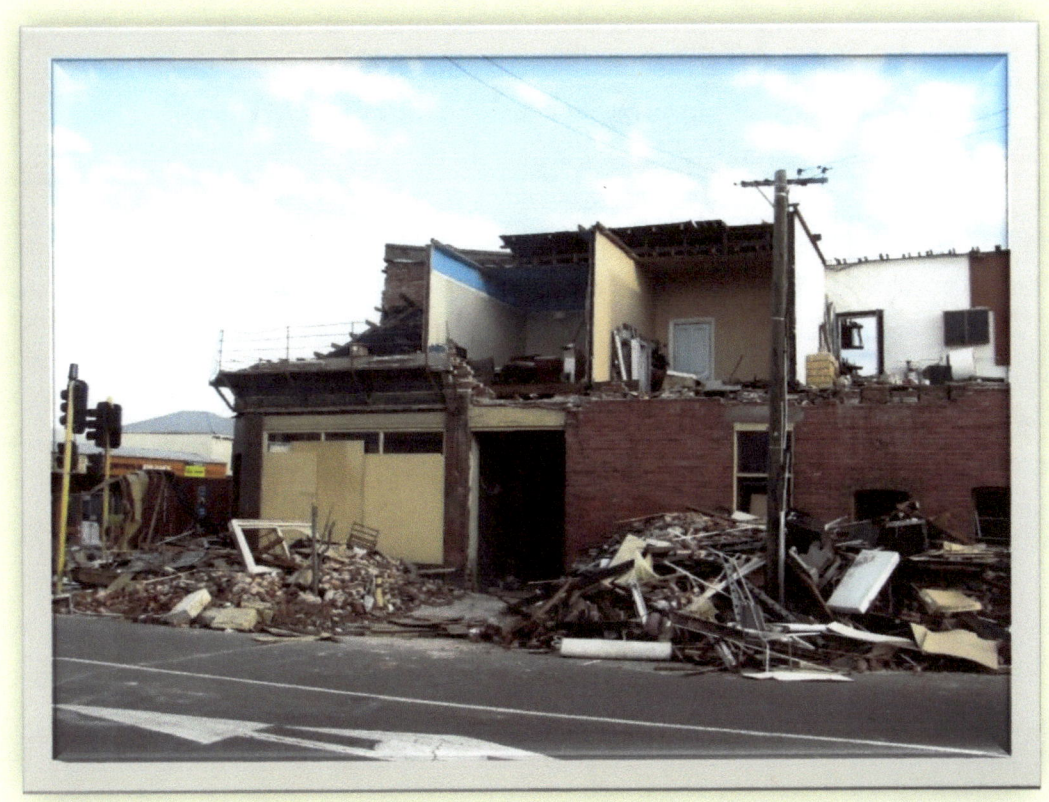
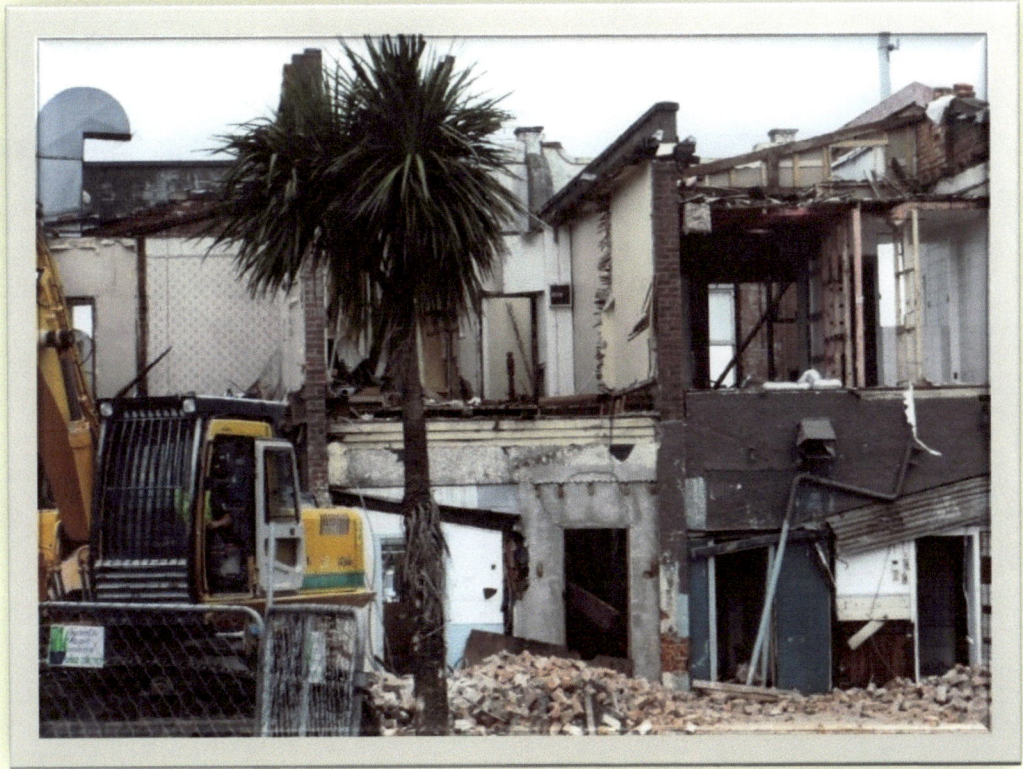

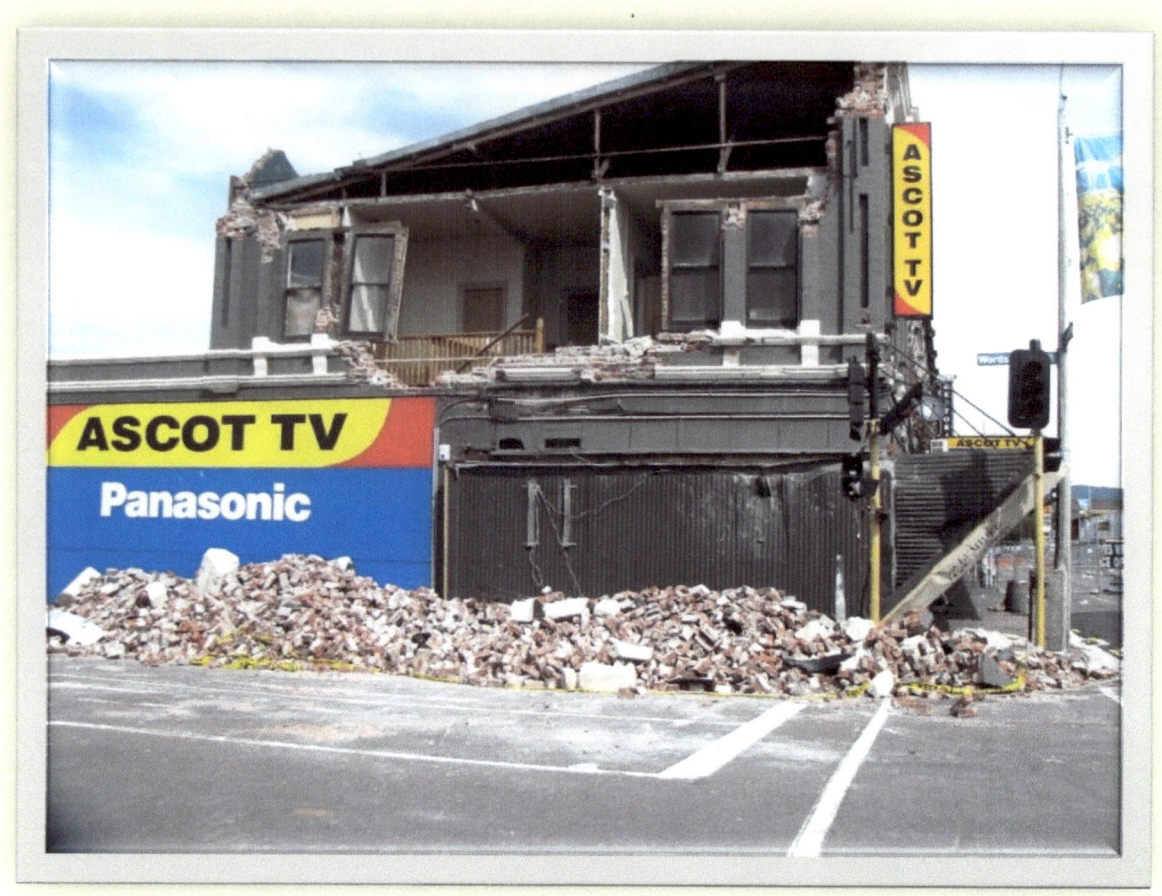

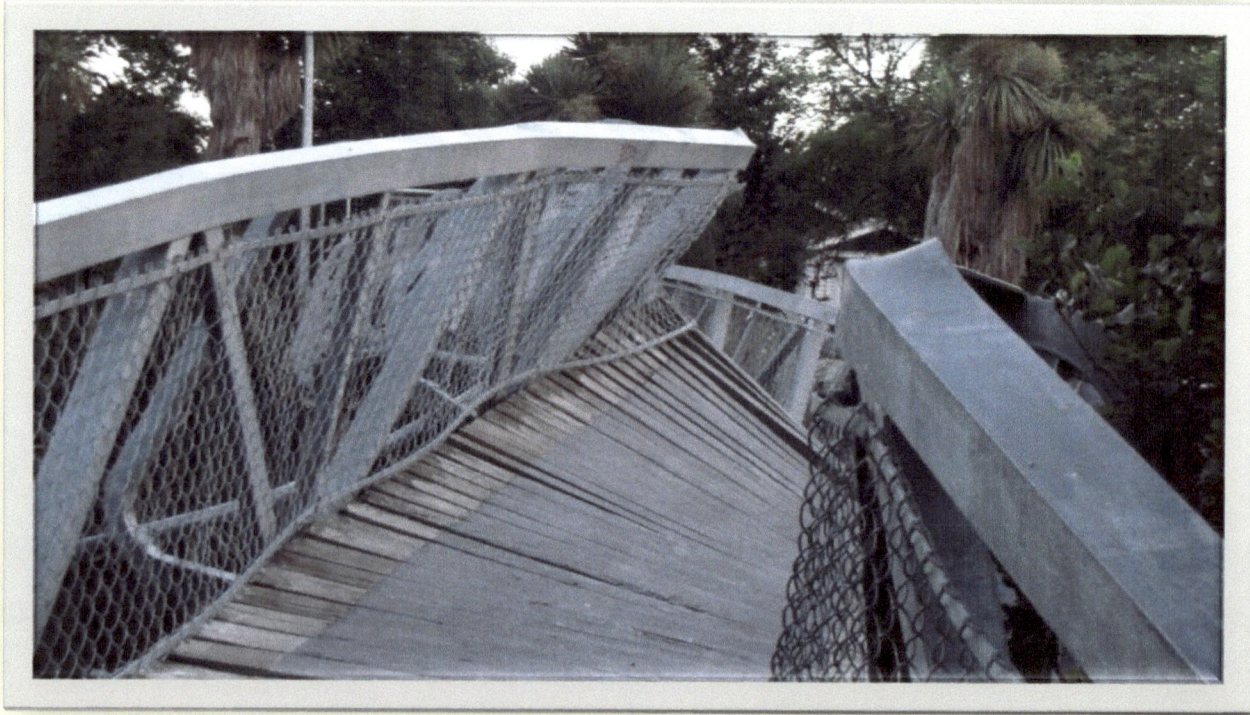

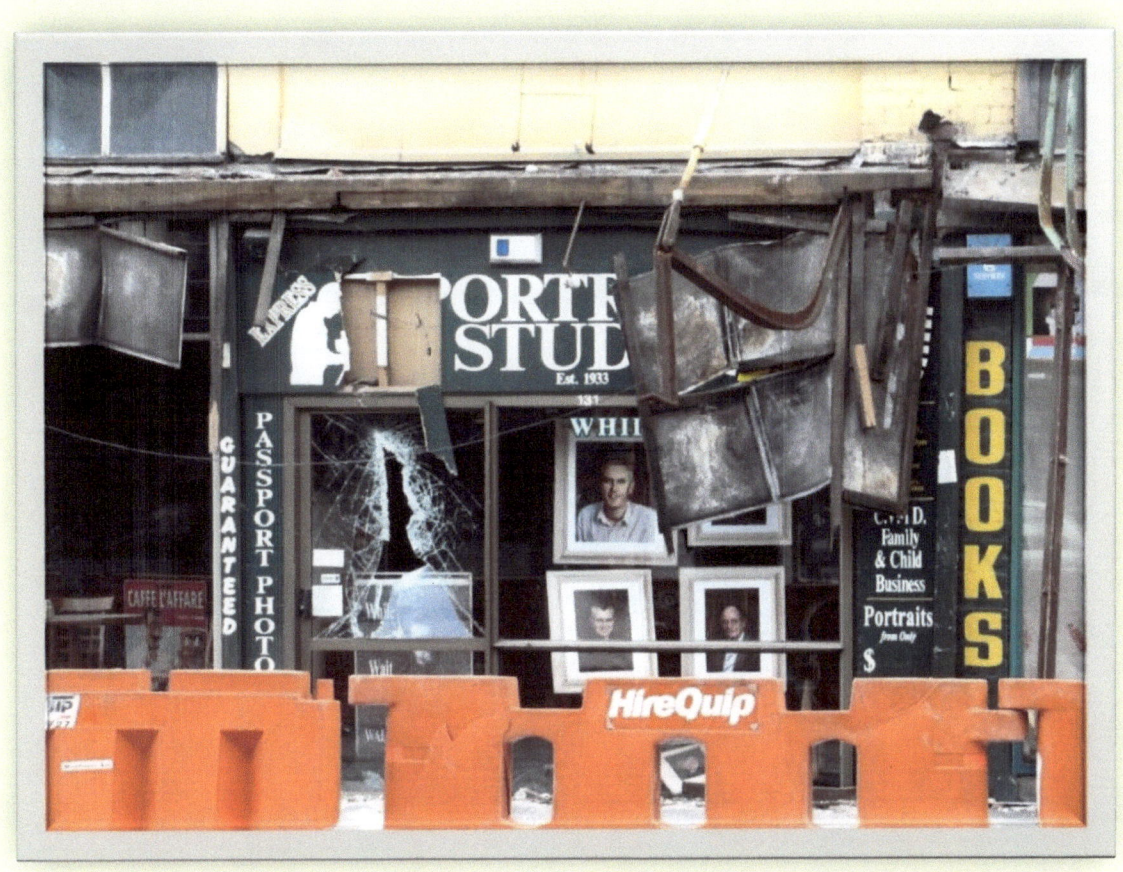

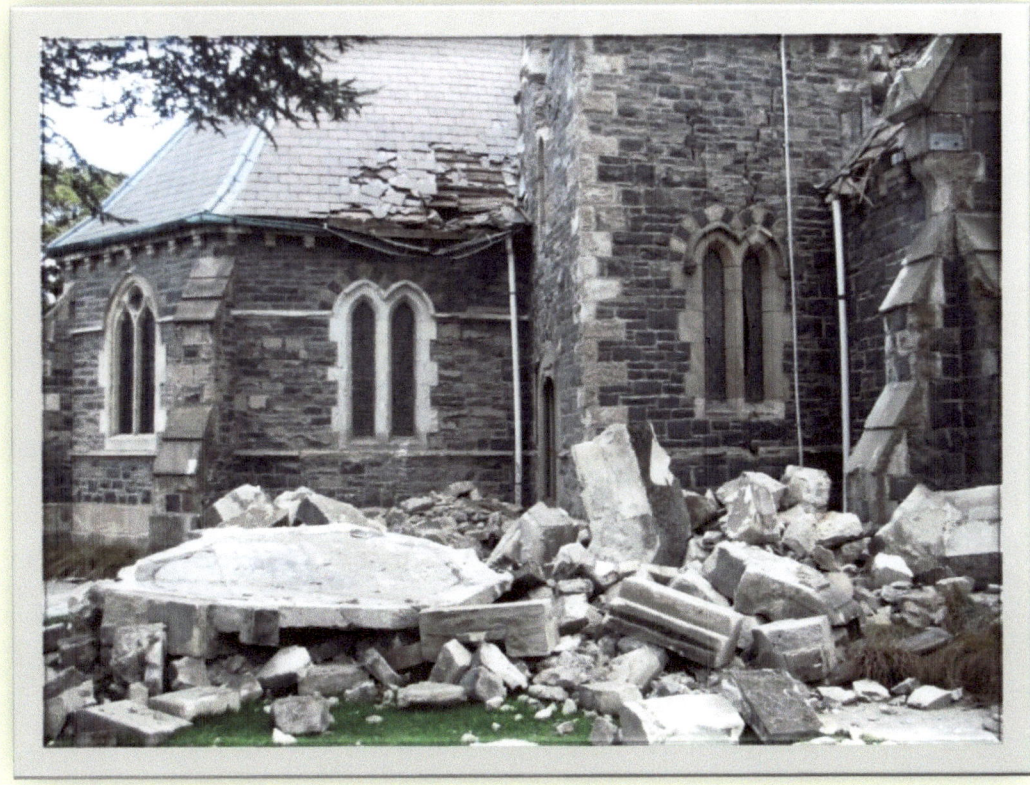

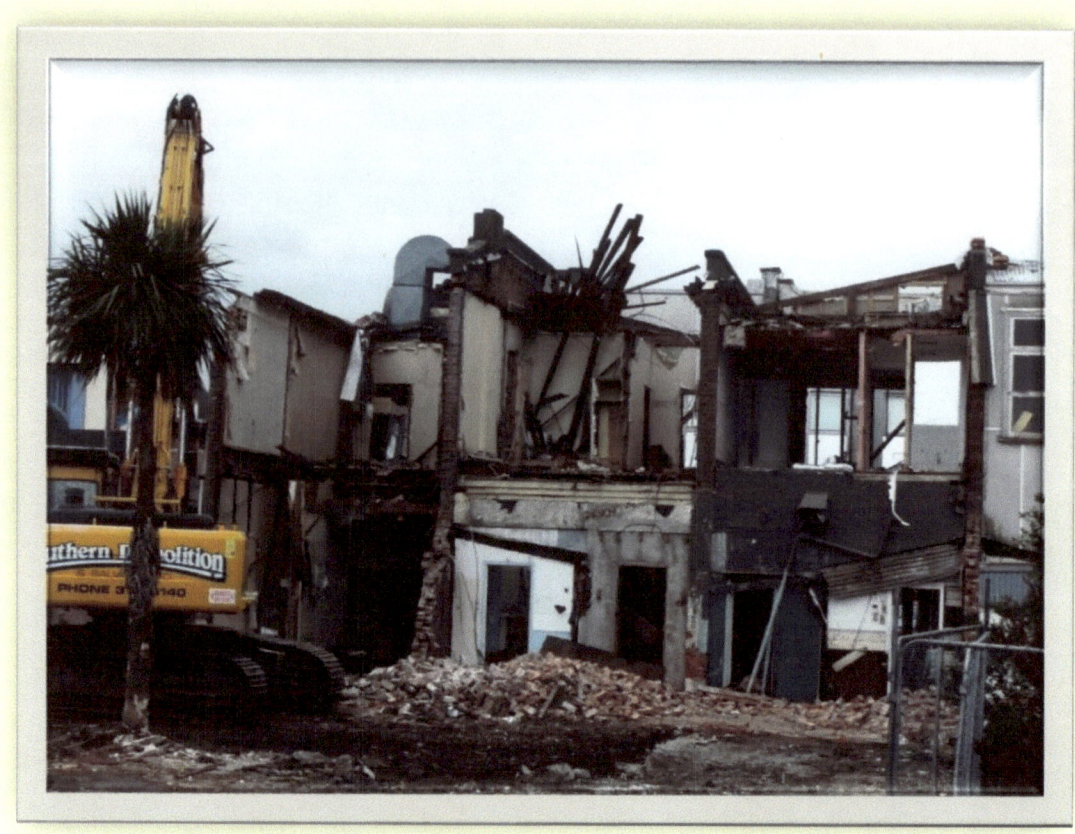

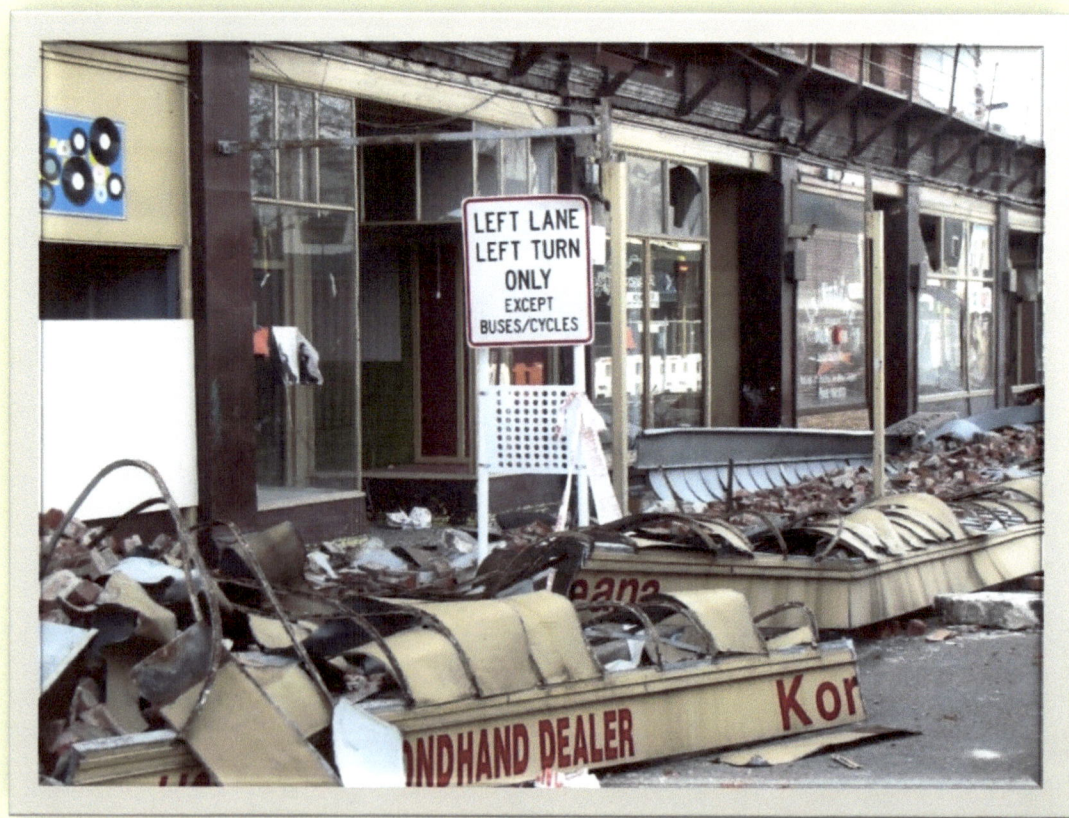

Chapter Three
Christchurch on and after the 22nd February 2011

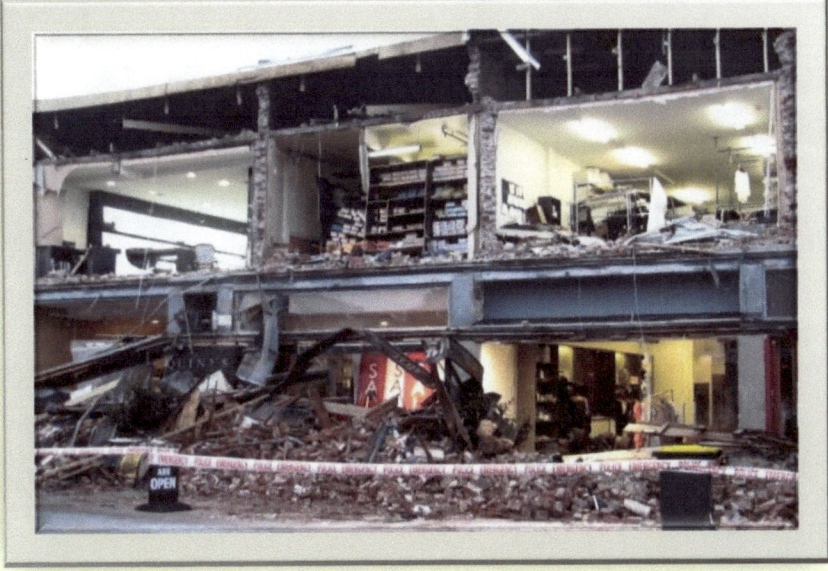

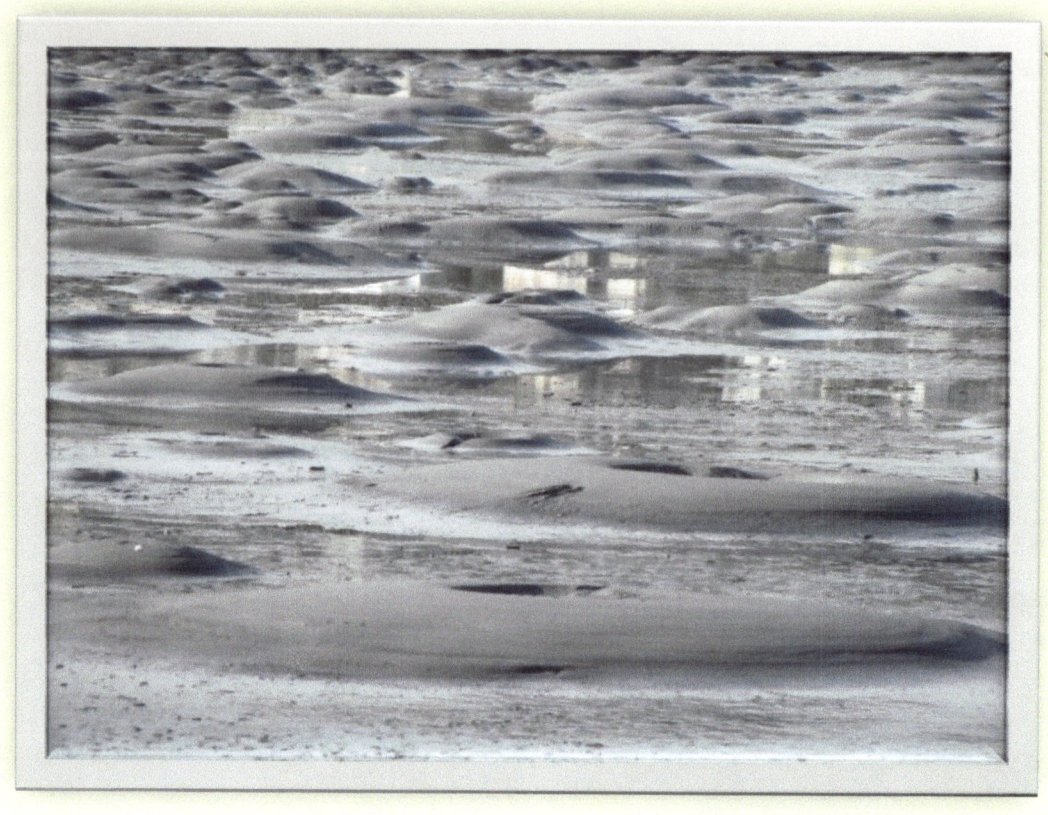

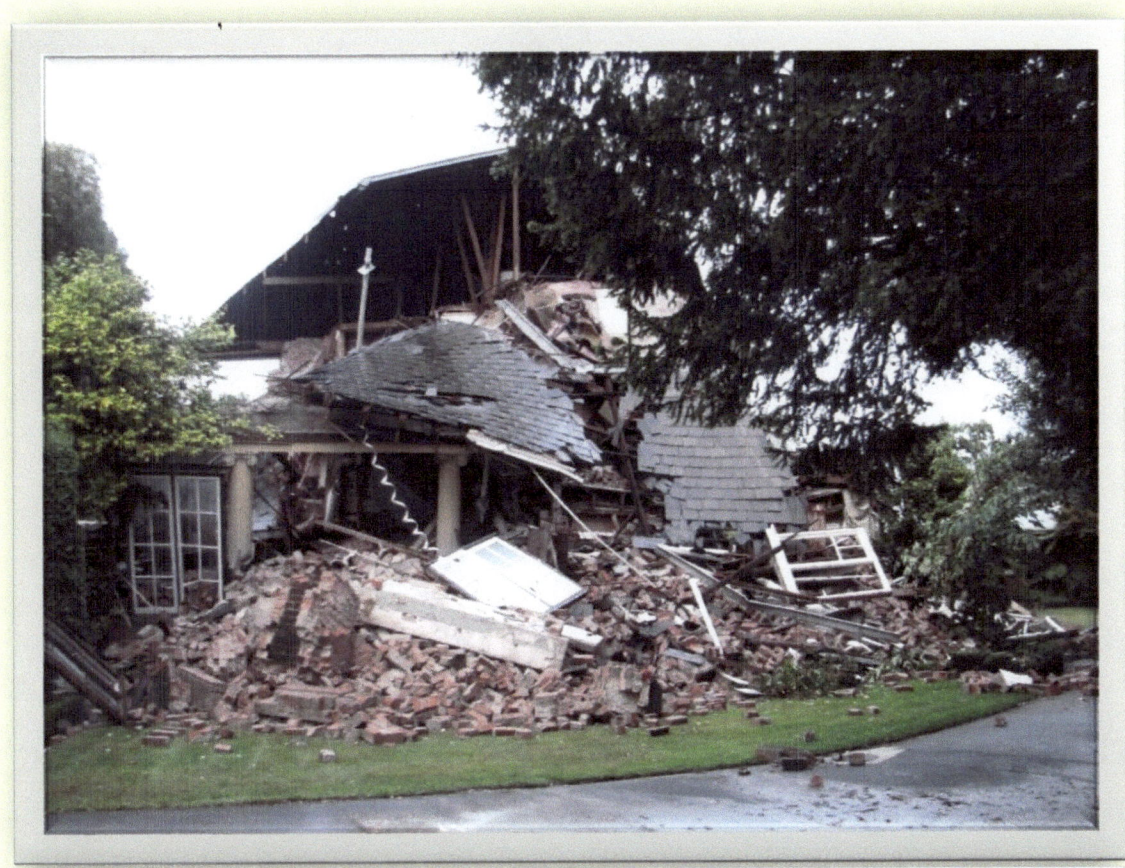

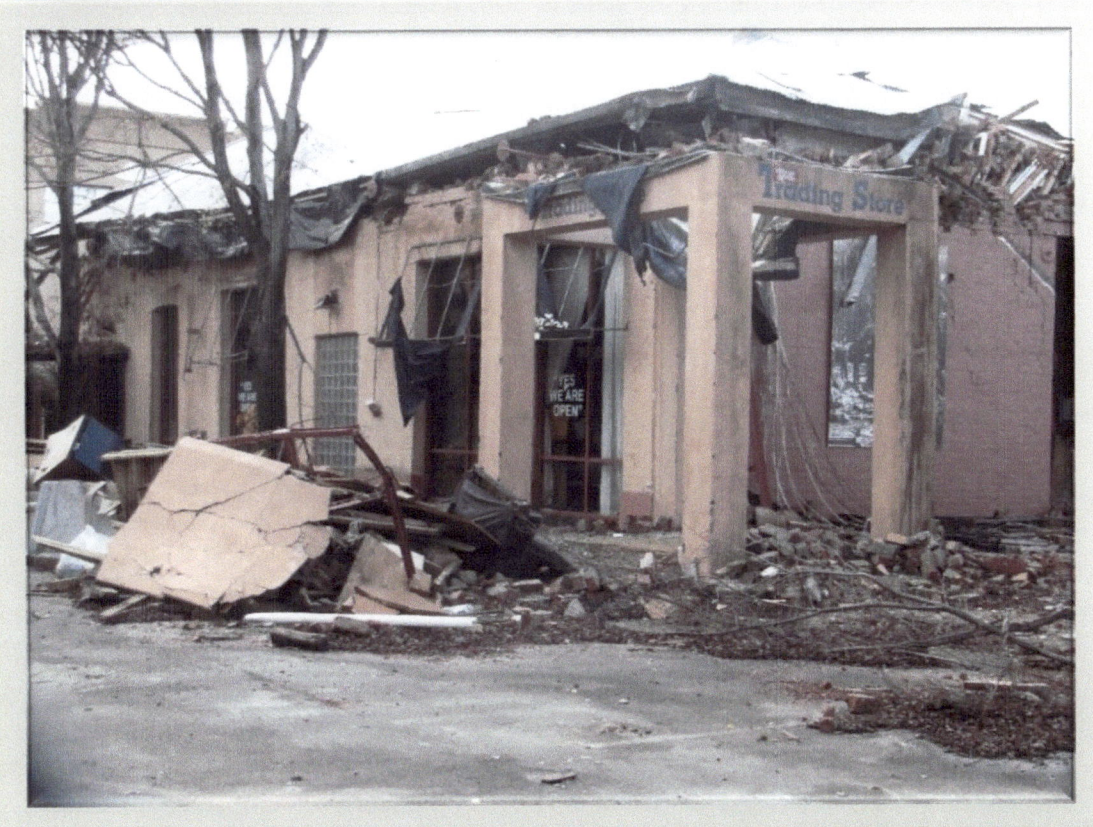

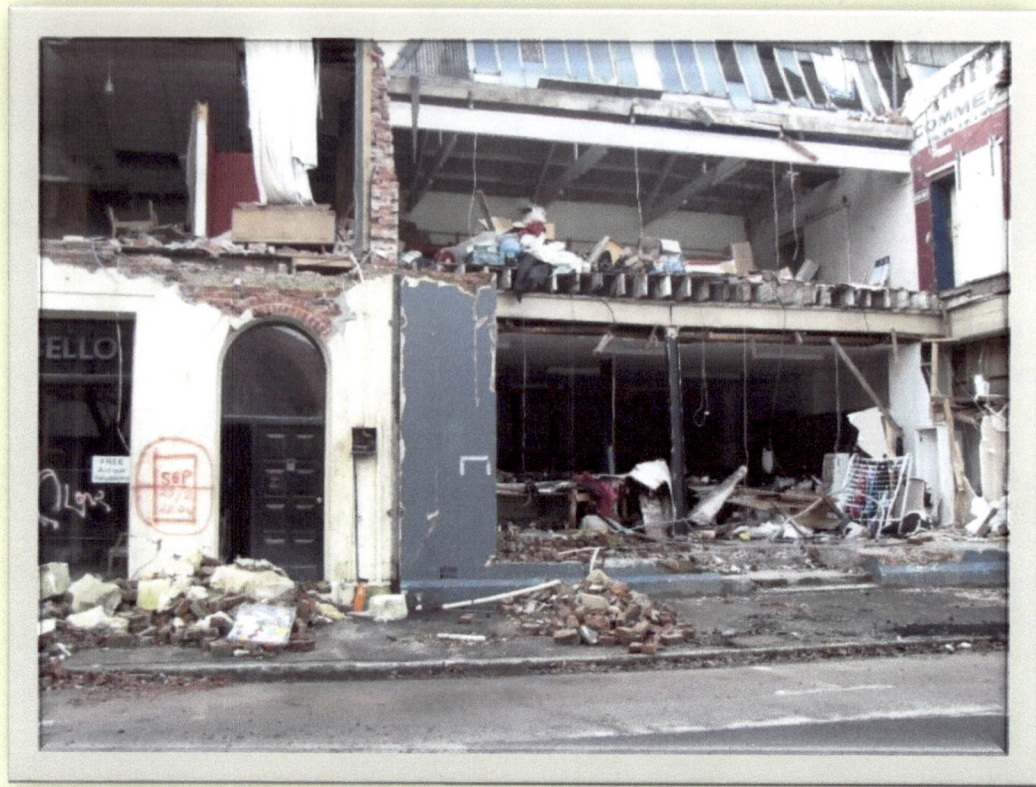

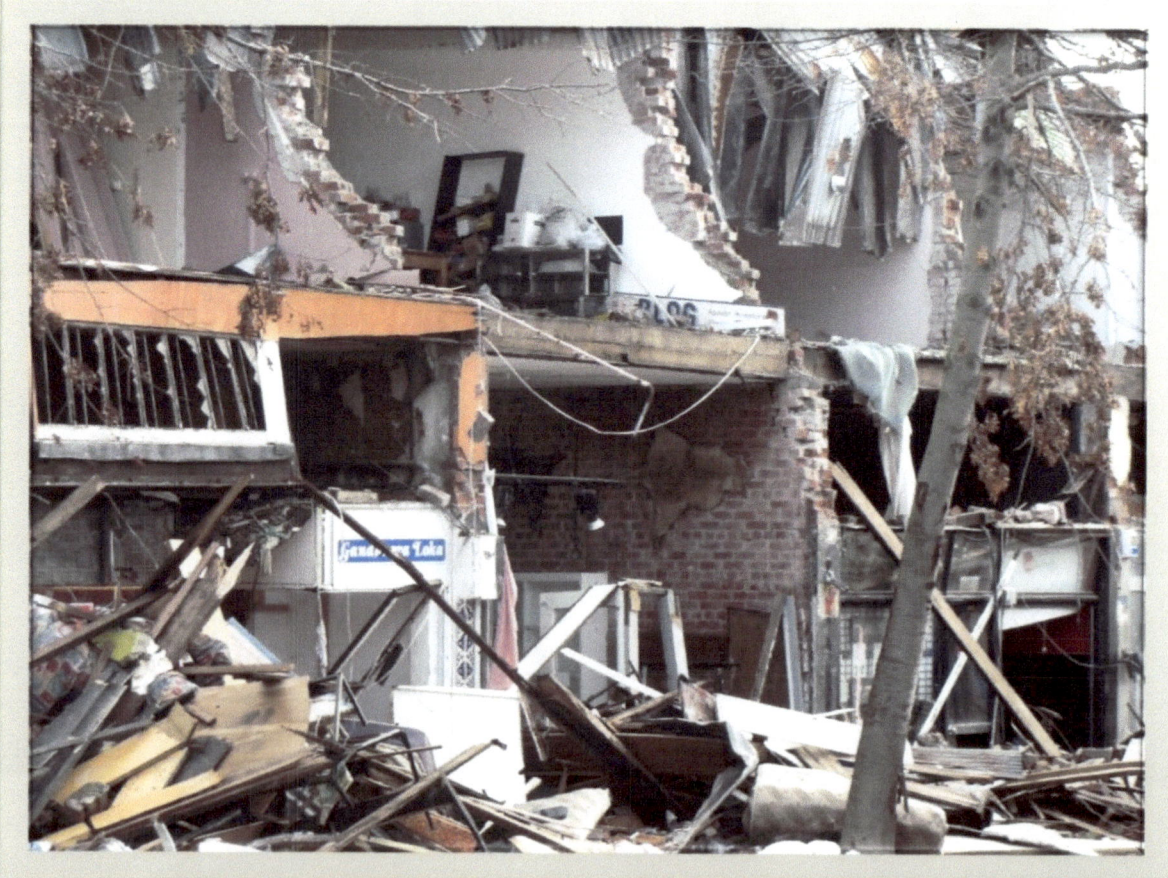

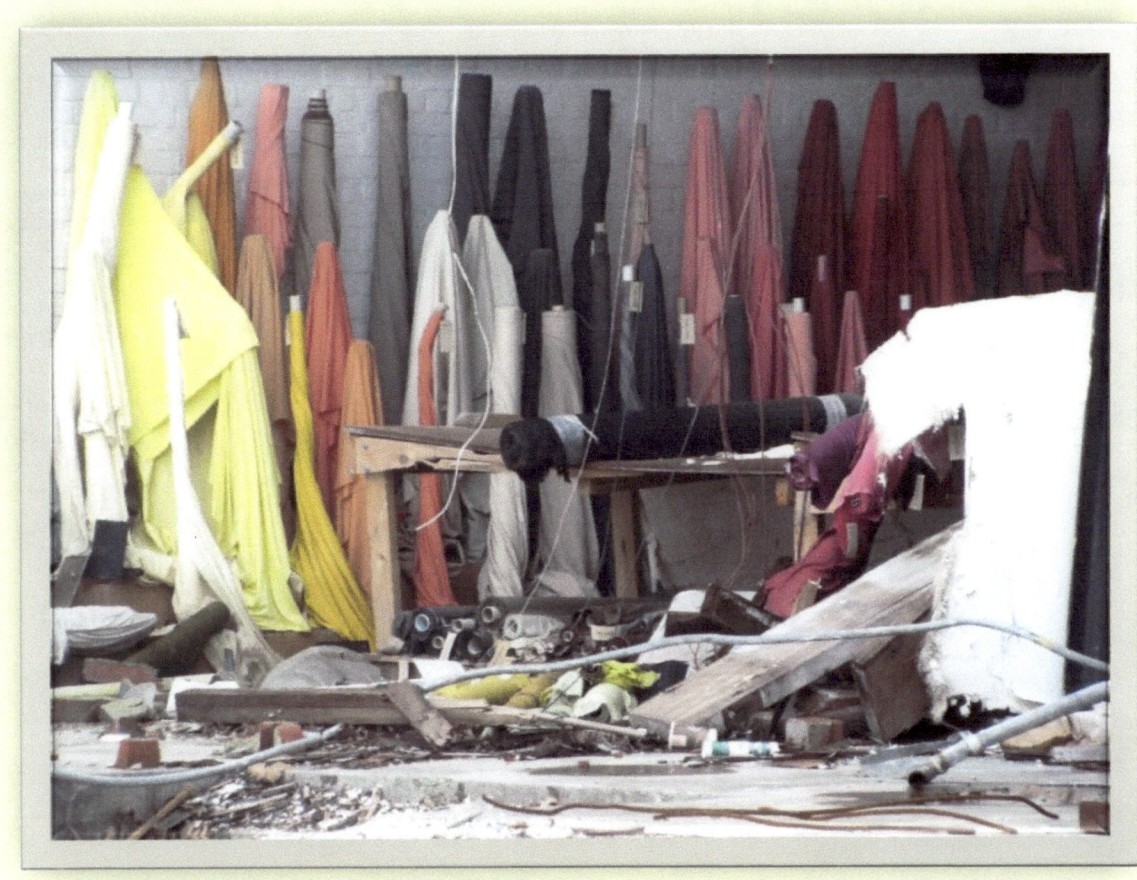

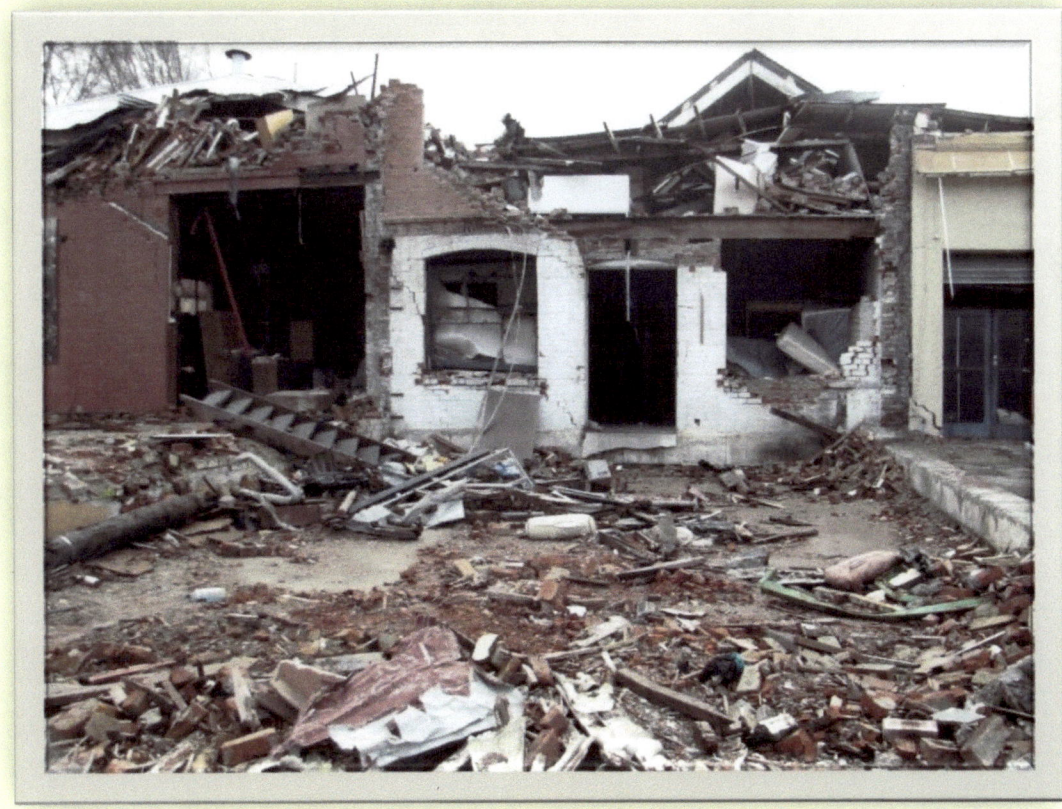

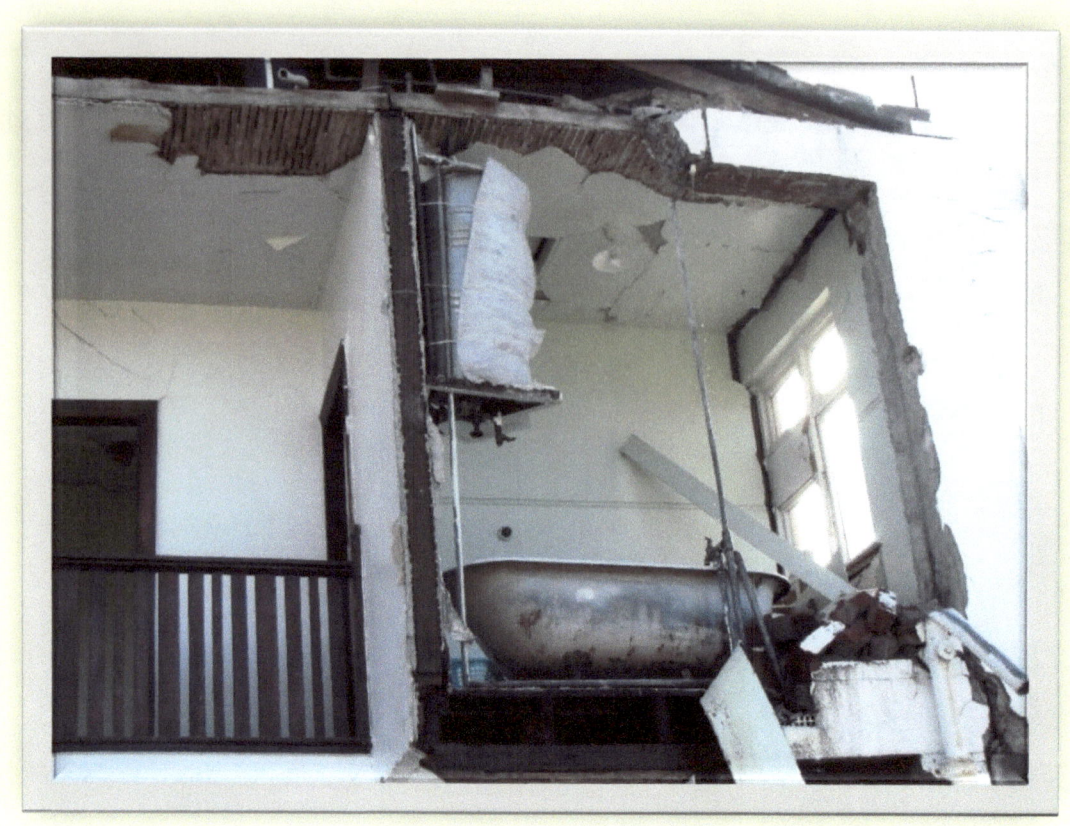

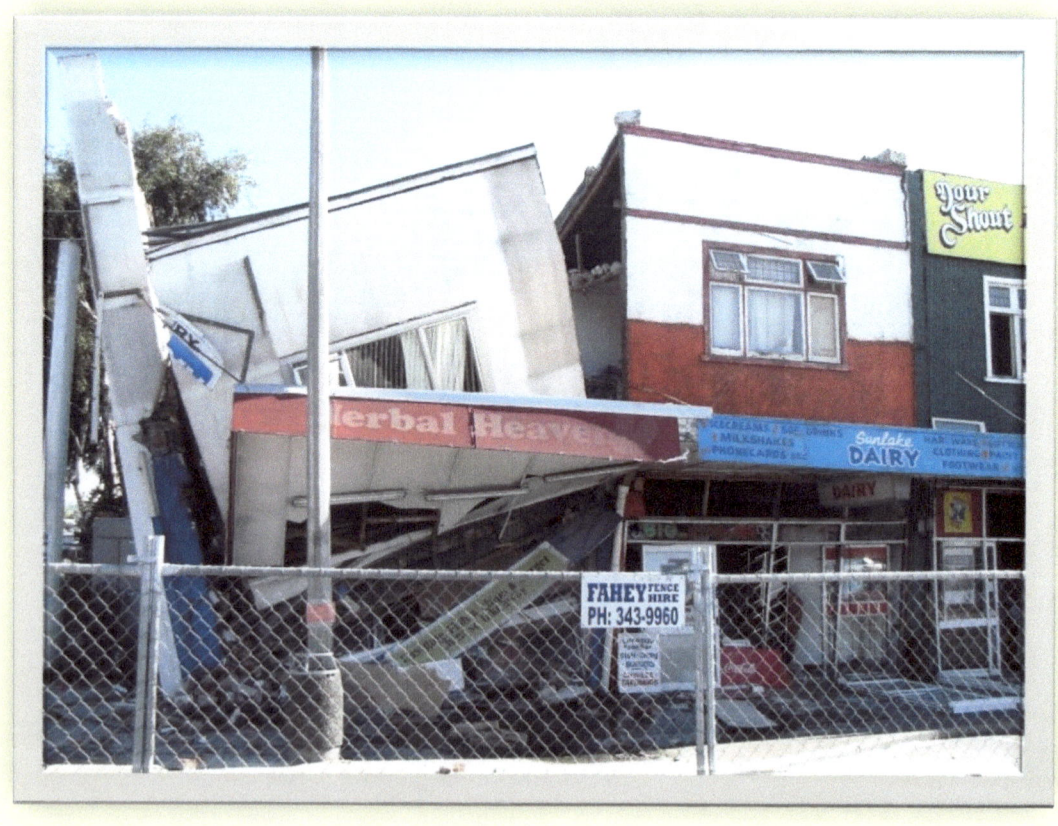

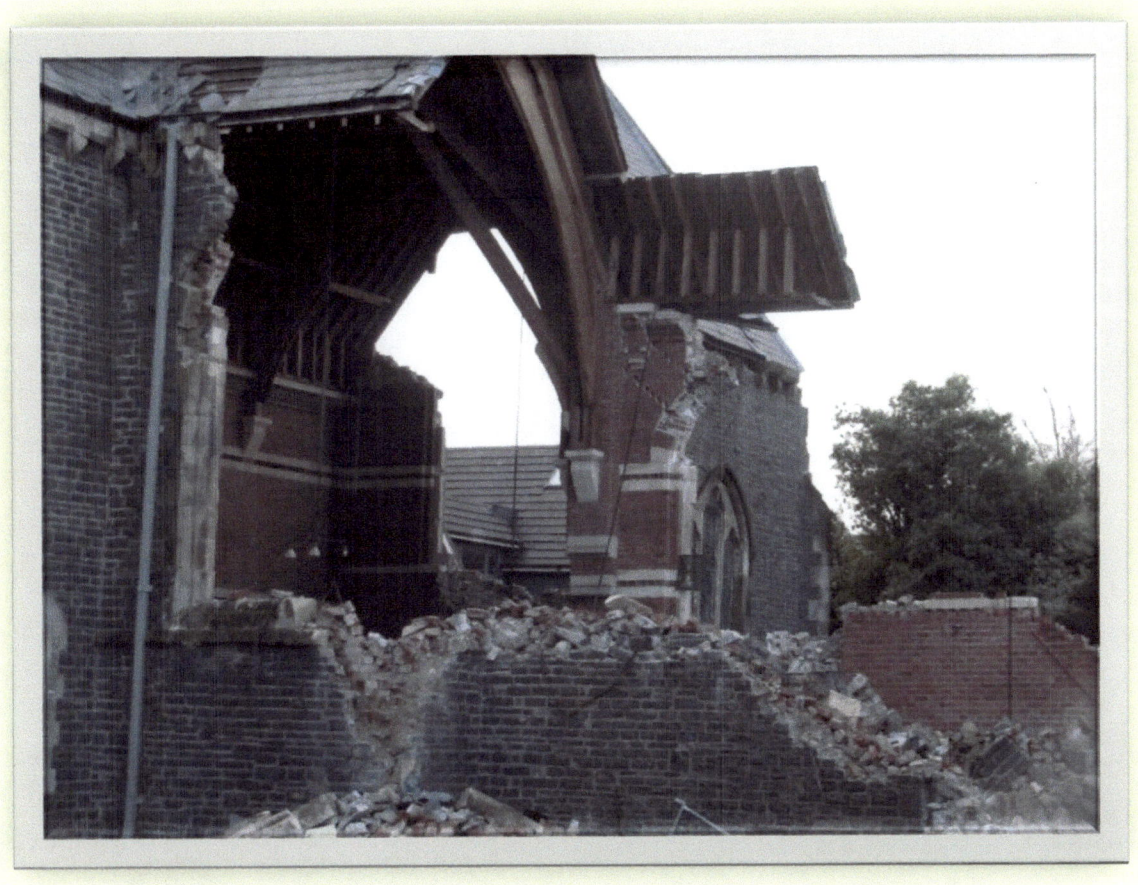

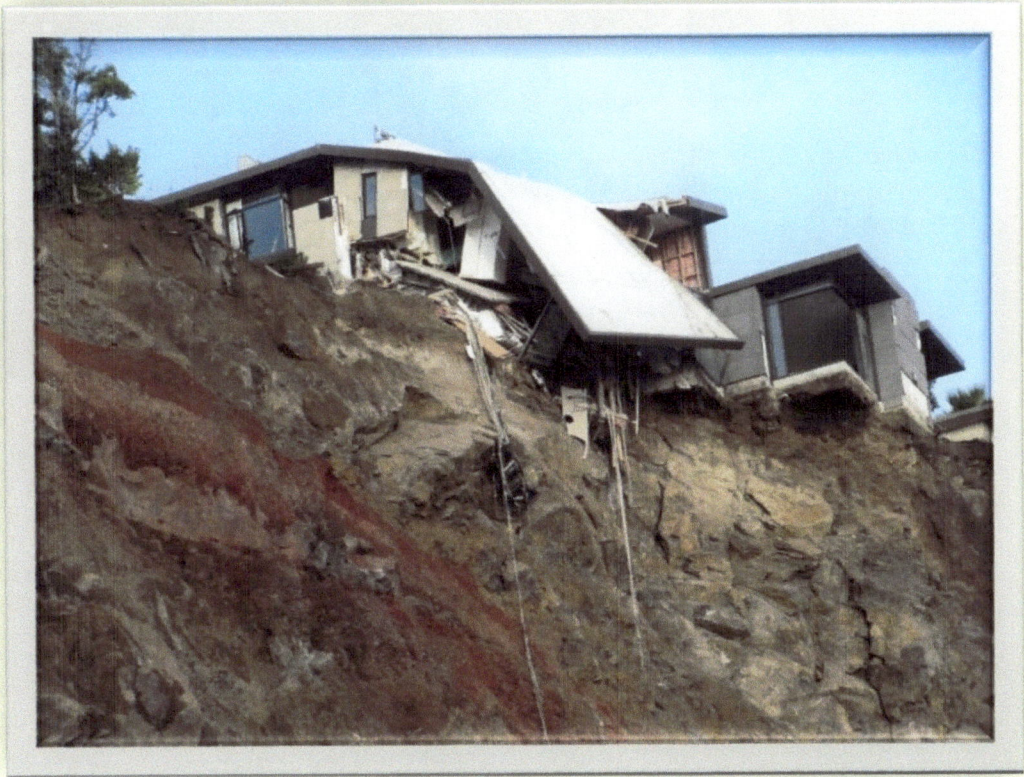

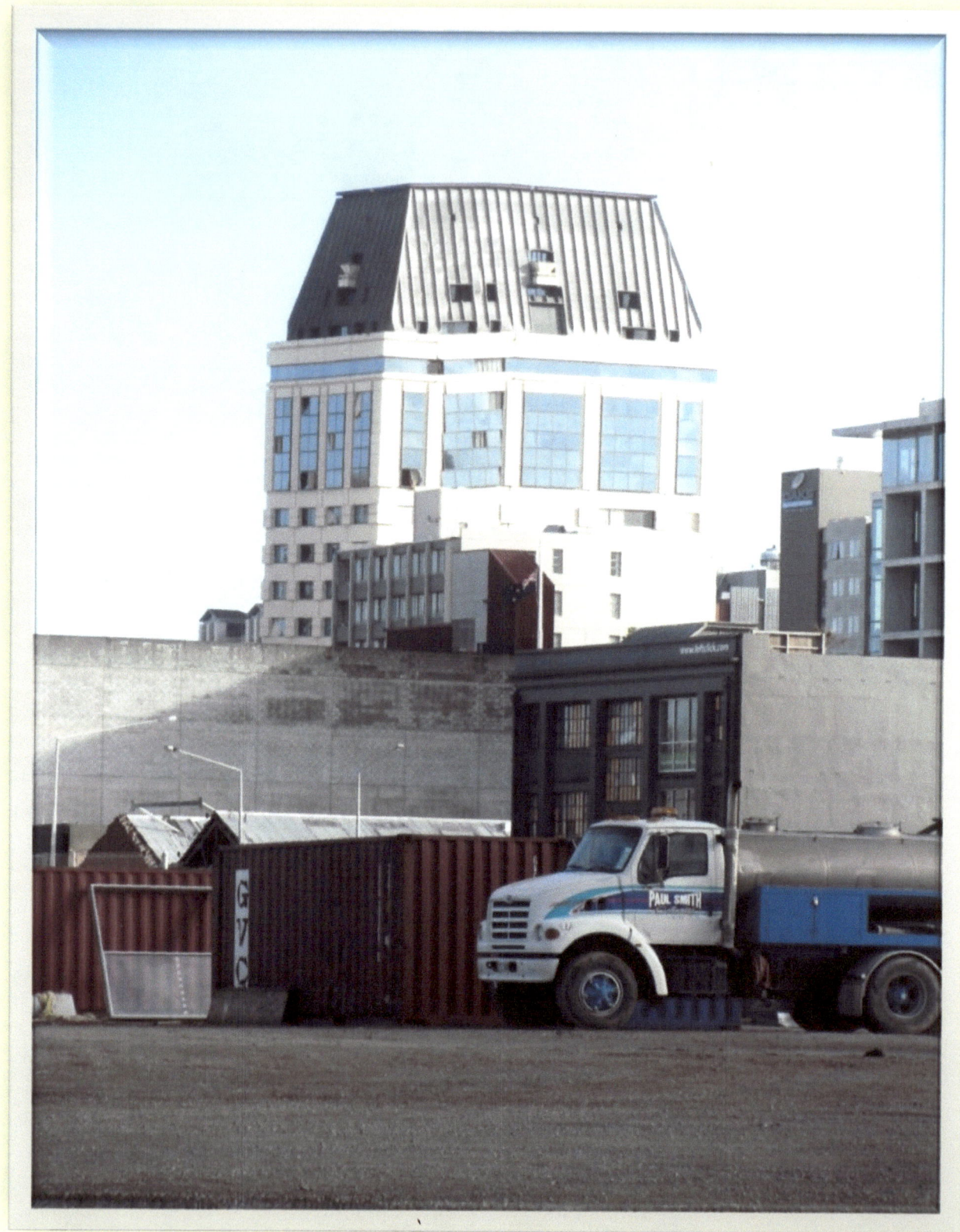

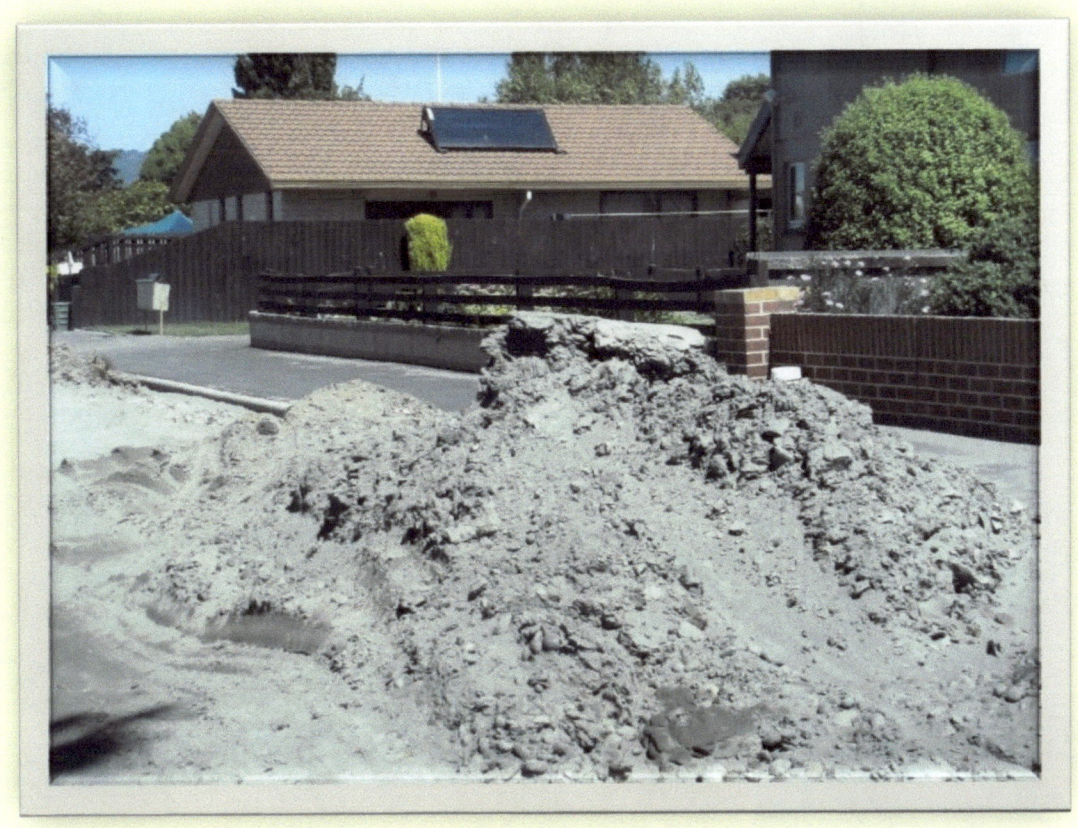

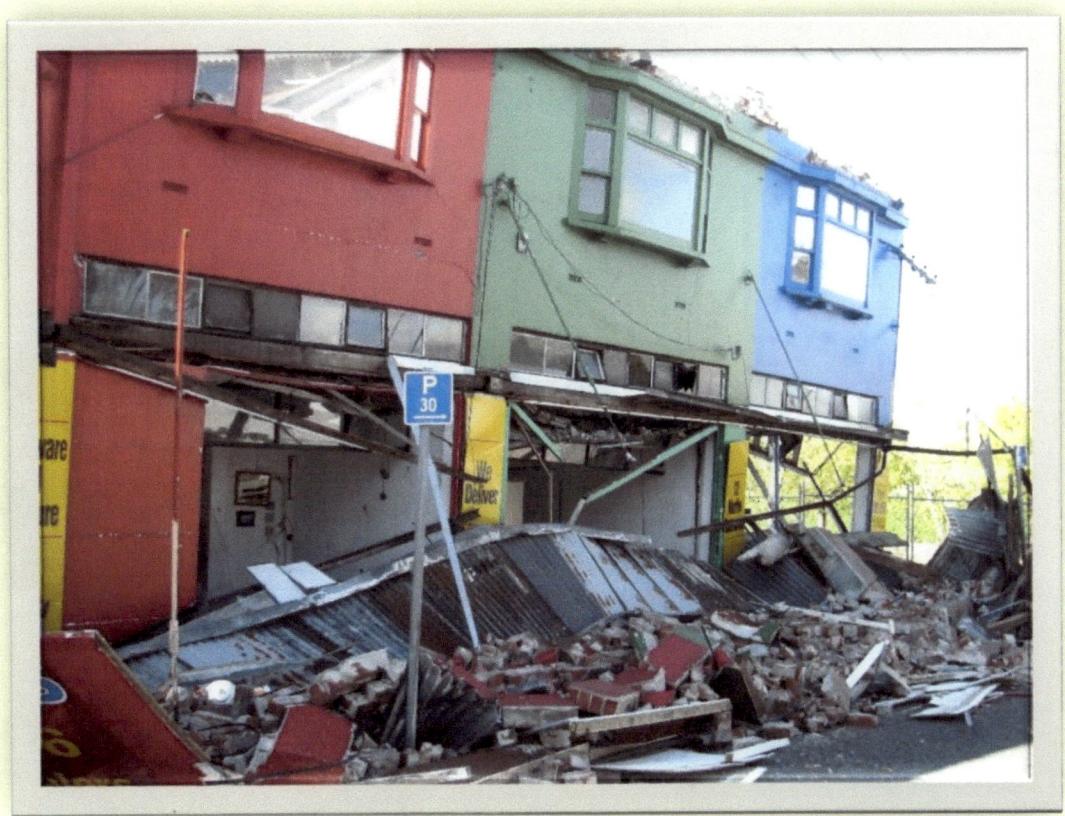

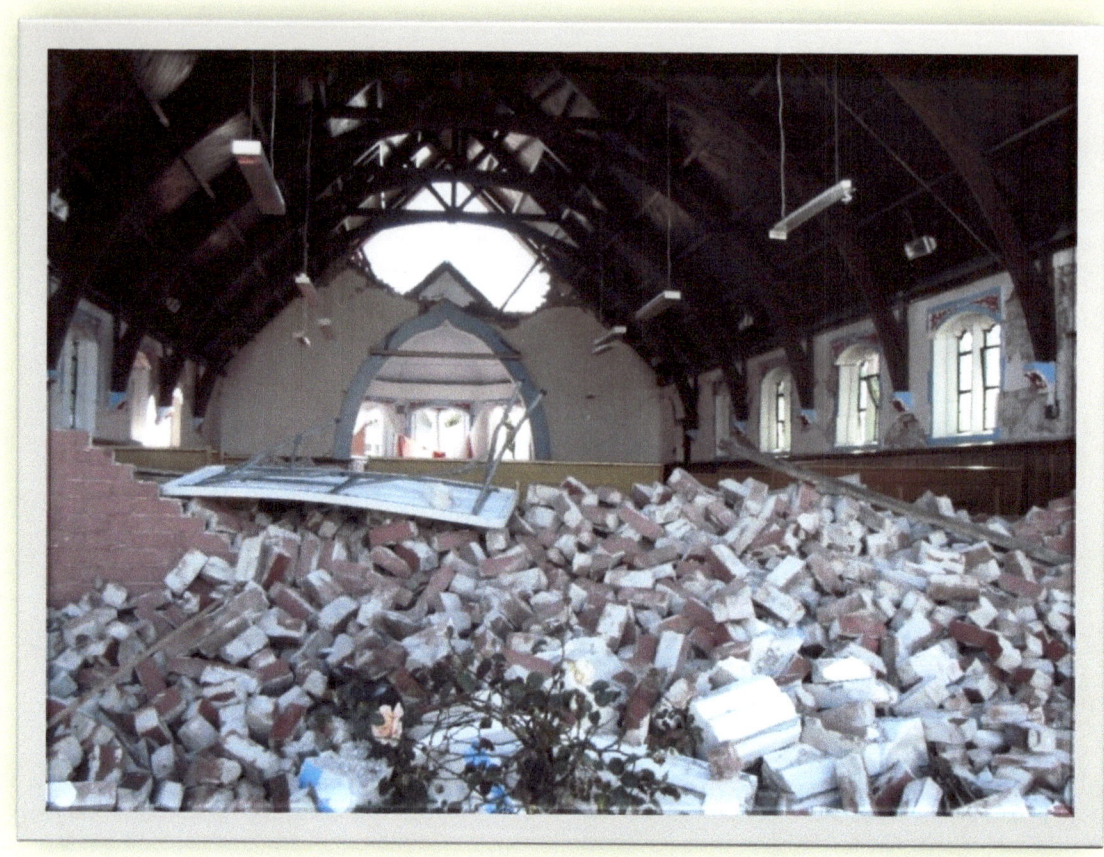
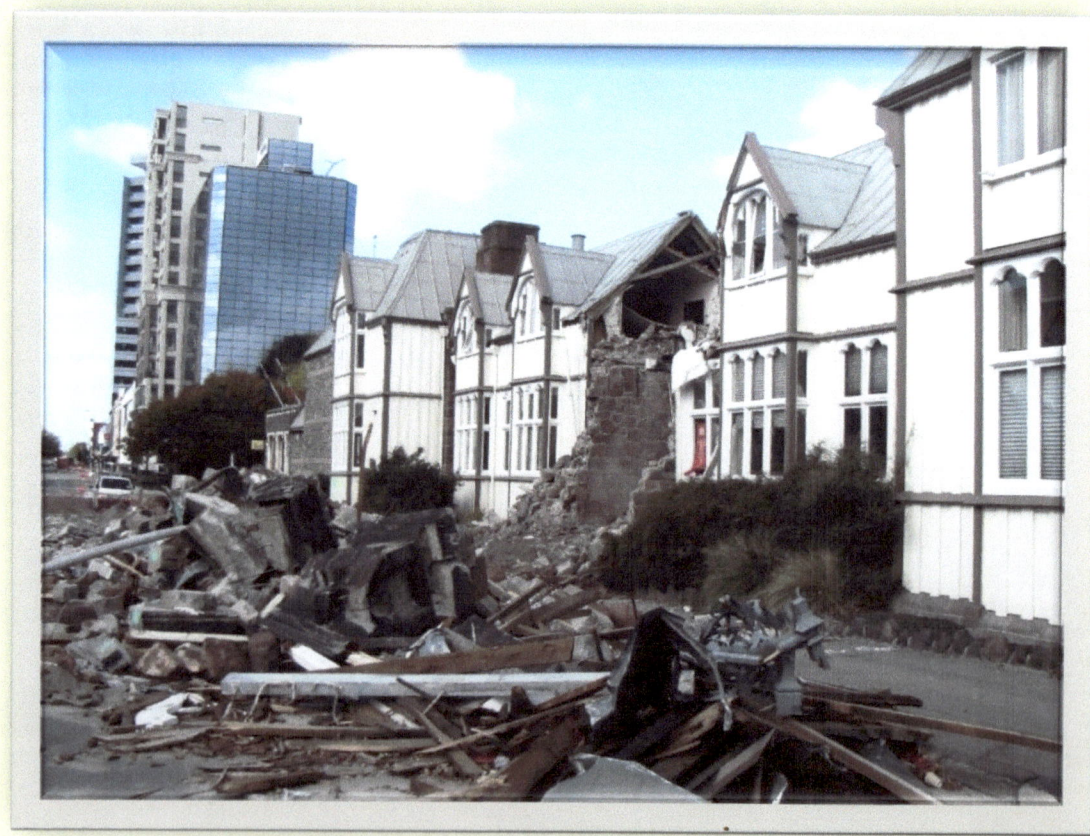

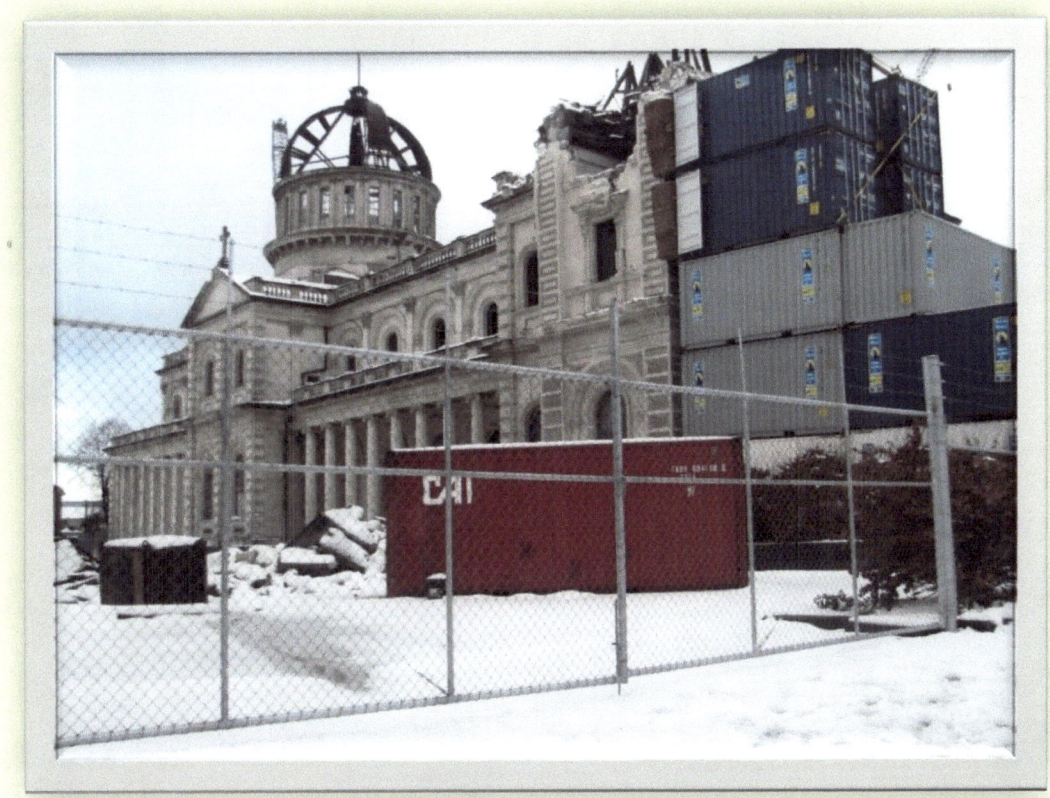
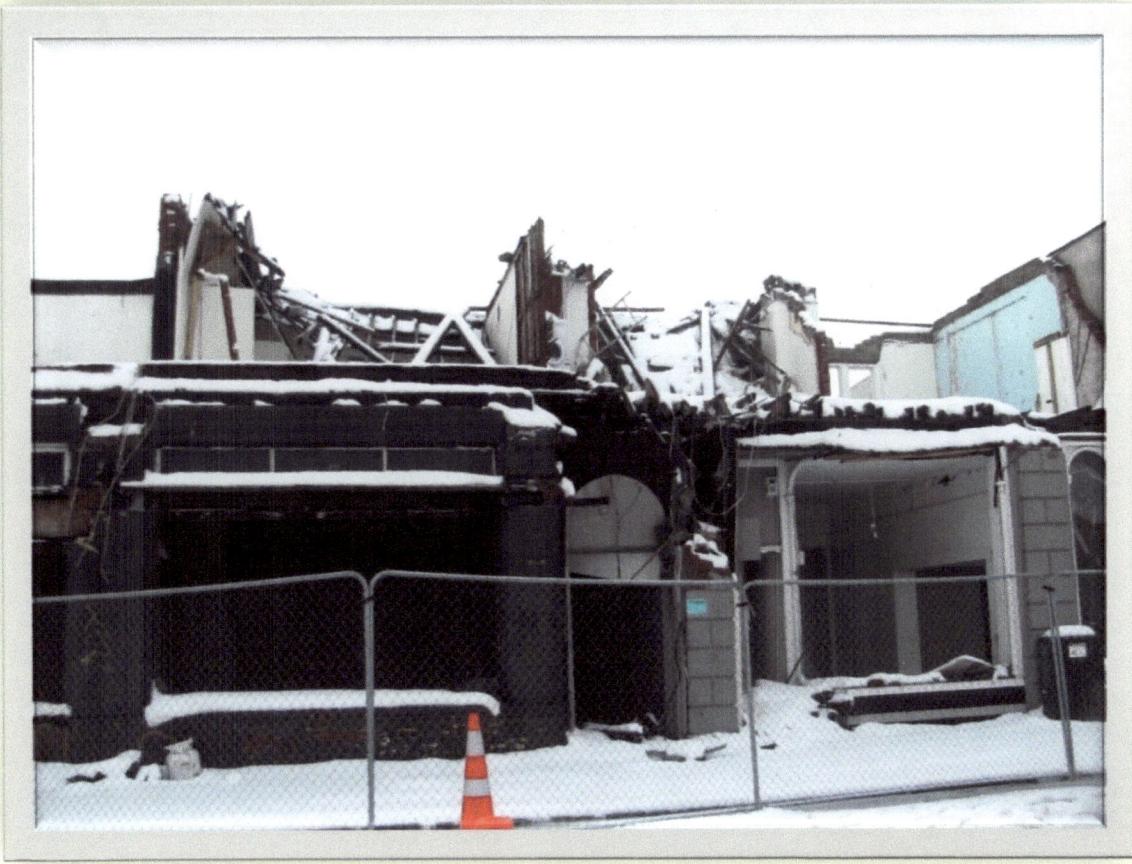

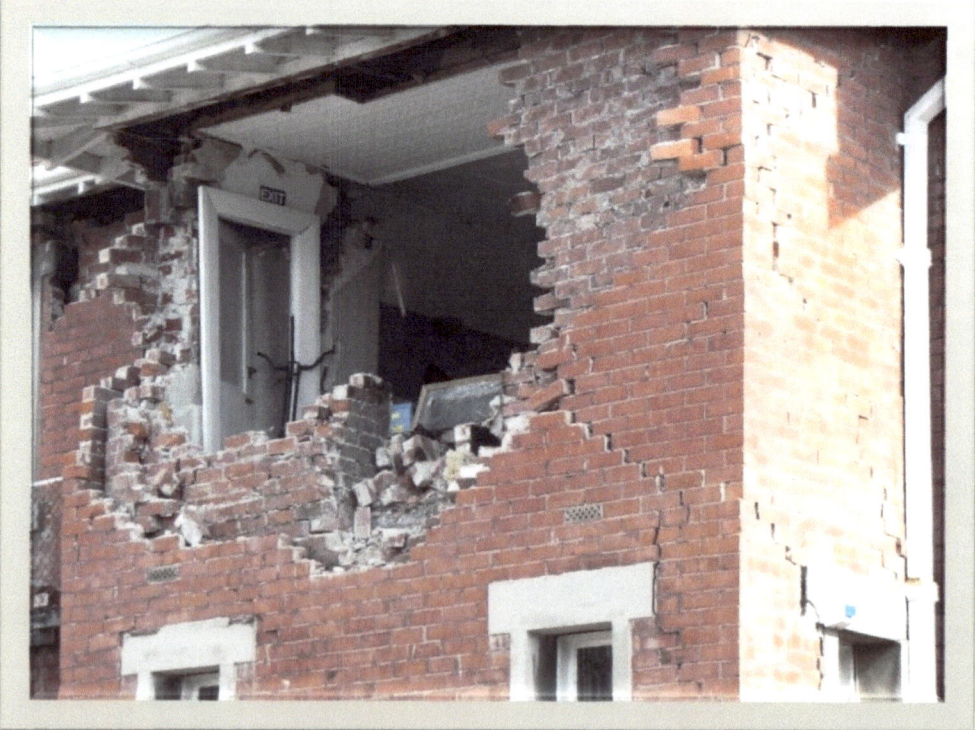

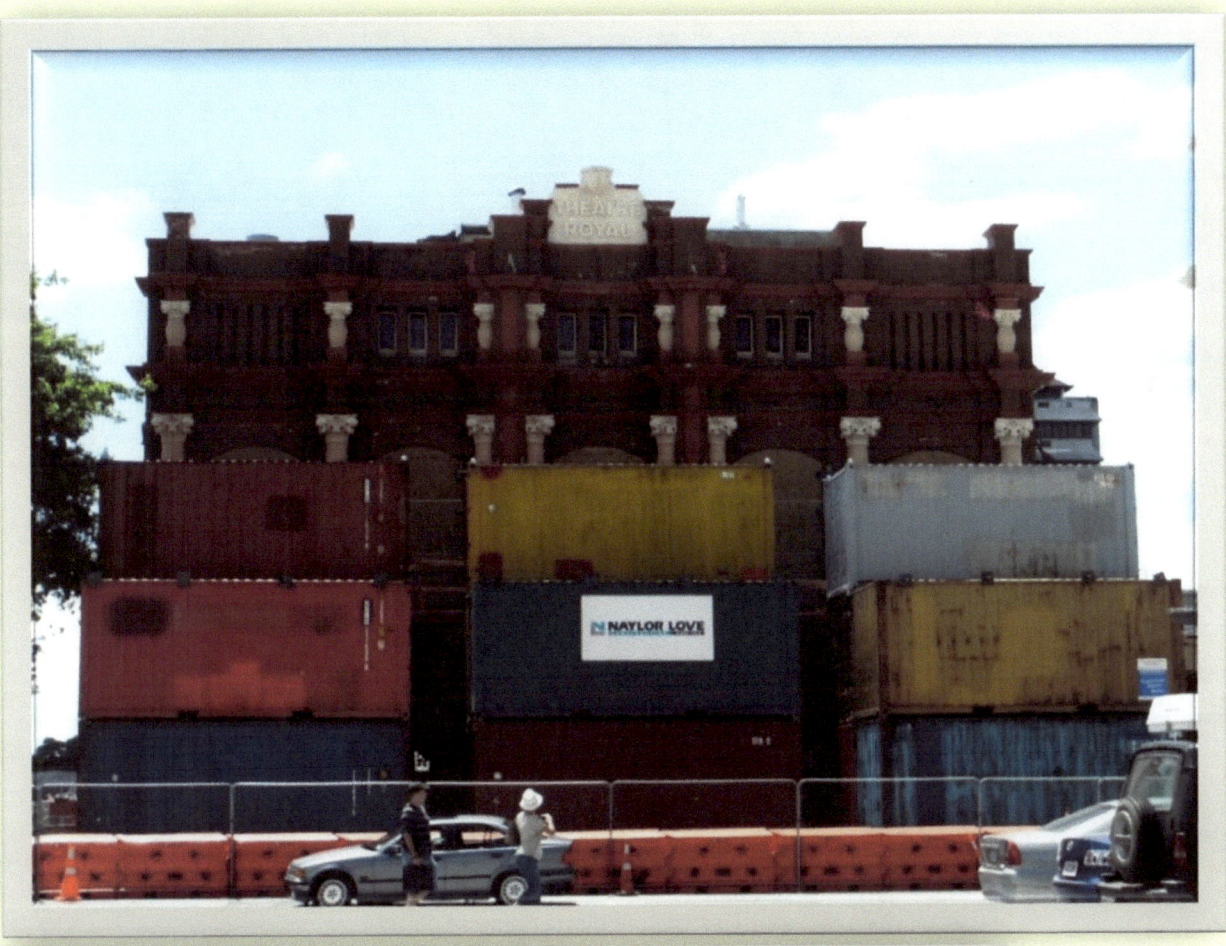
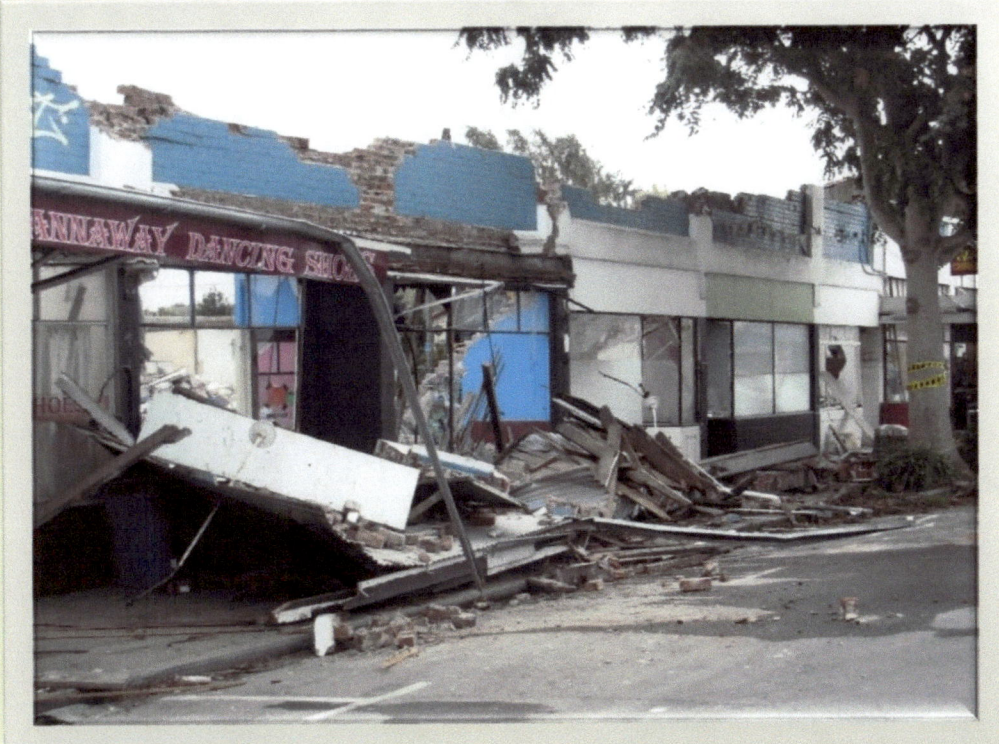

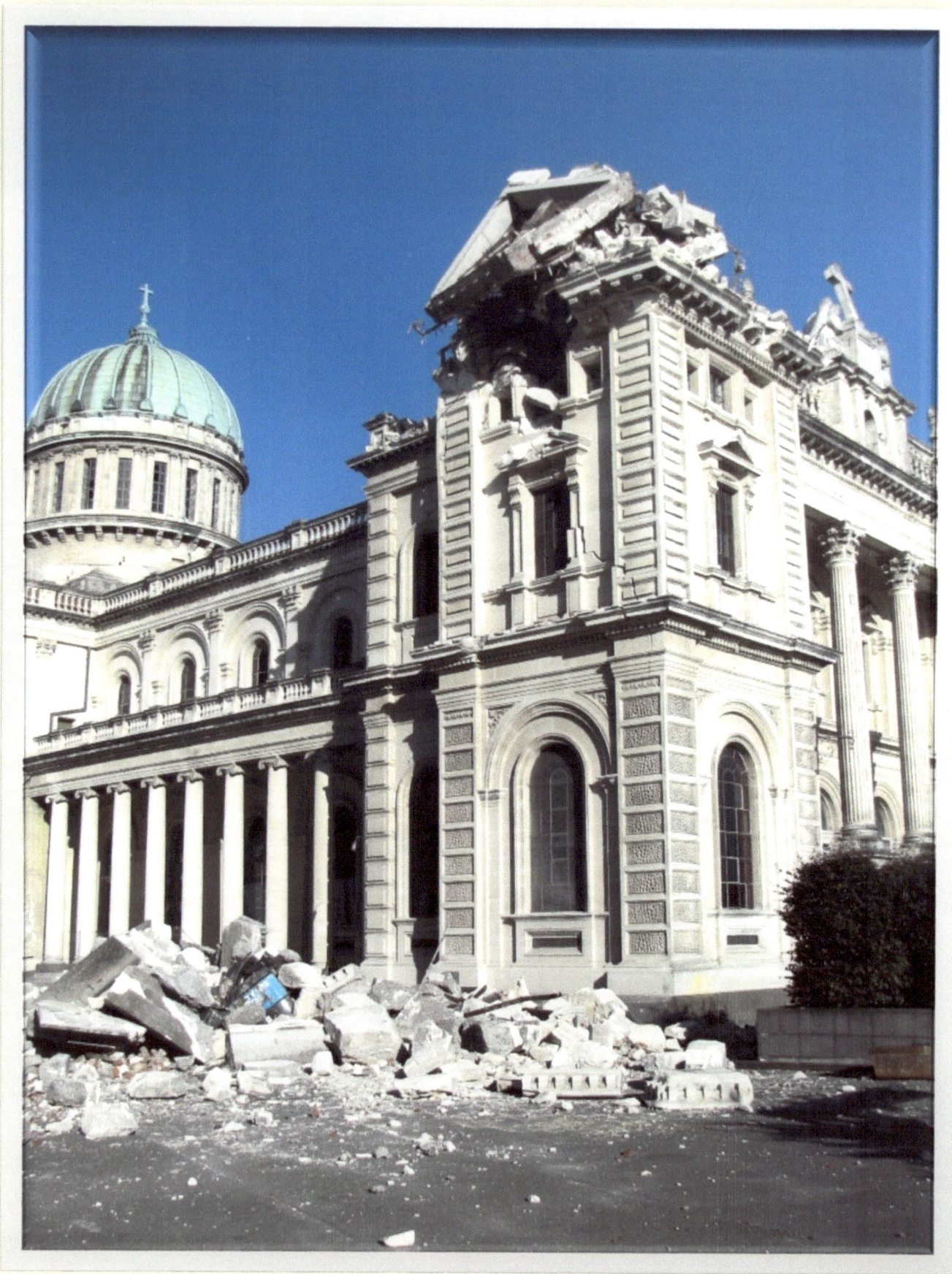

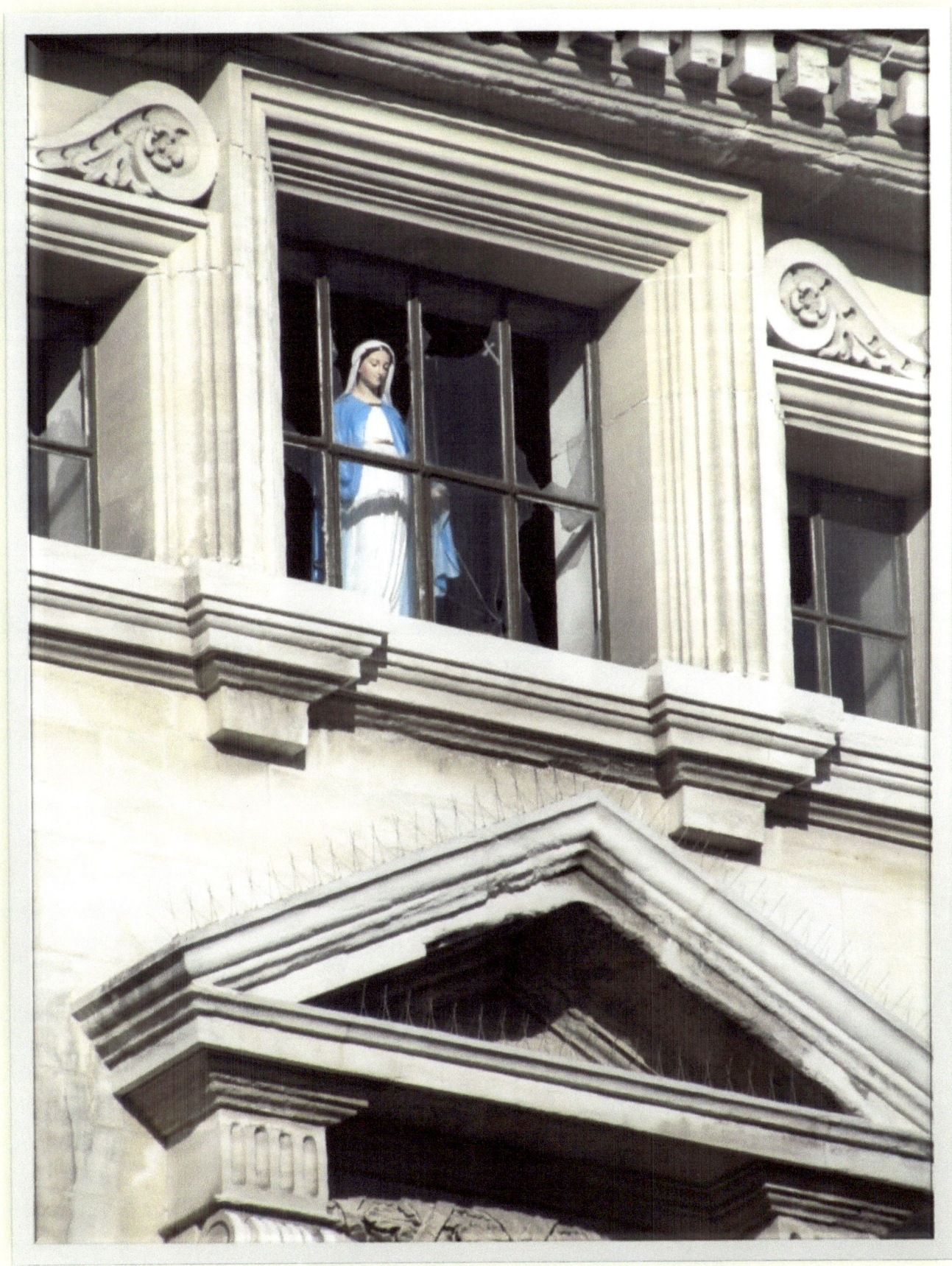

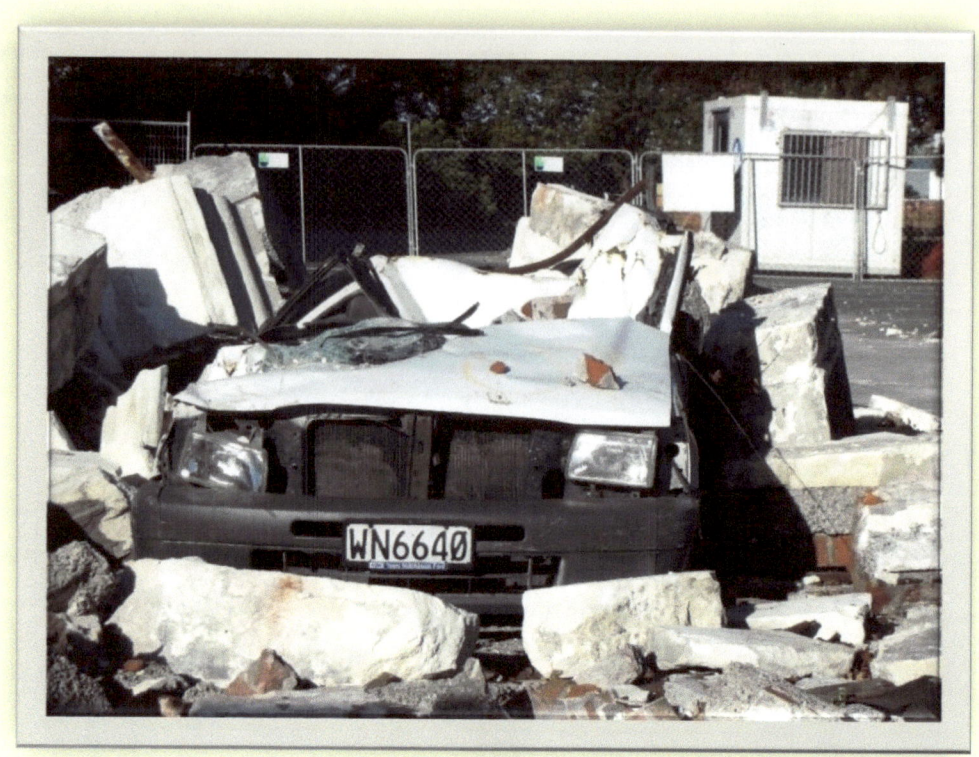

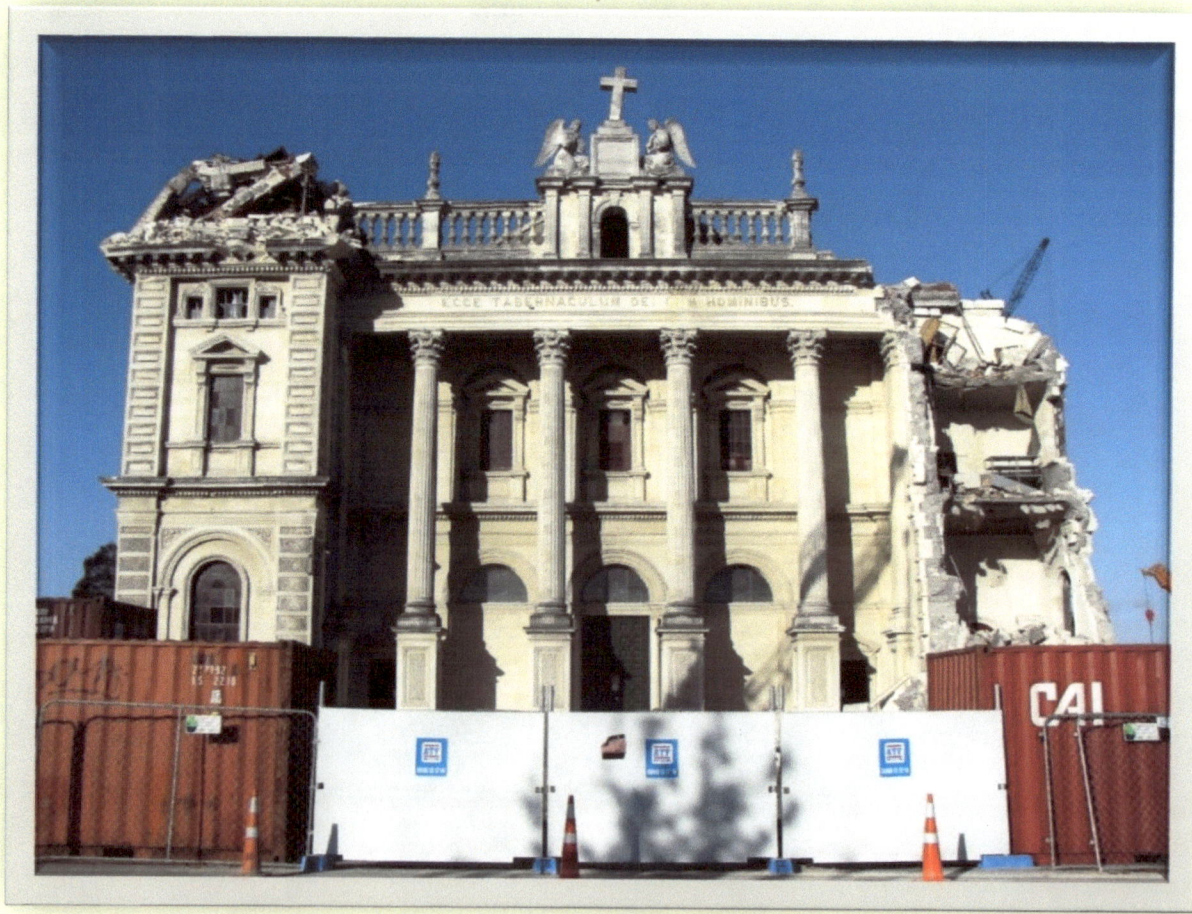

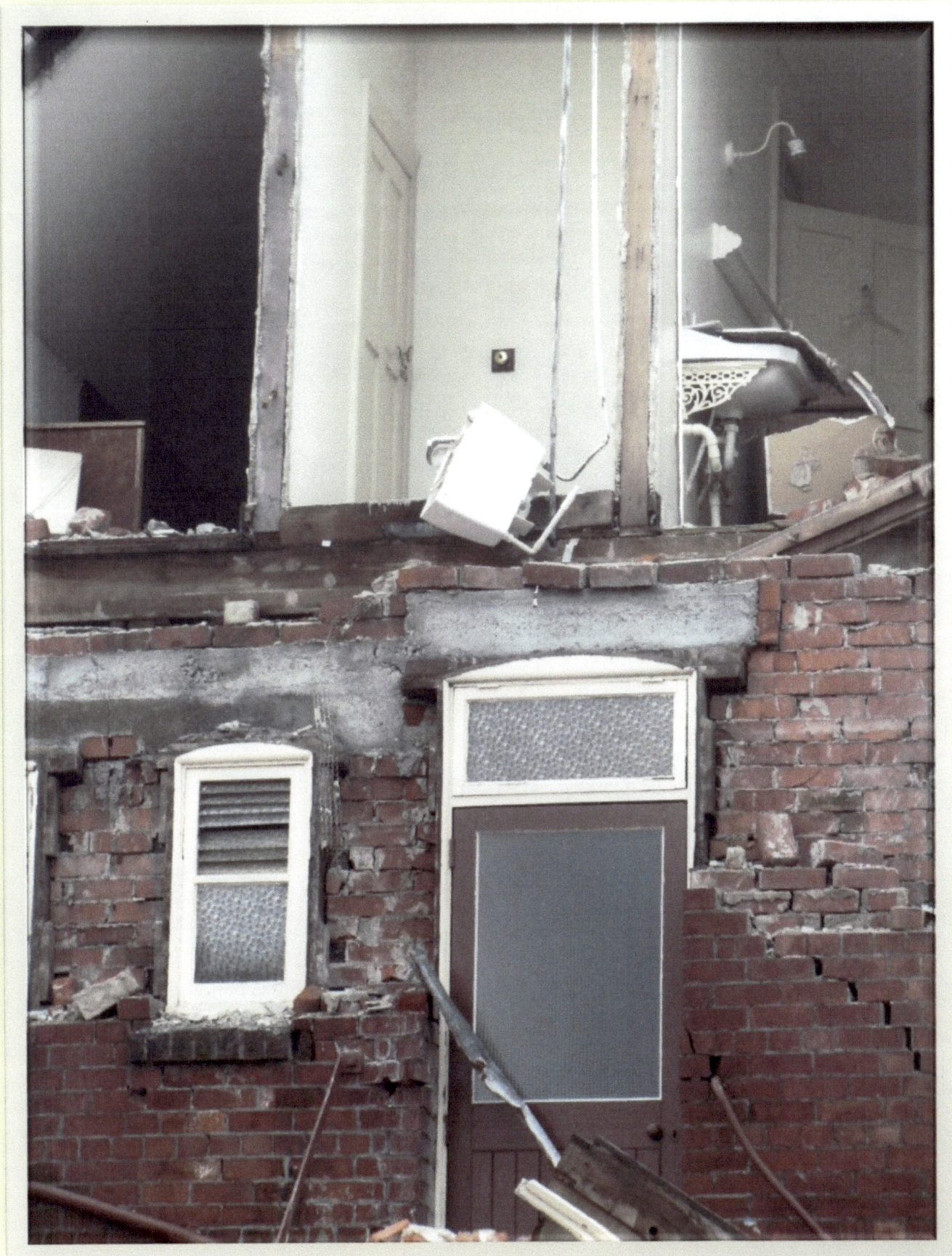

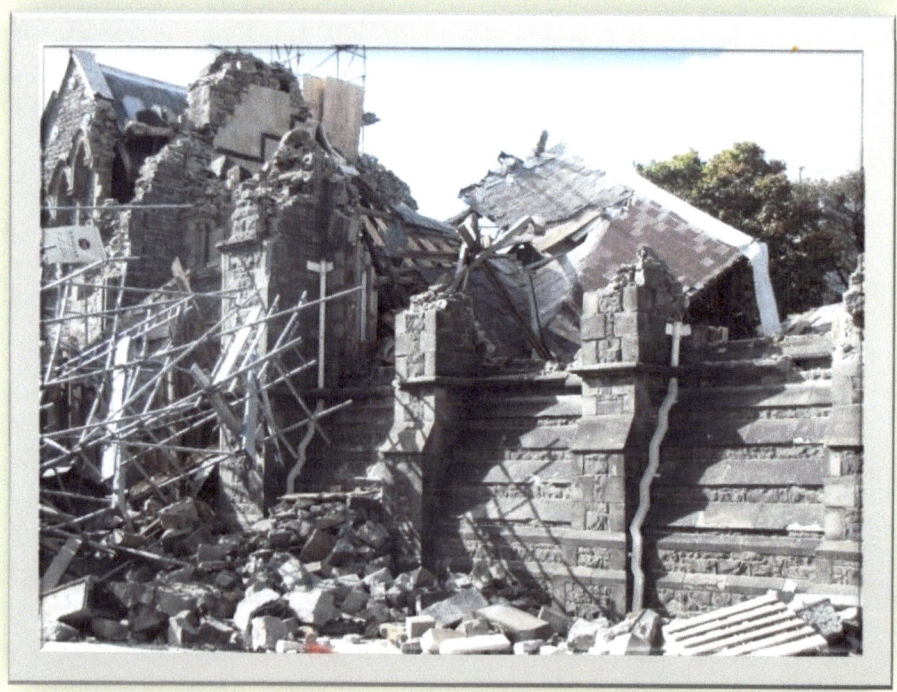

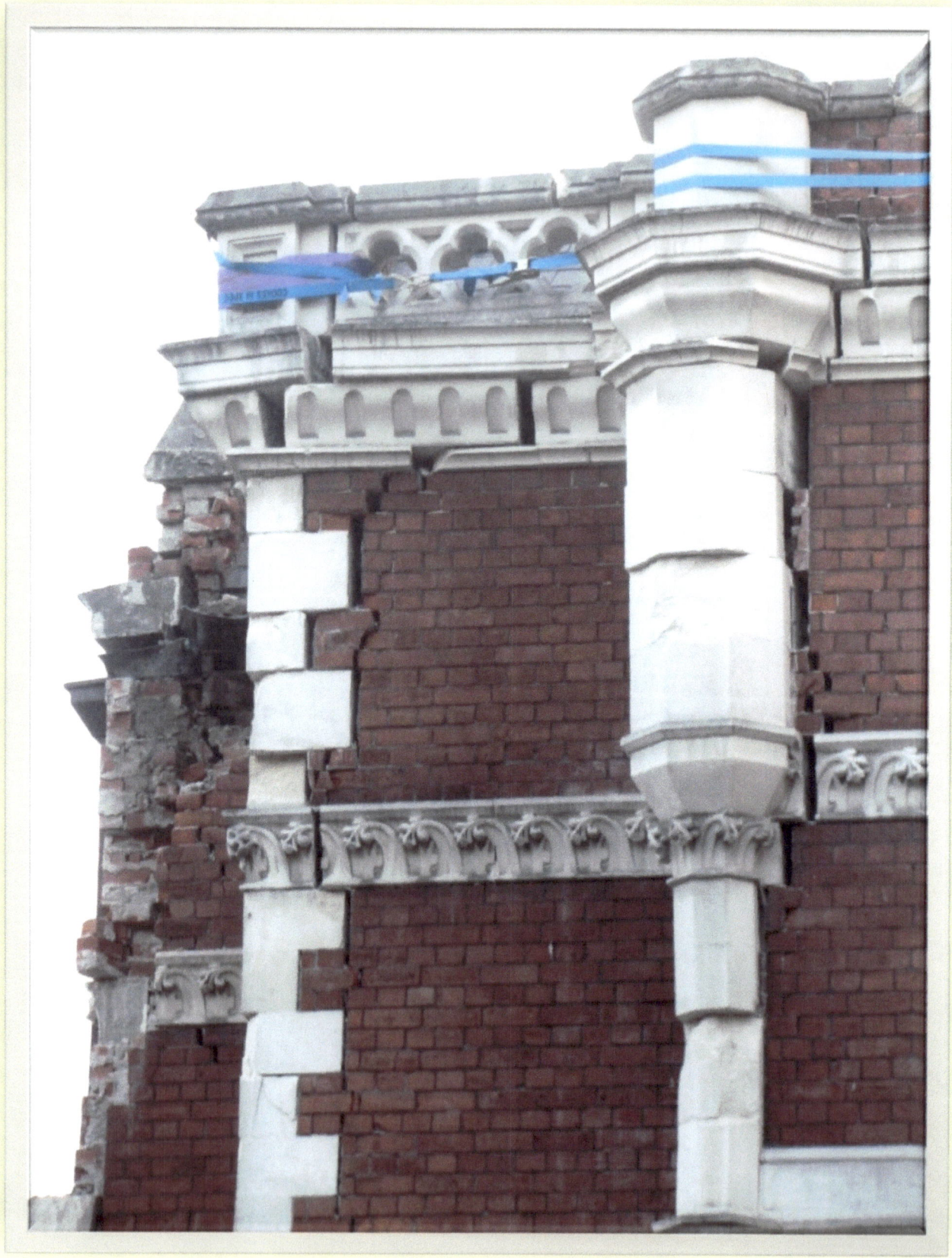

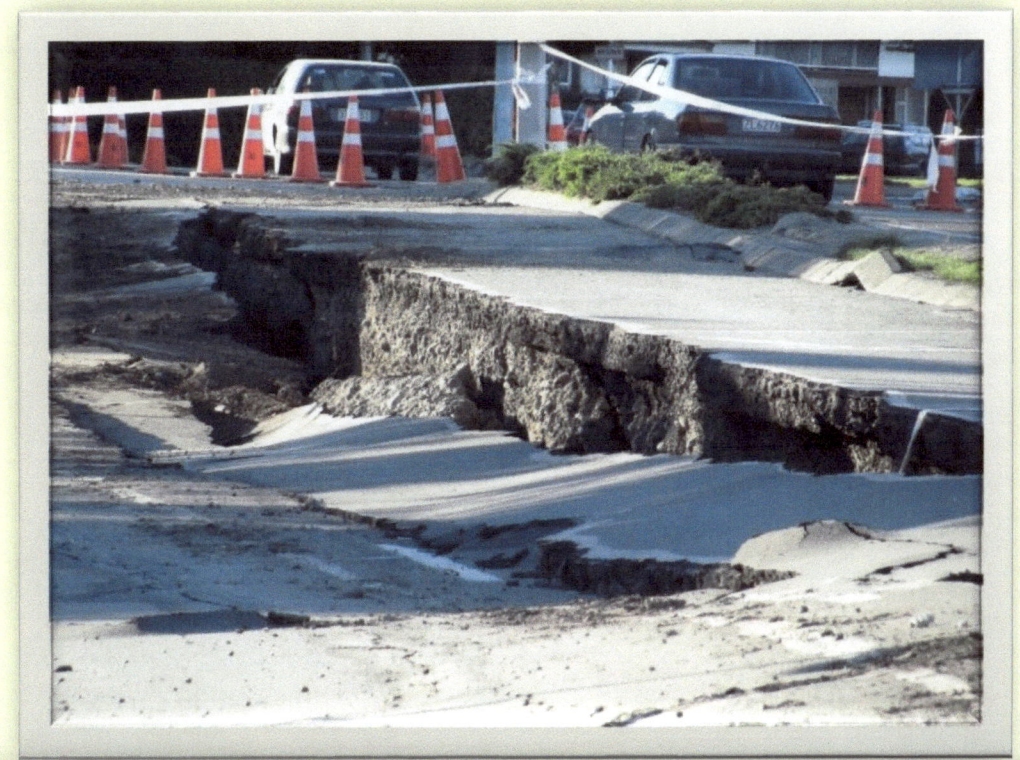
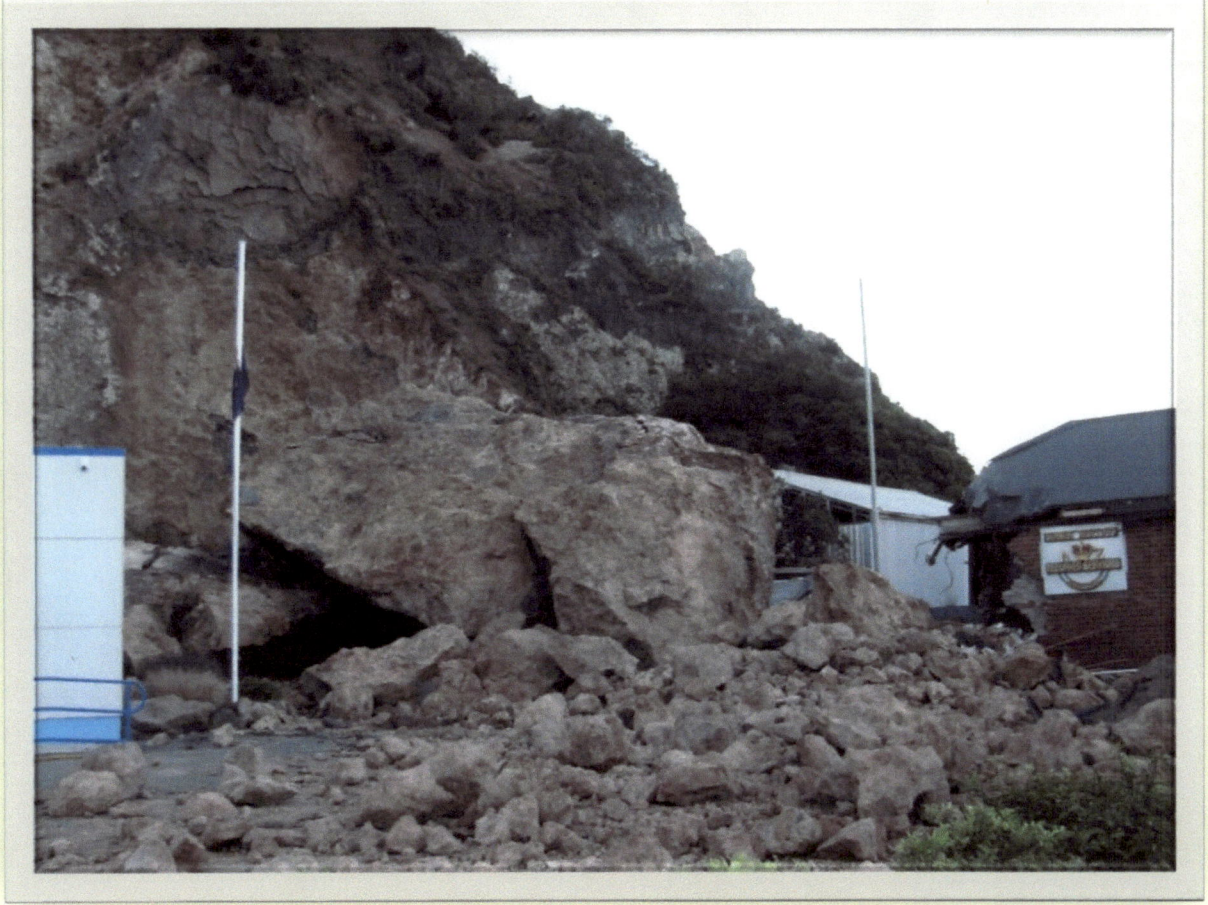

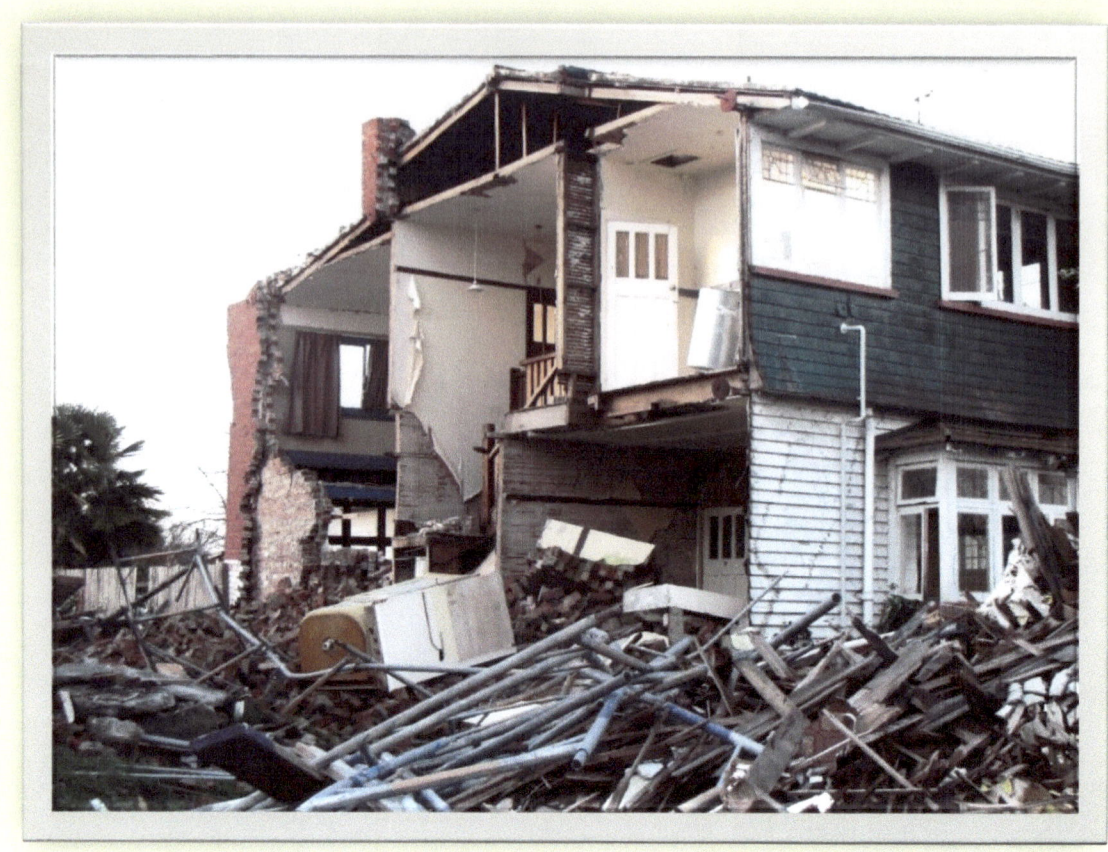
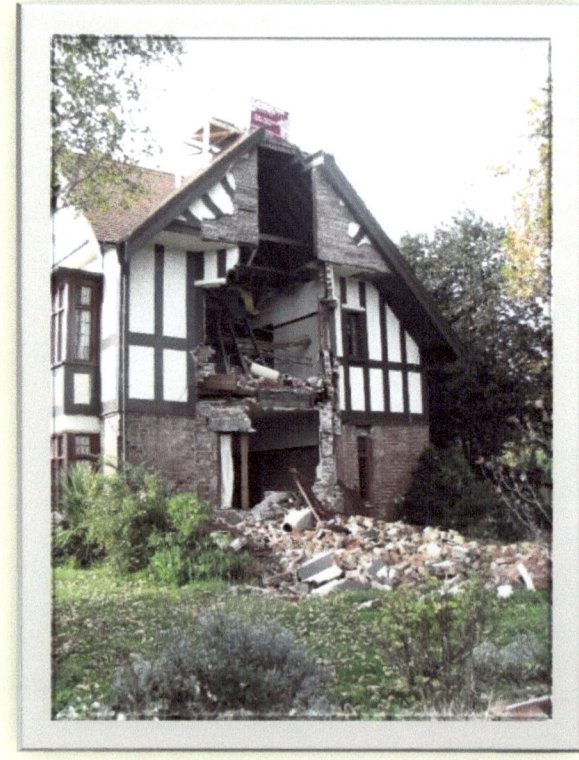
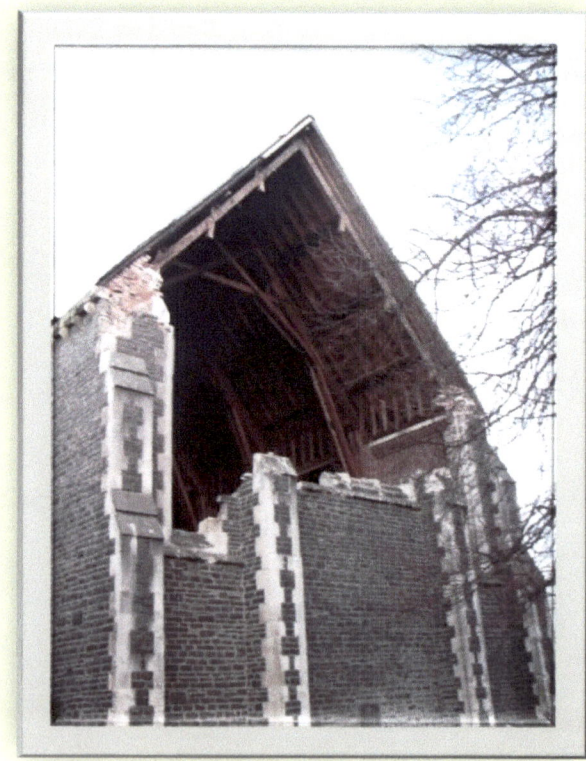

Chapter Four
Inside the Red Zone November 2011

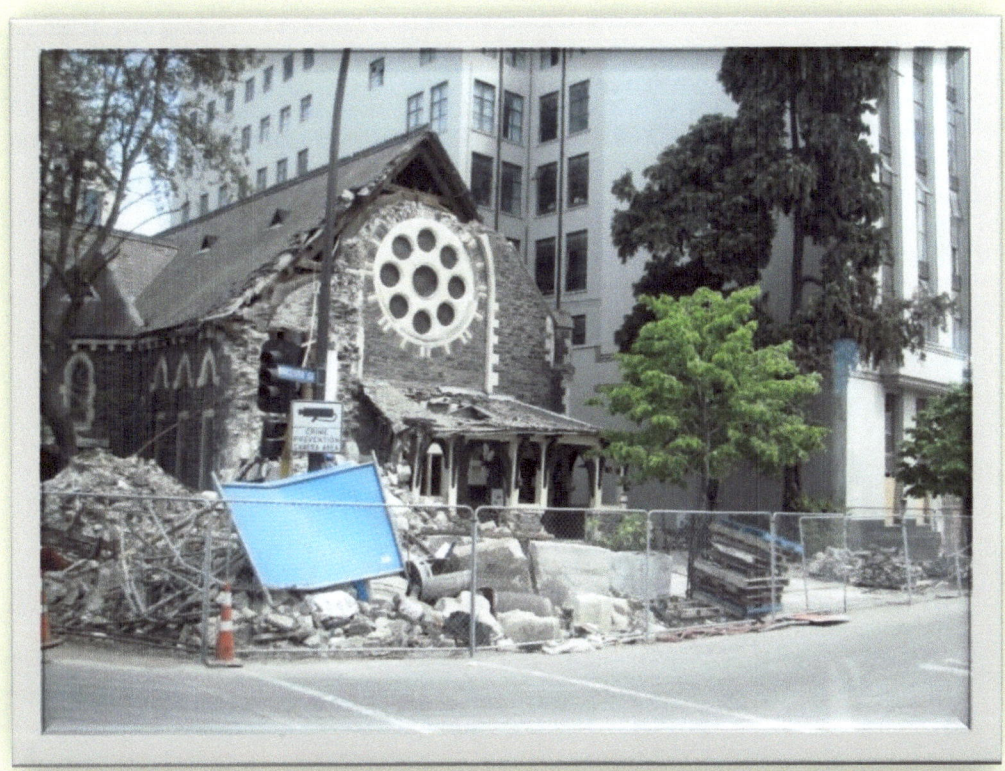

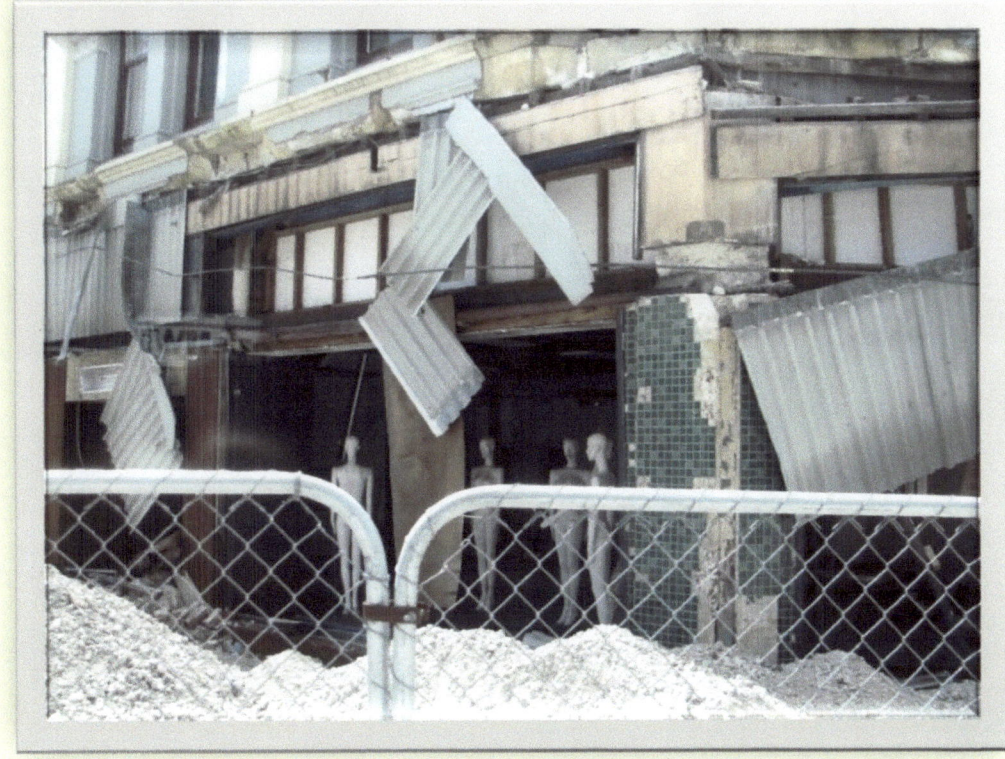

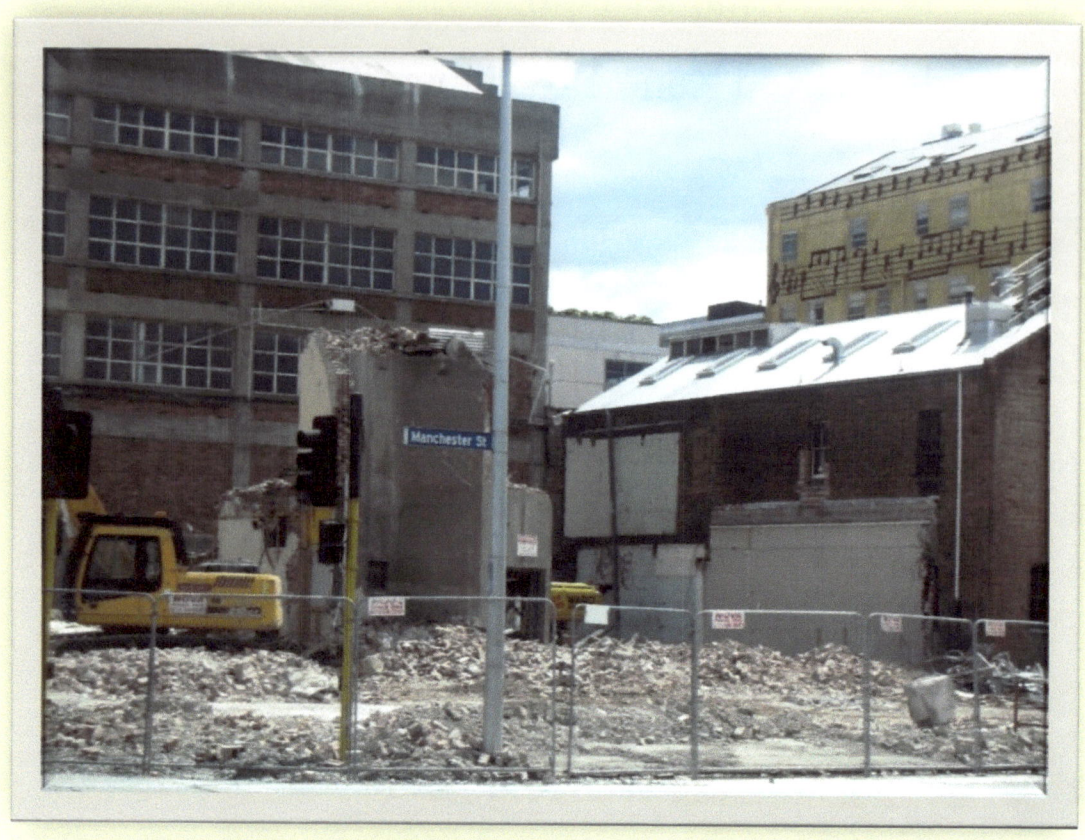

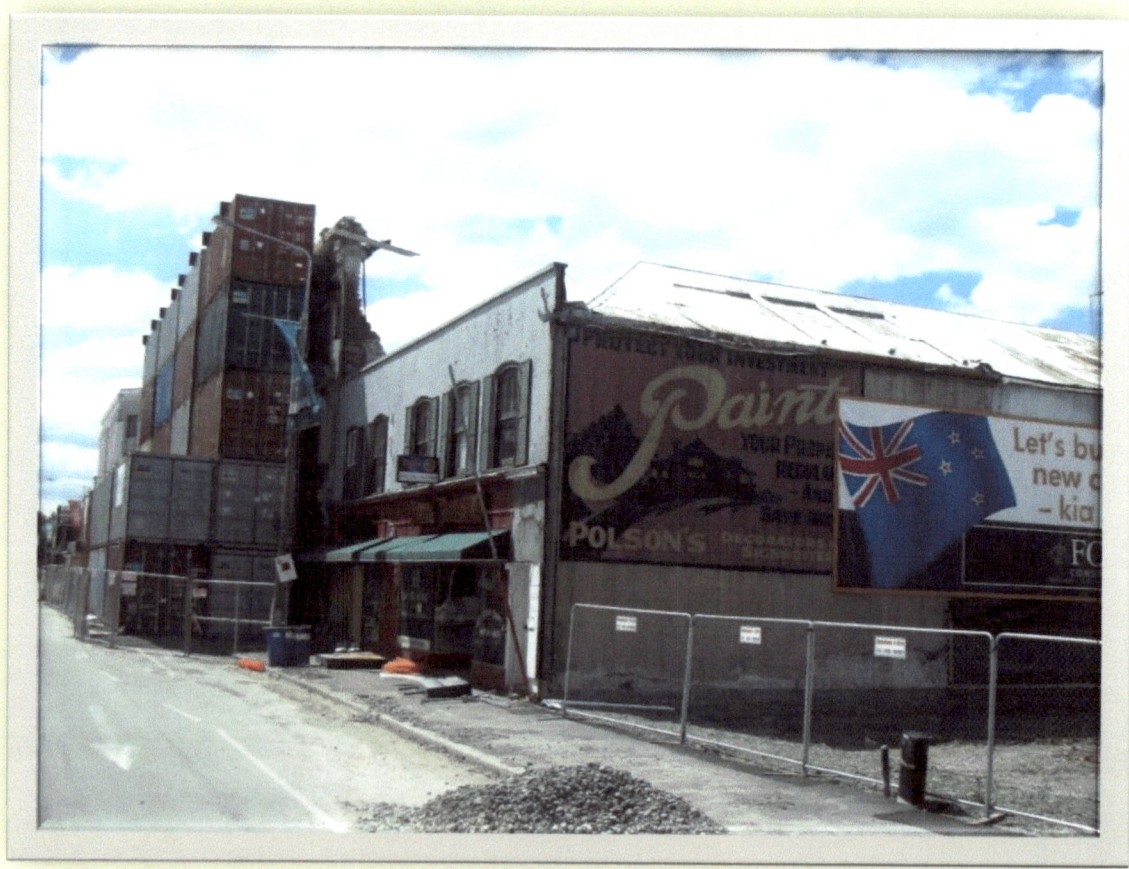

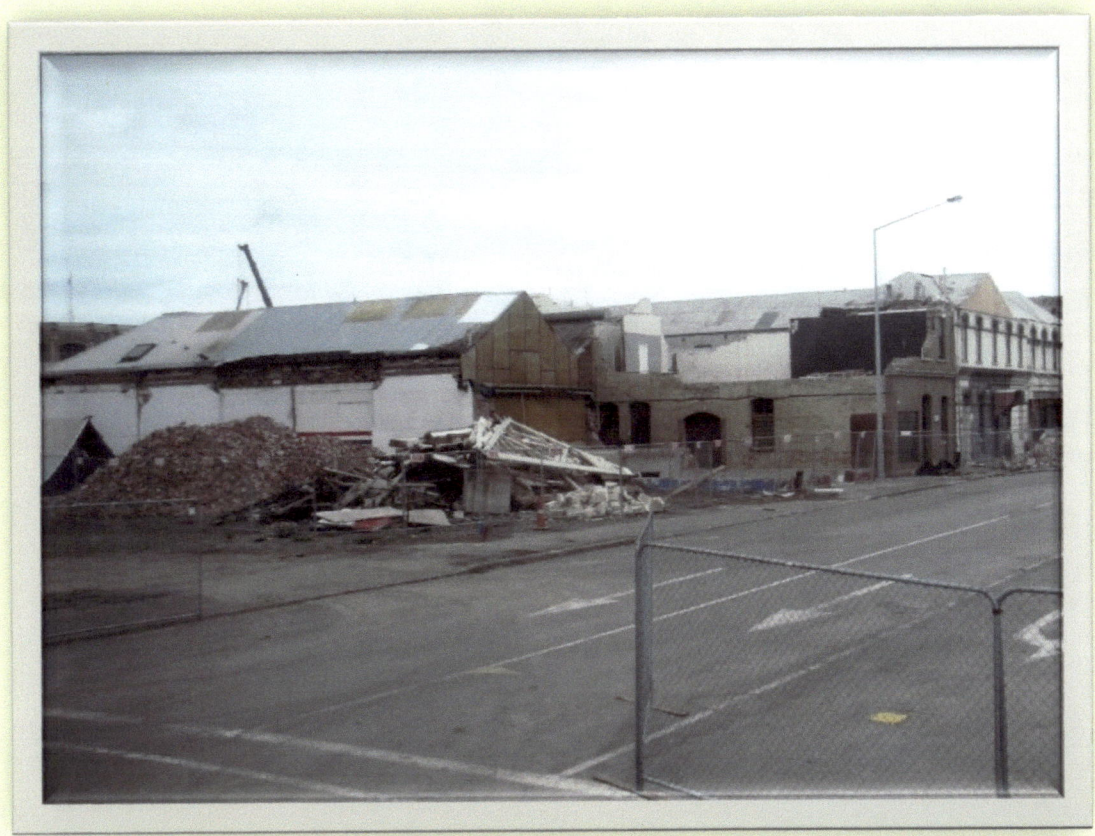
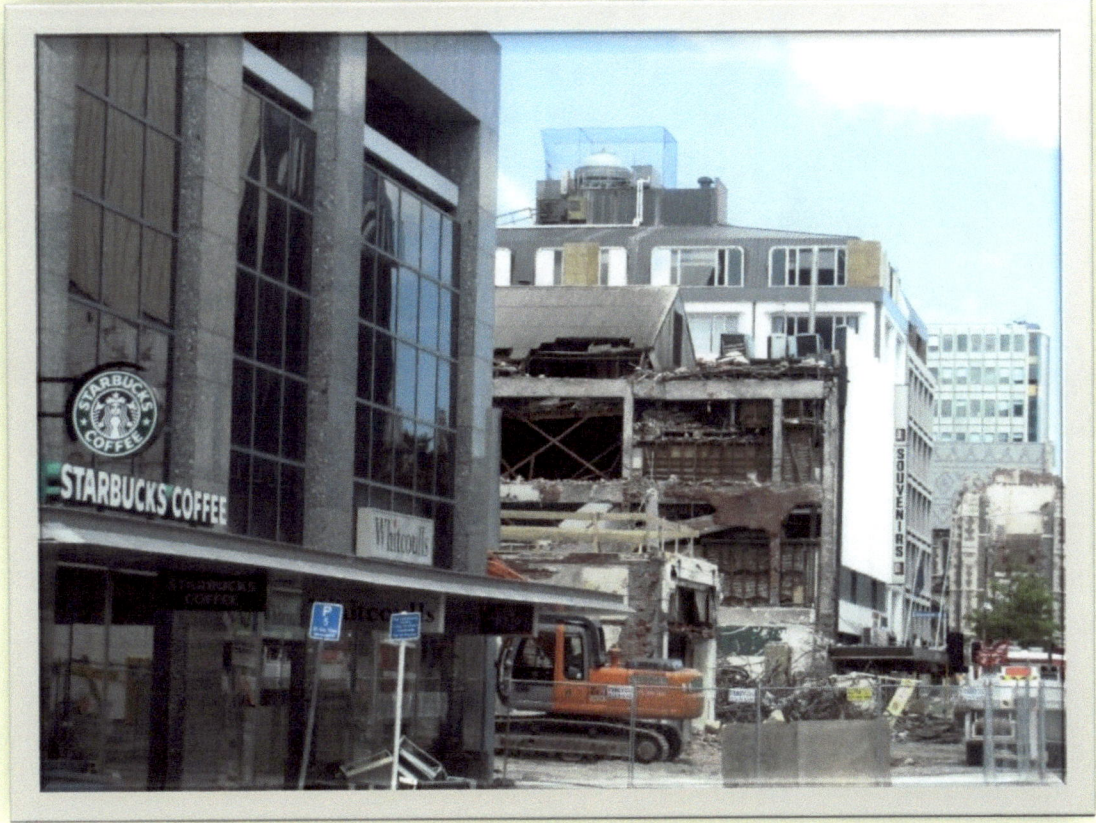

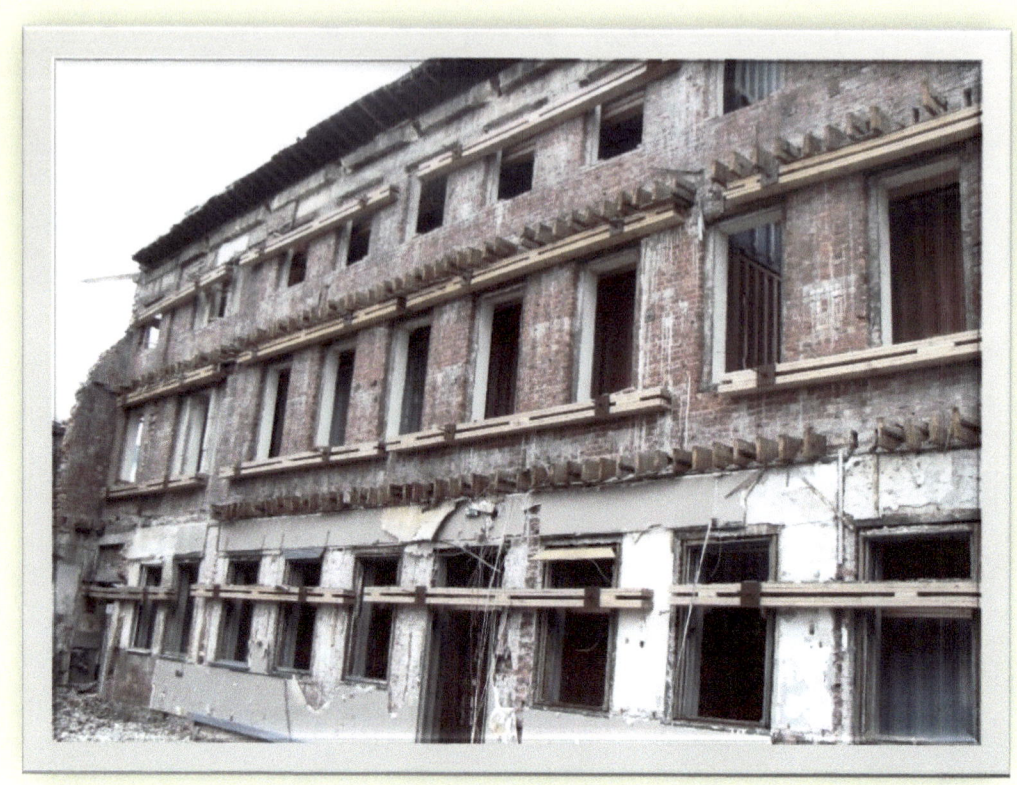
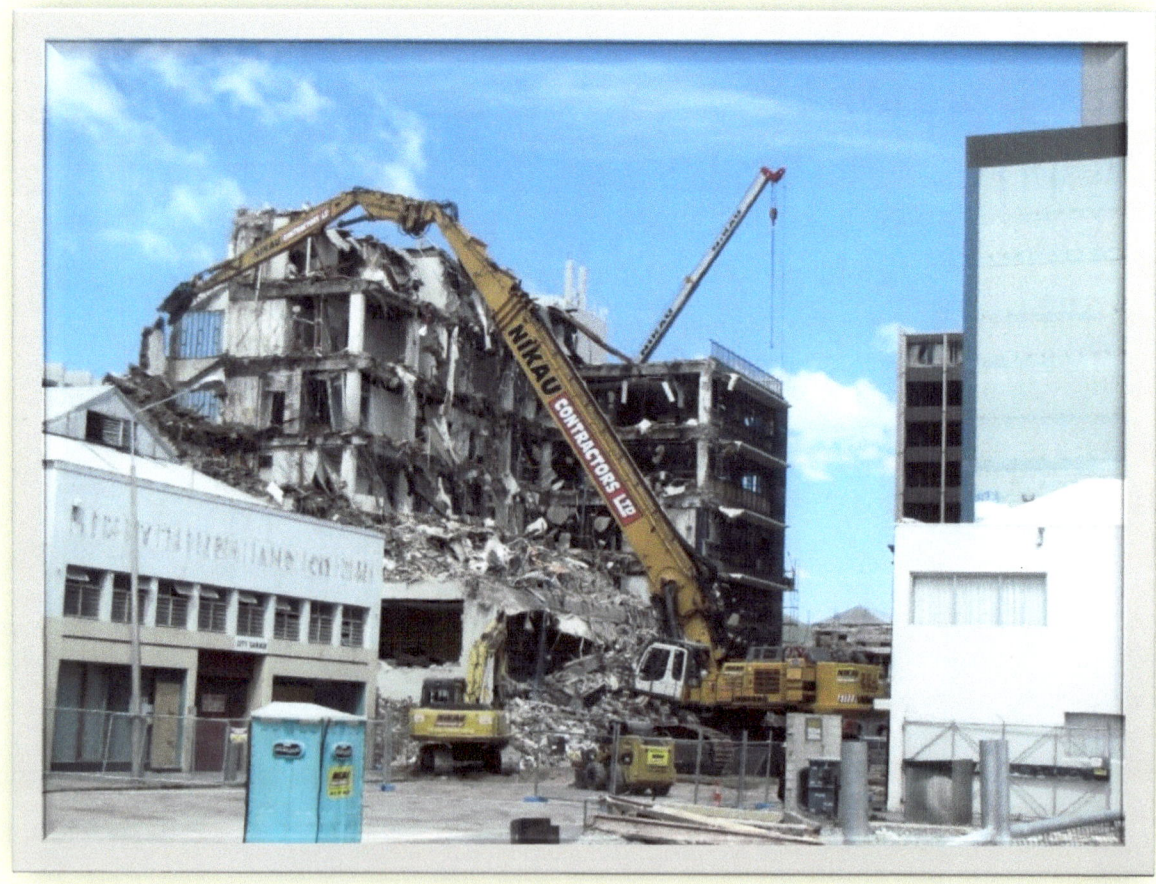

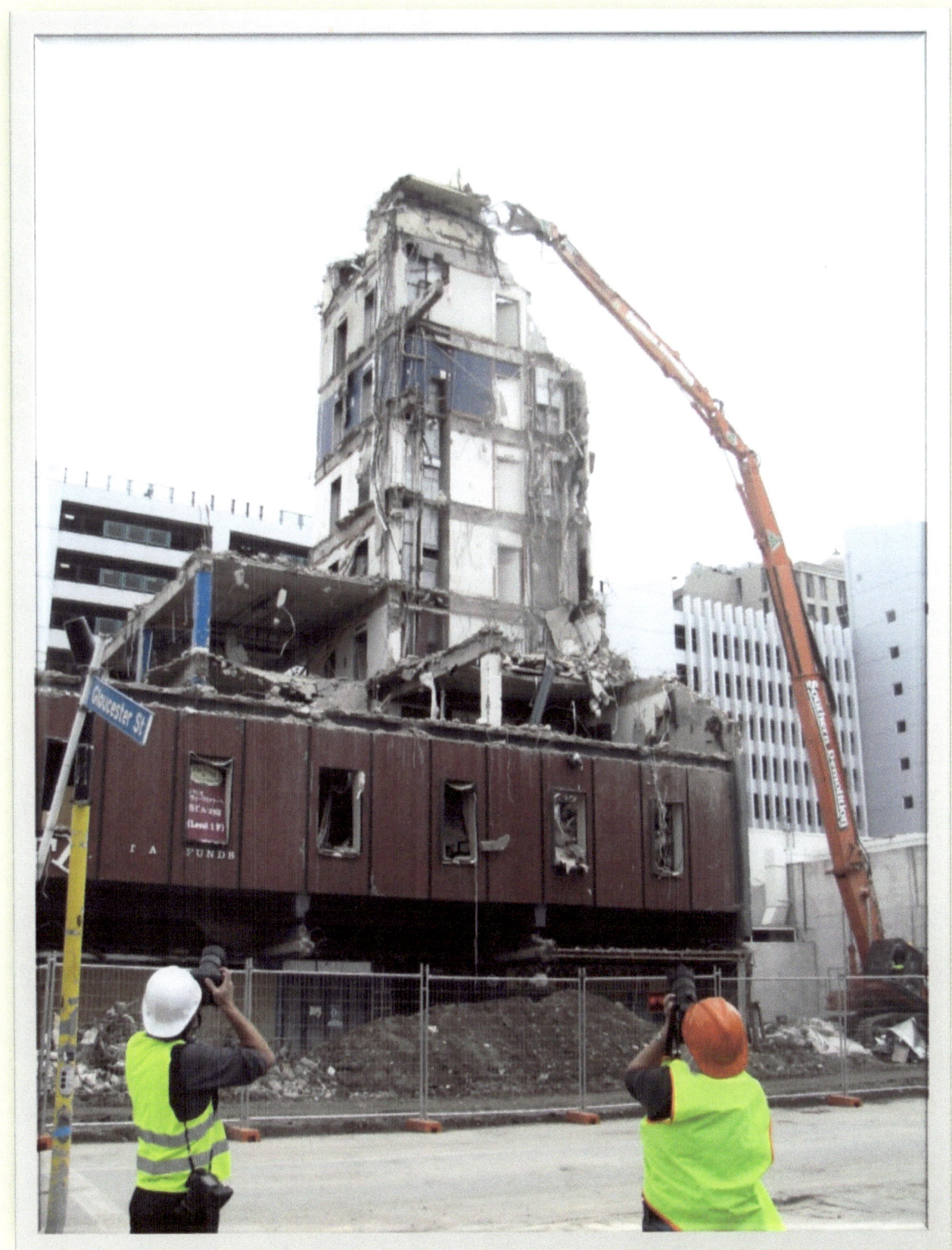

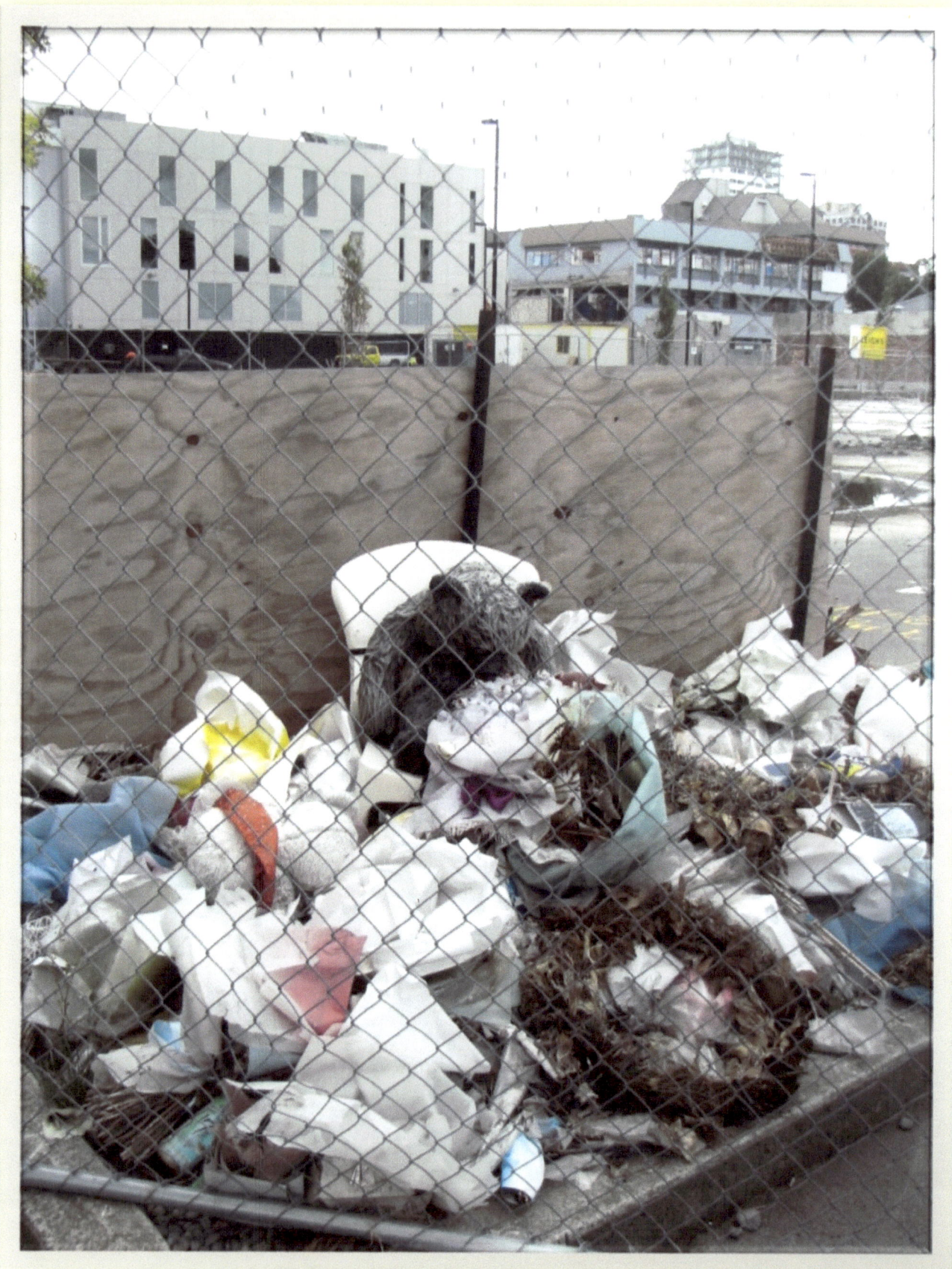

Chapter Five
Aerial Views of Christchurch 2011

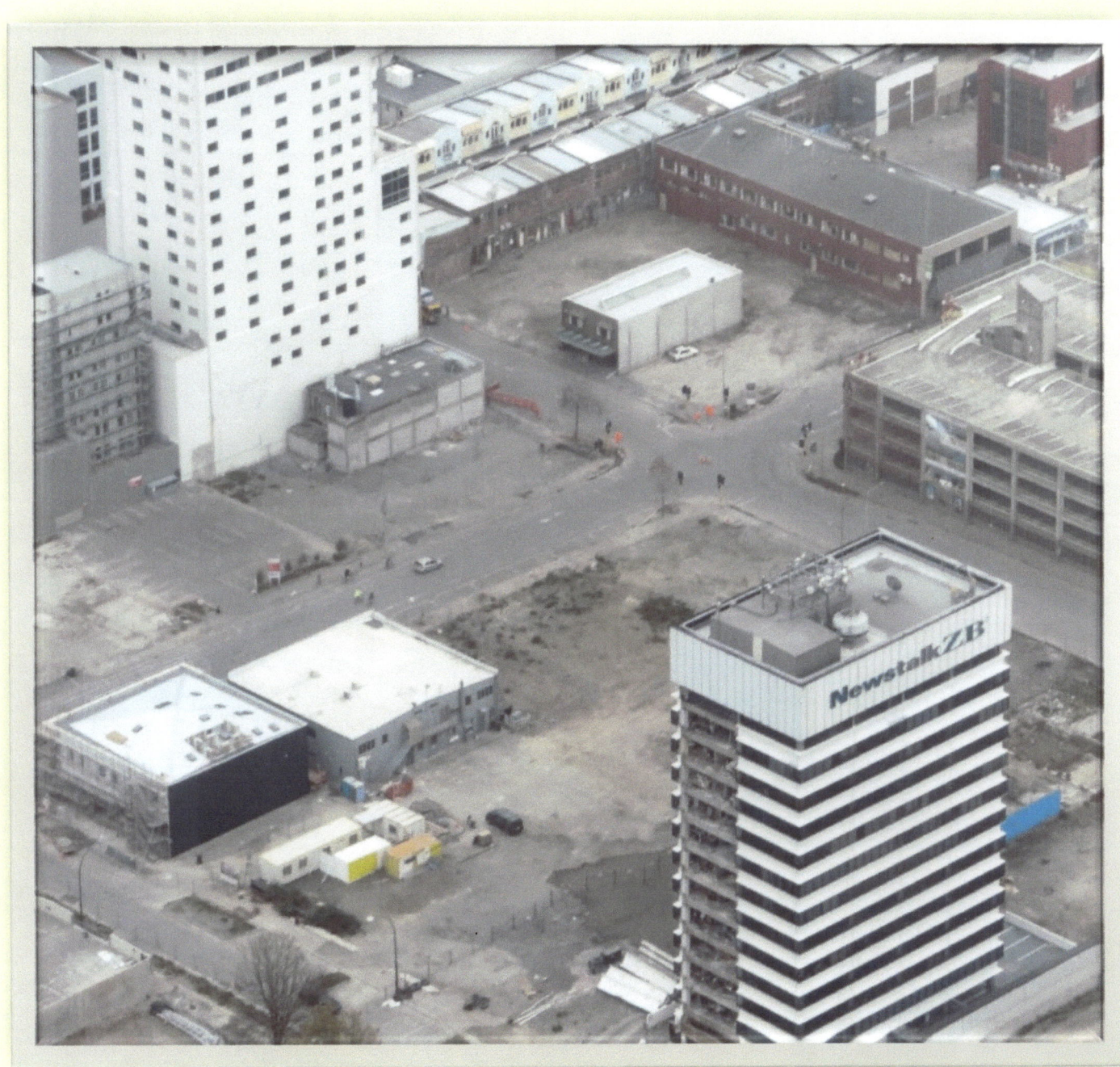

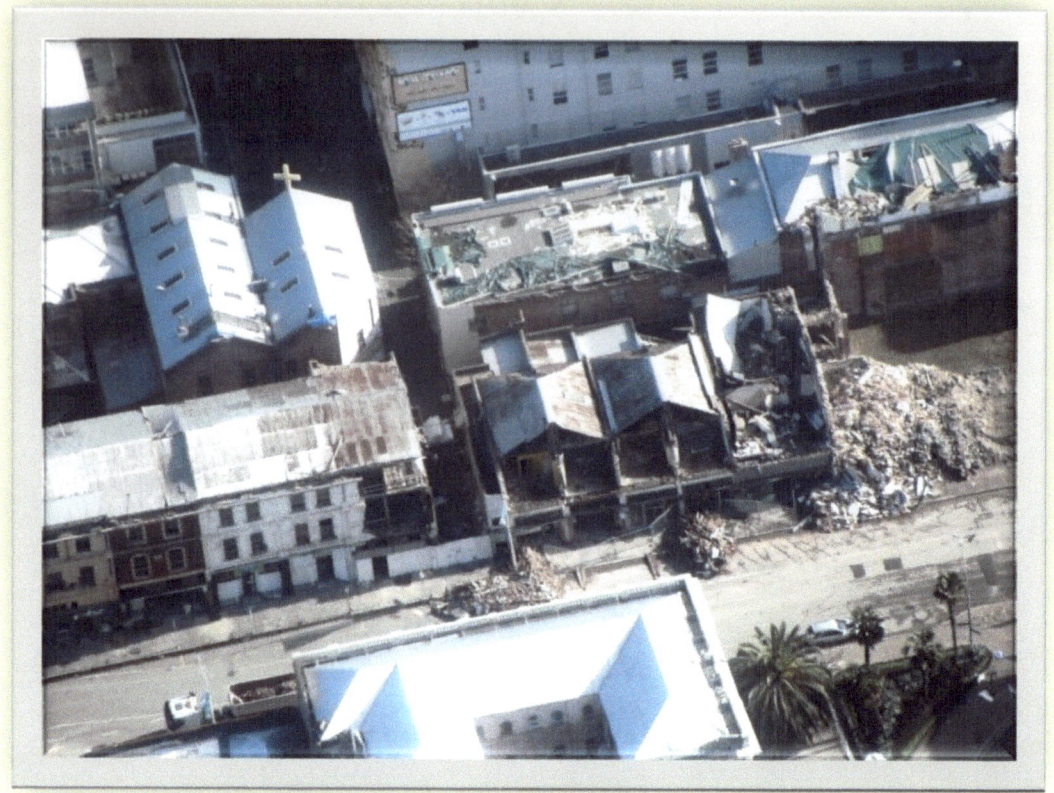
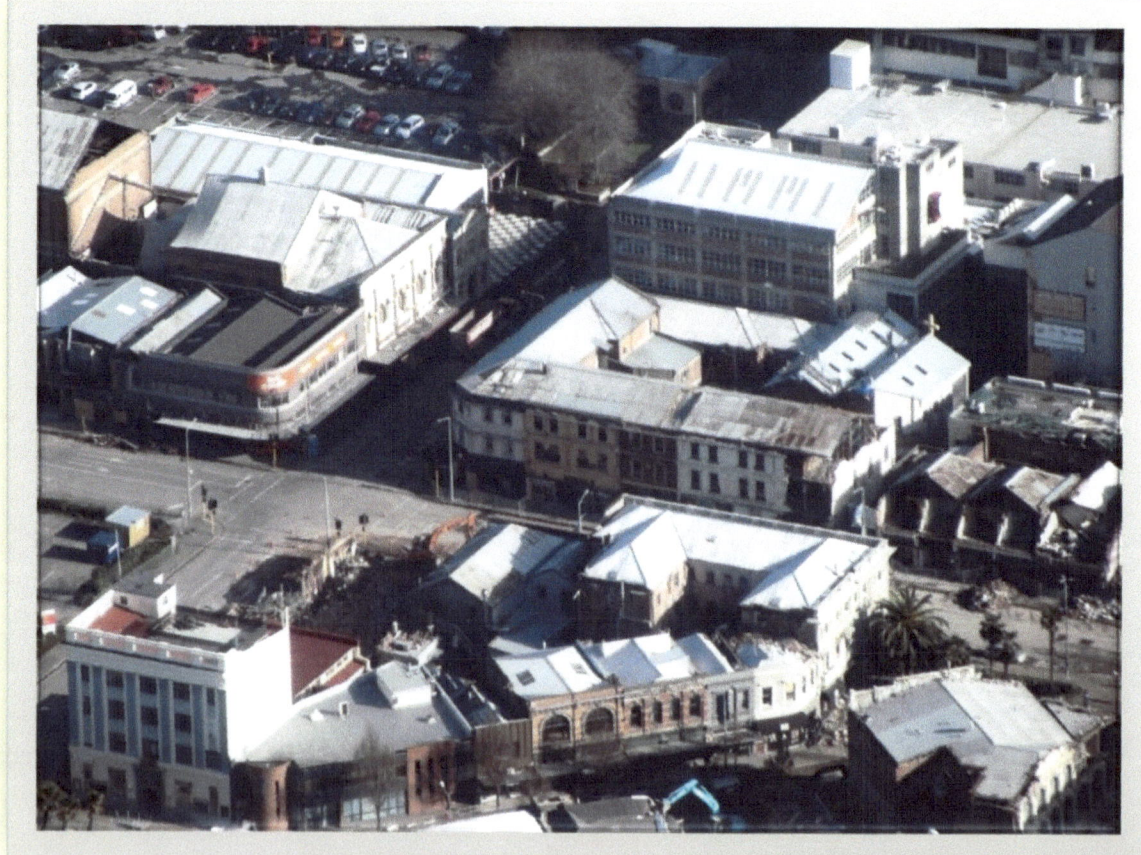

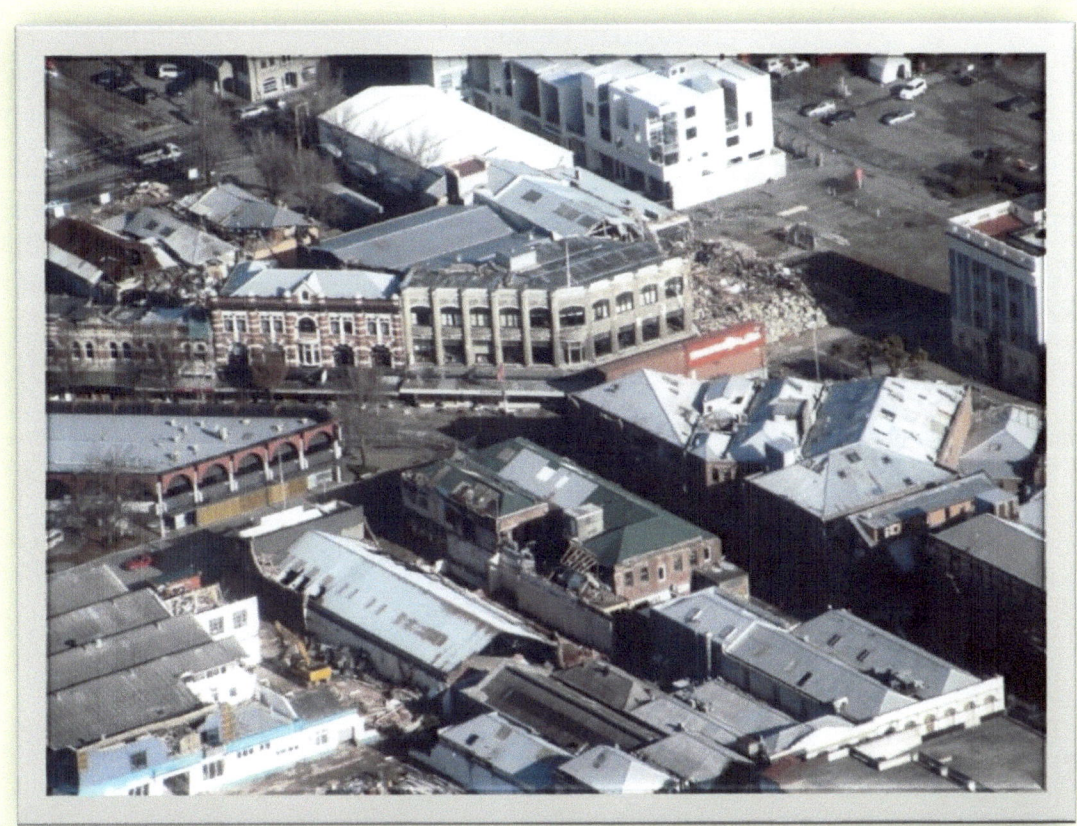

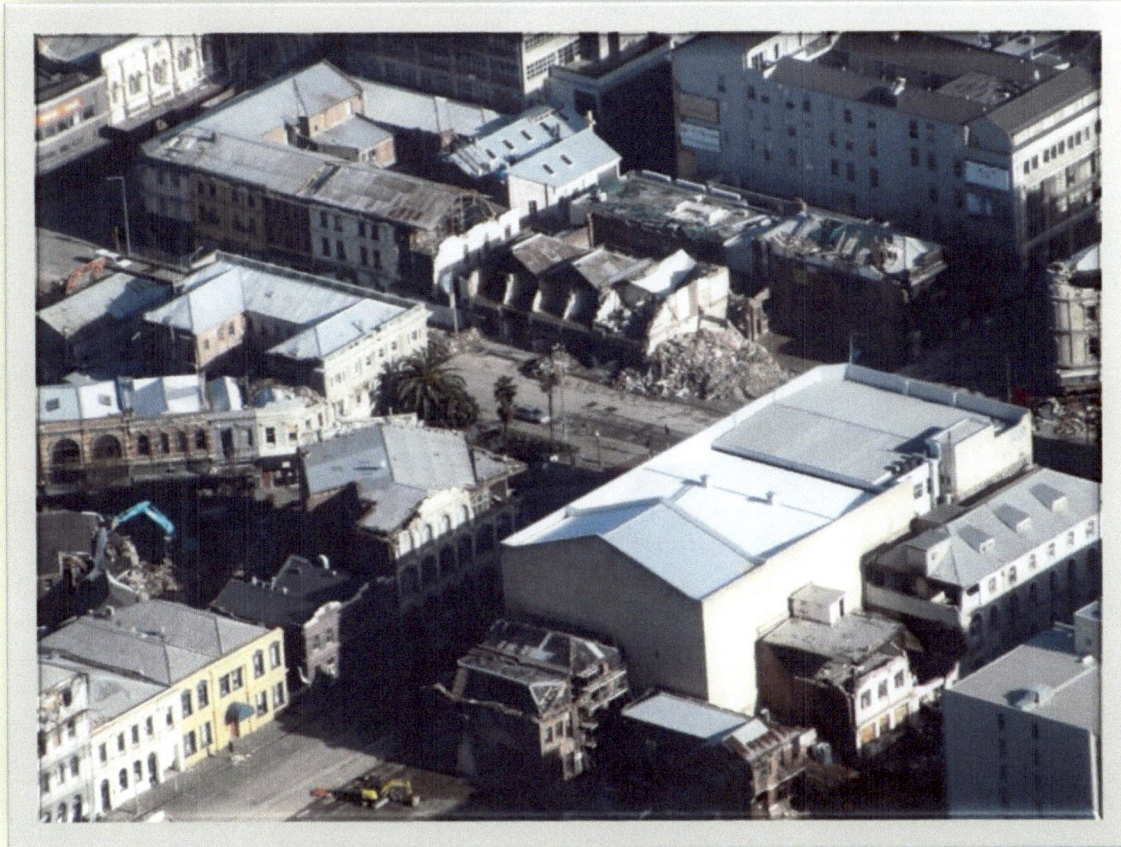

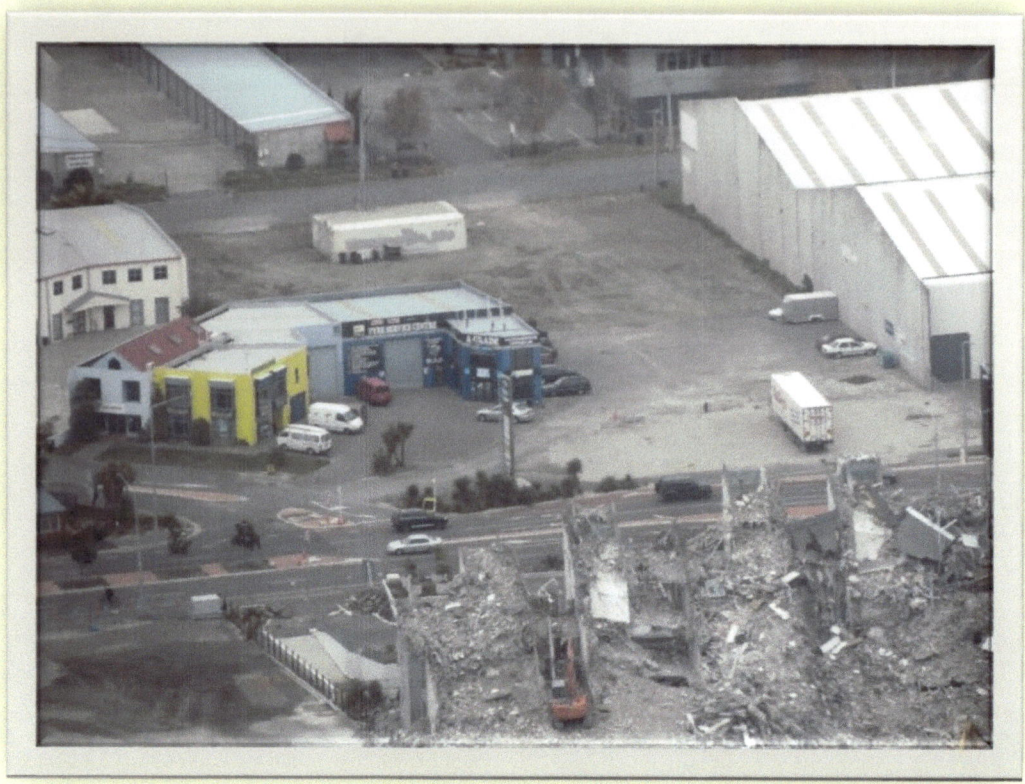

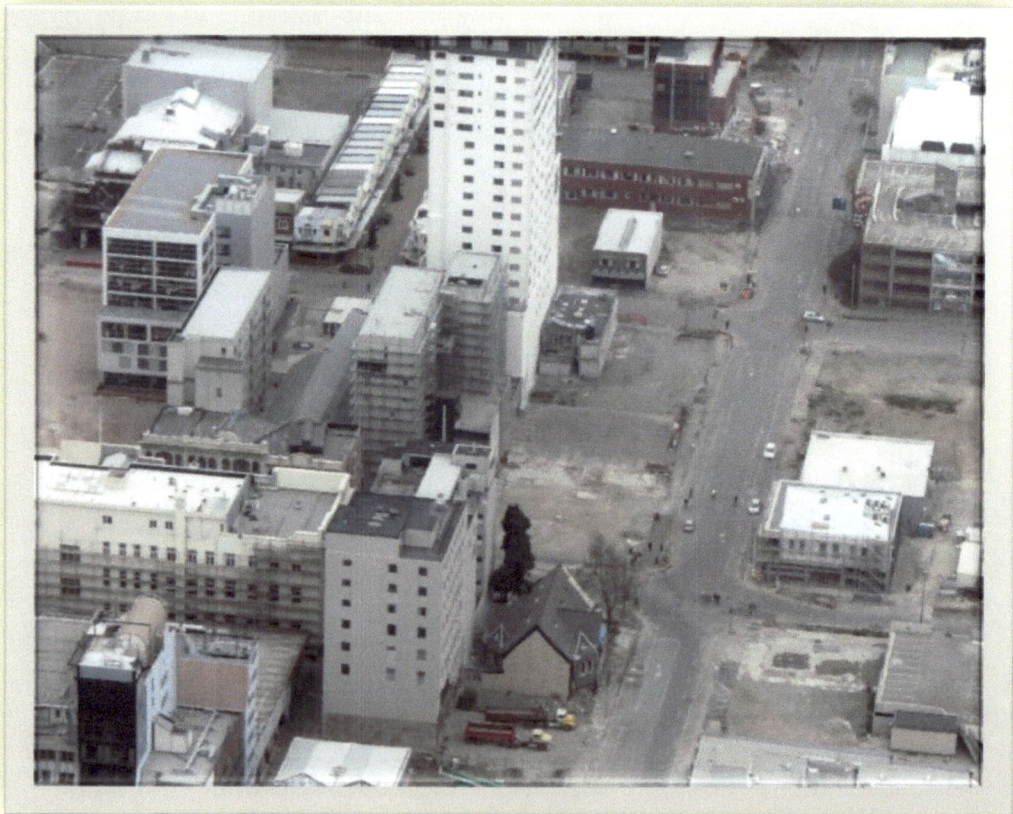

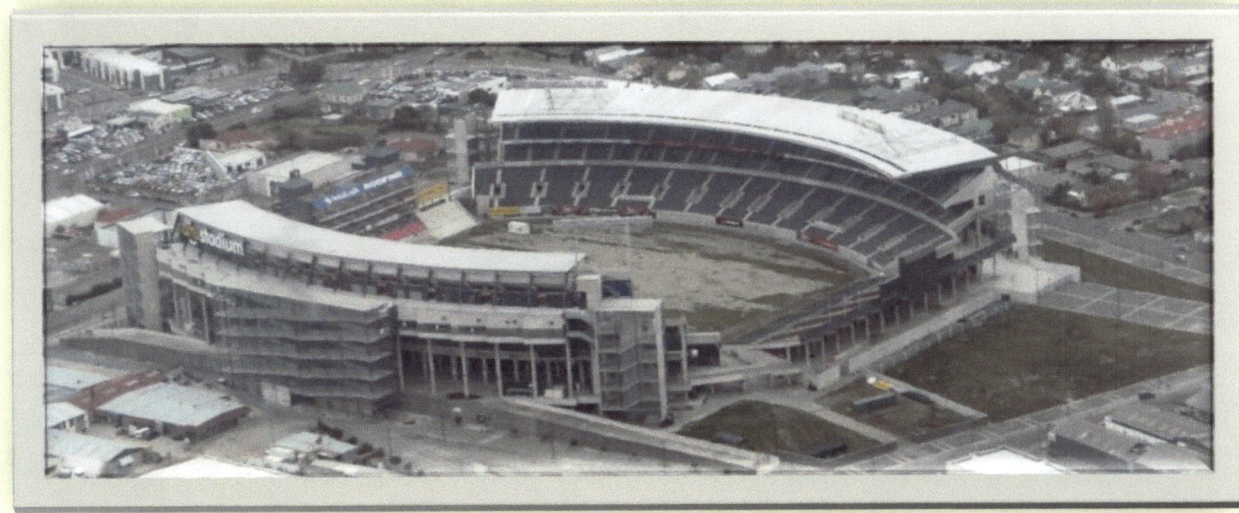

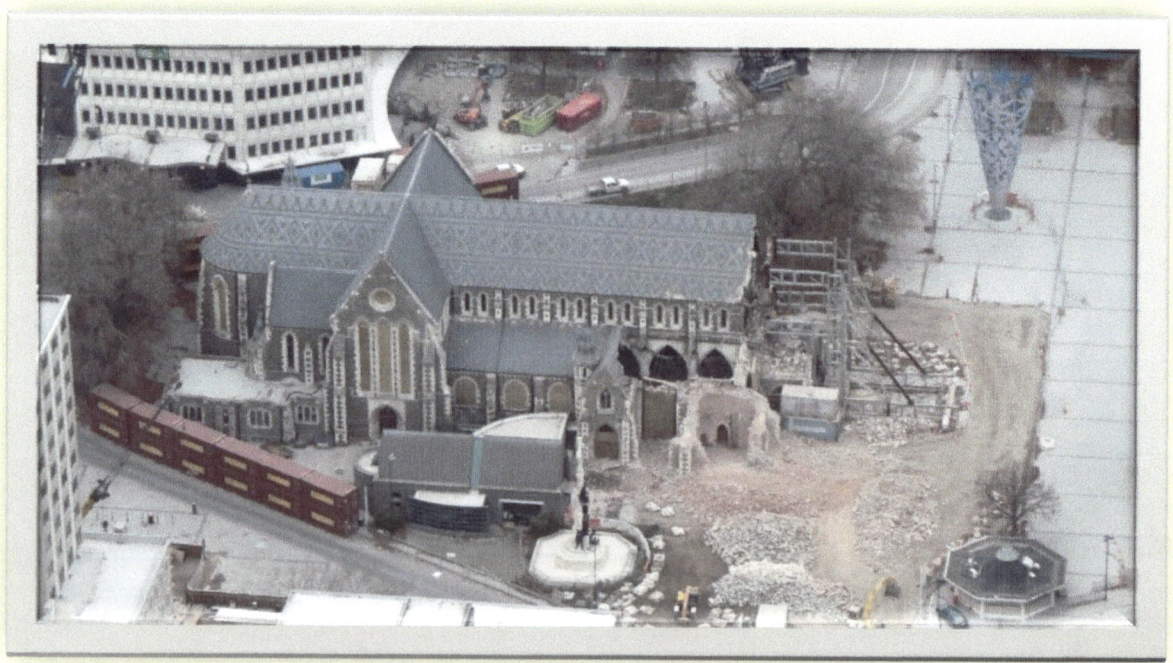

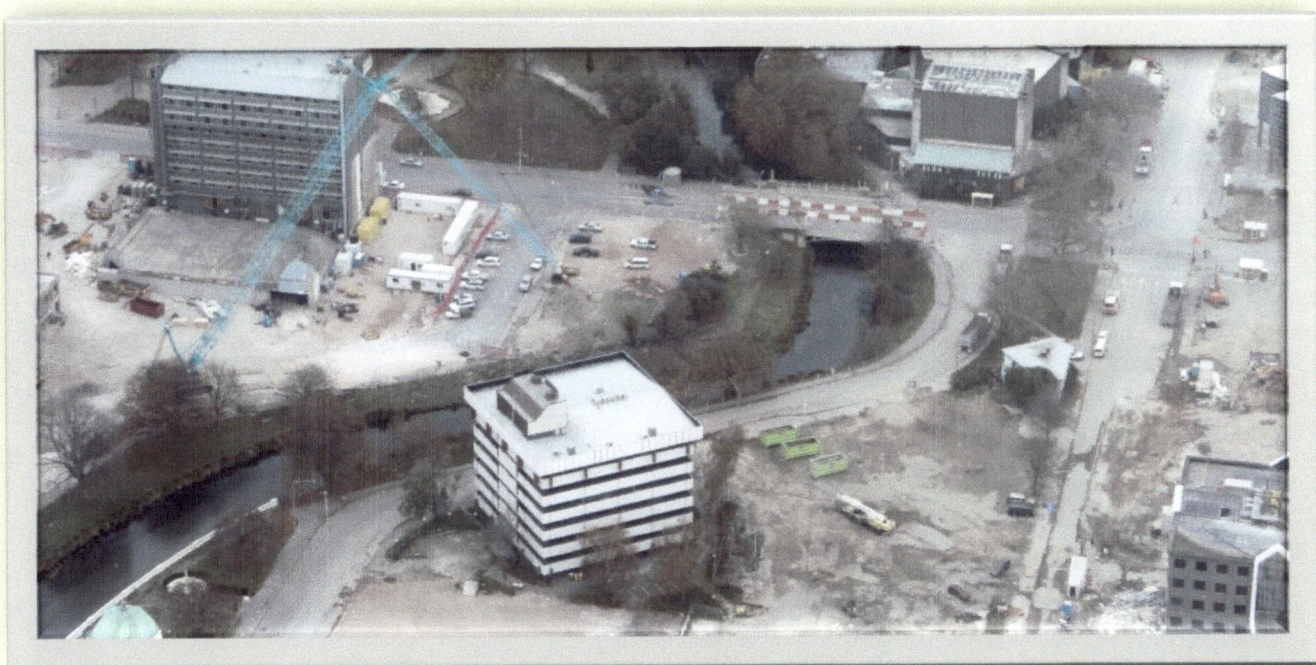

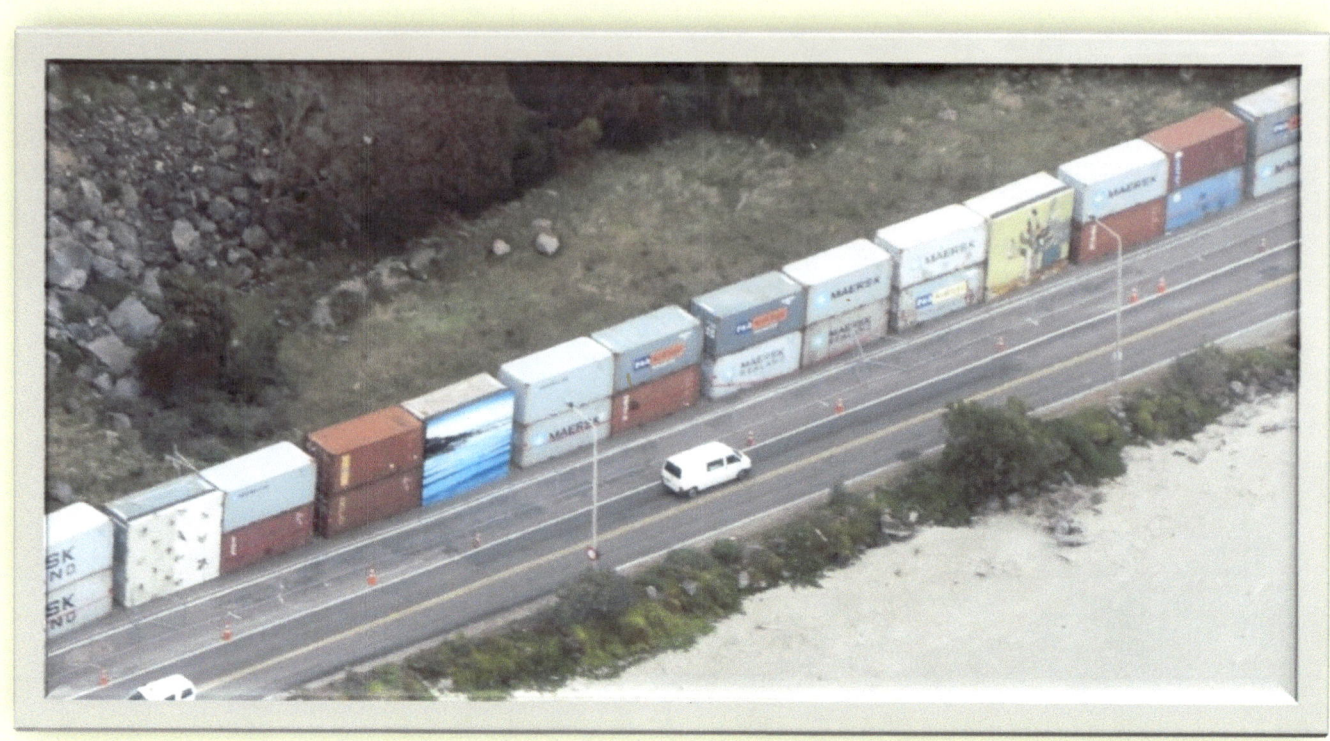

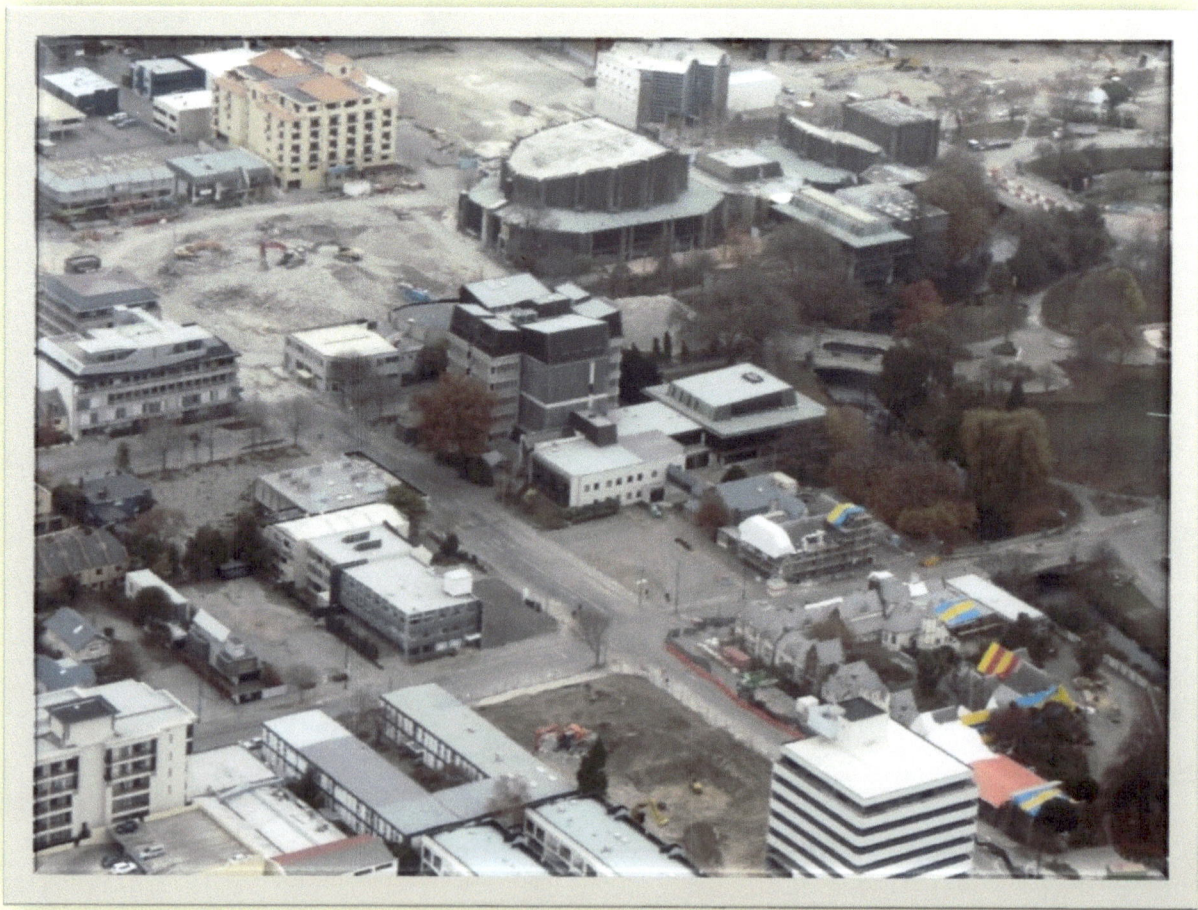

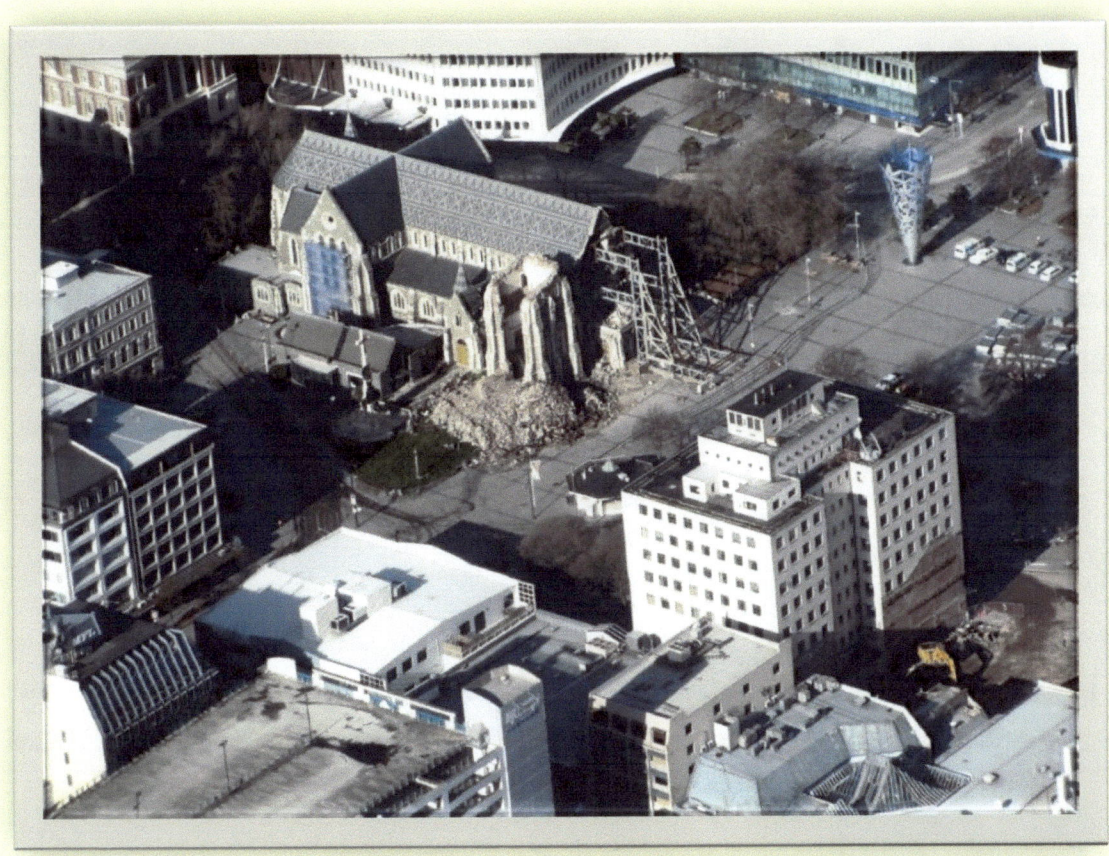
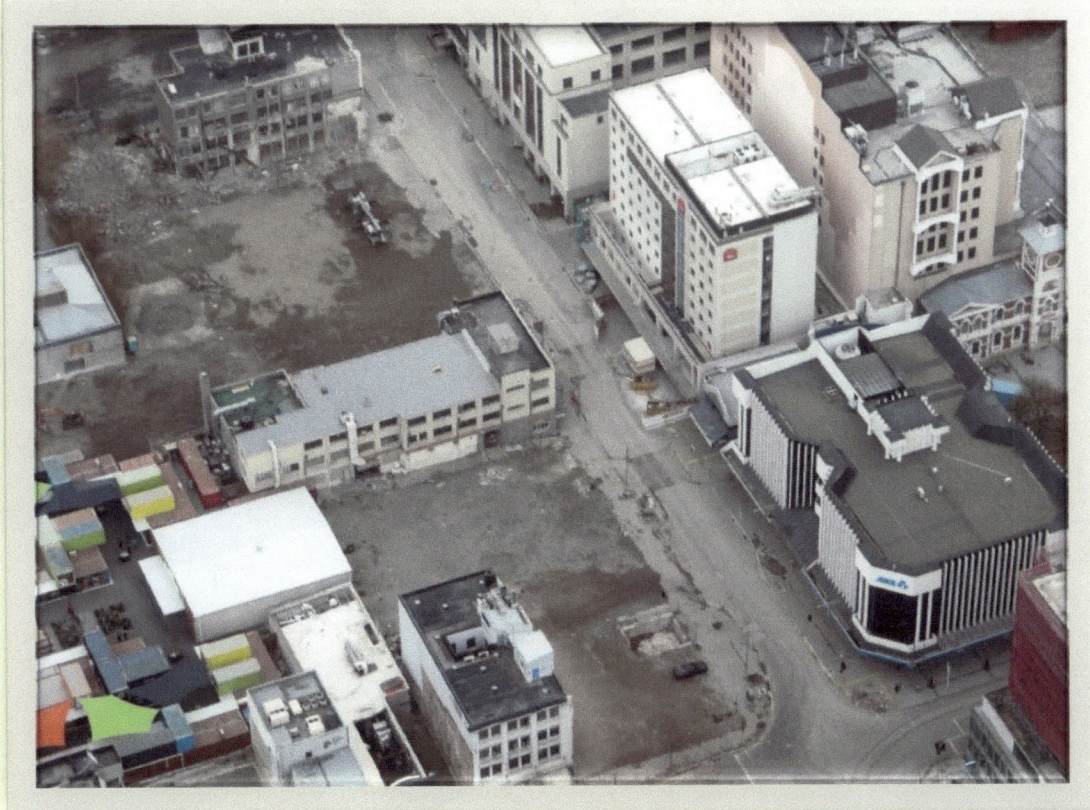

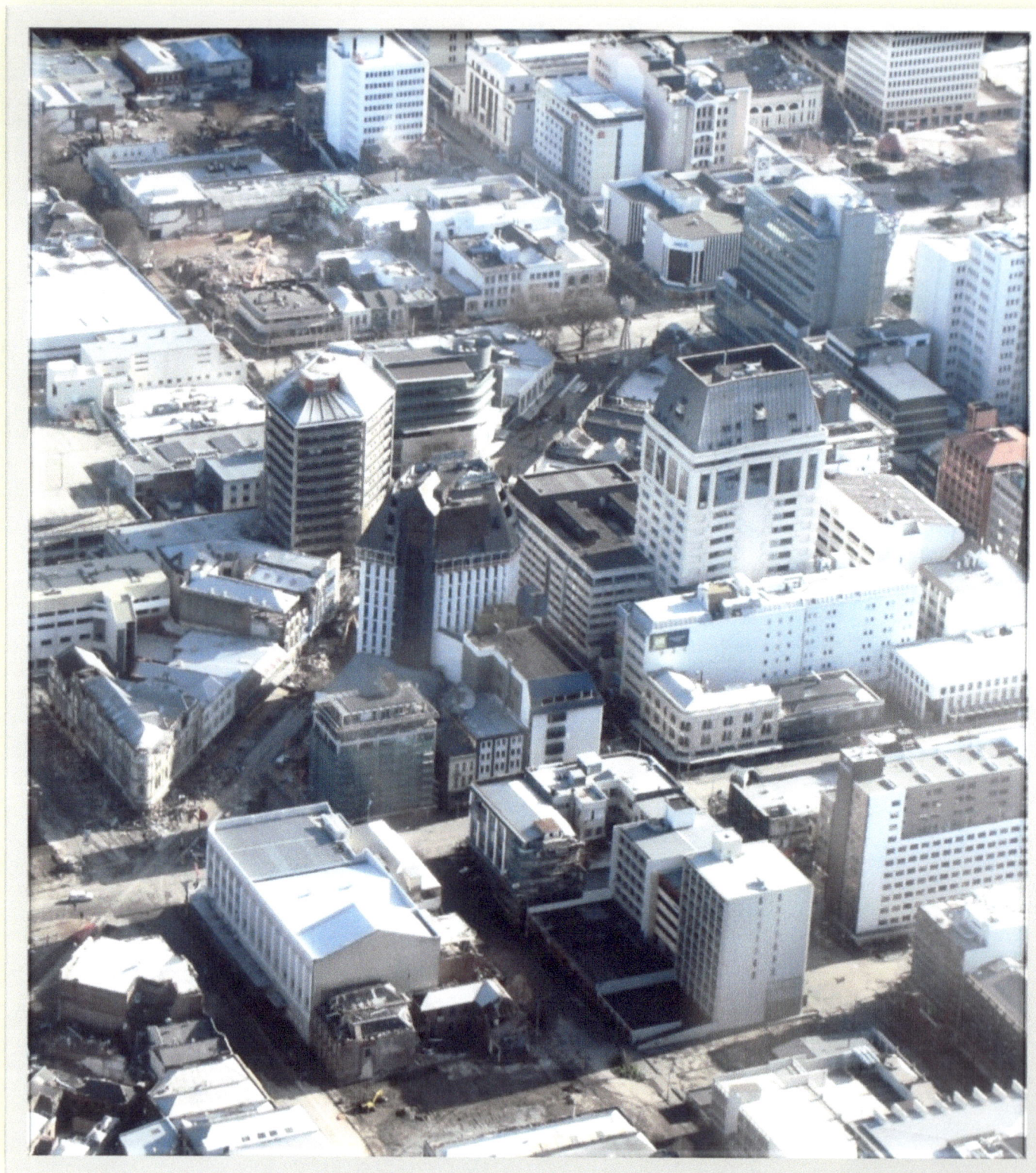

Chapter Six
Christchurch Cathedral throughout the Earthquakes

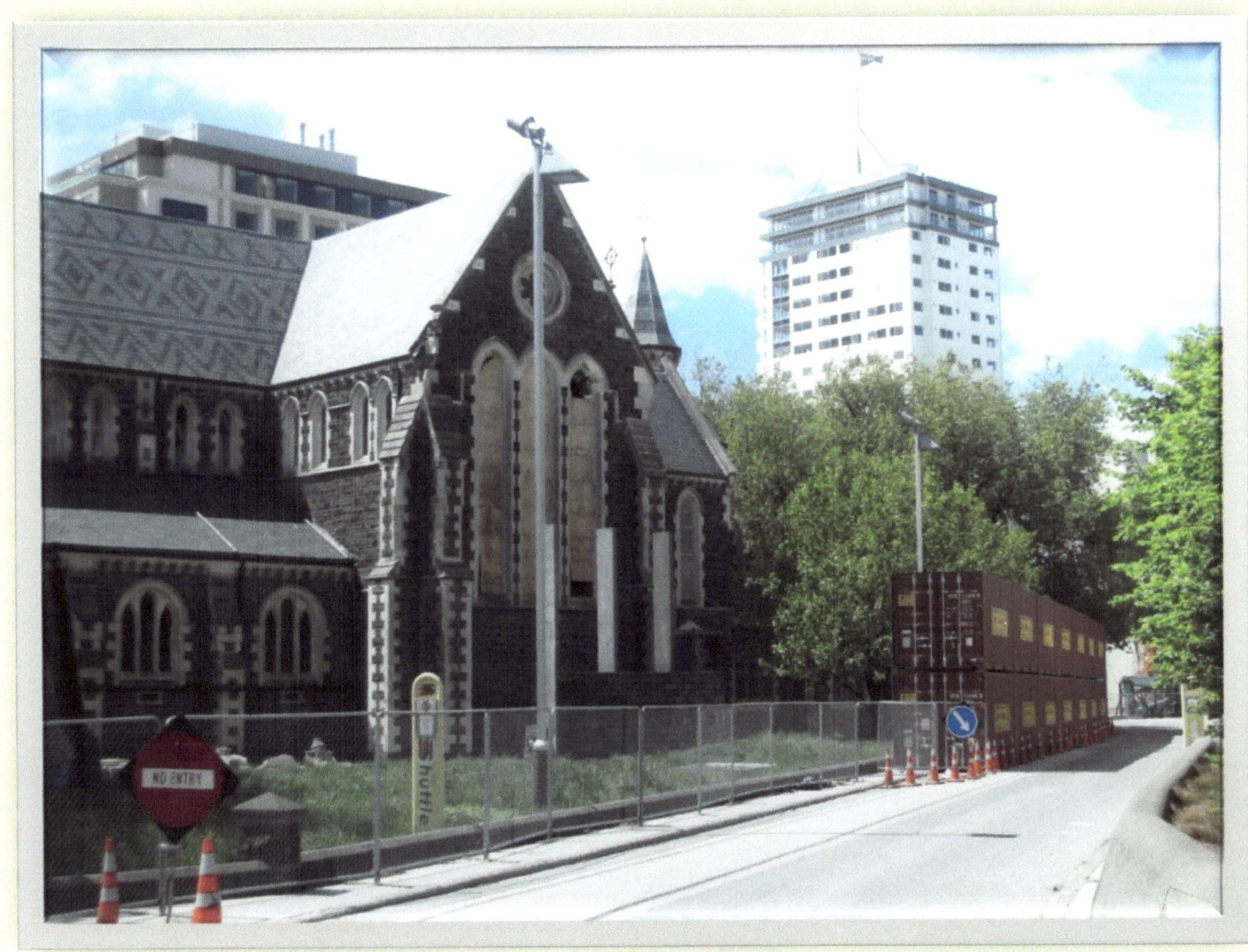

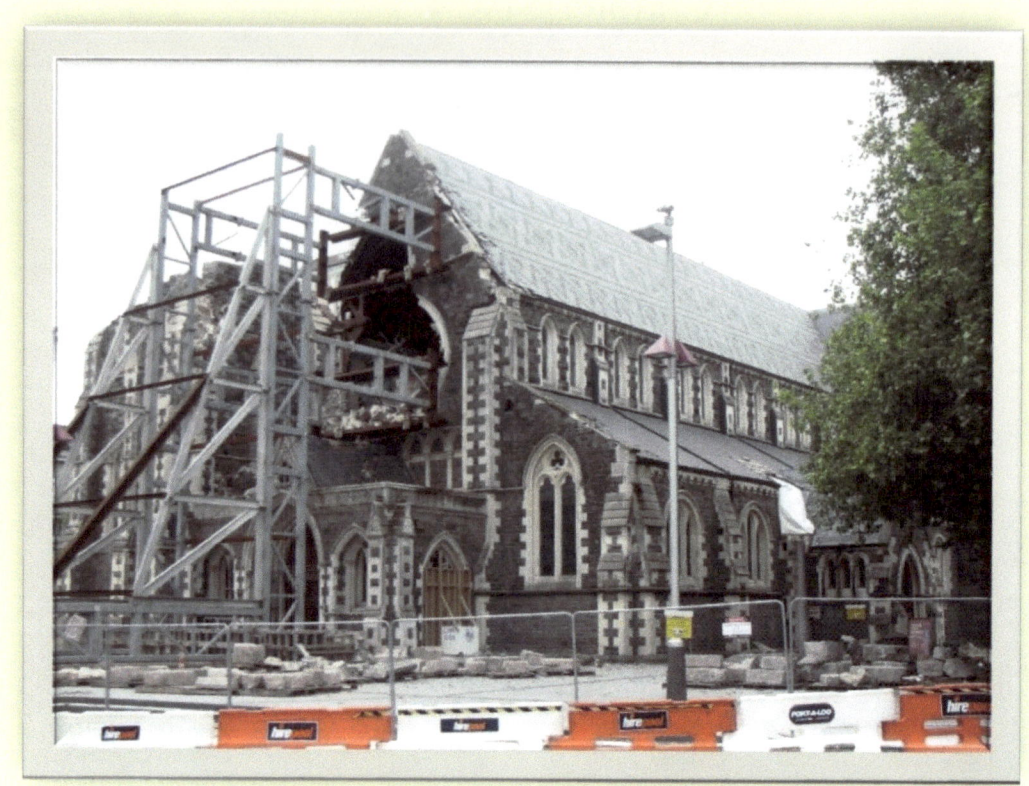

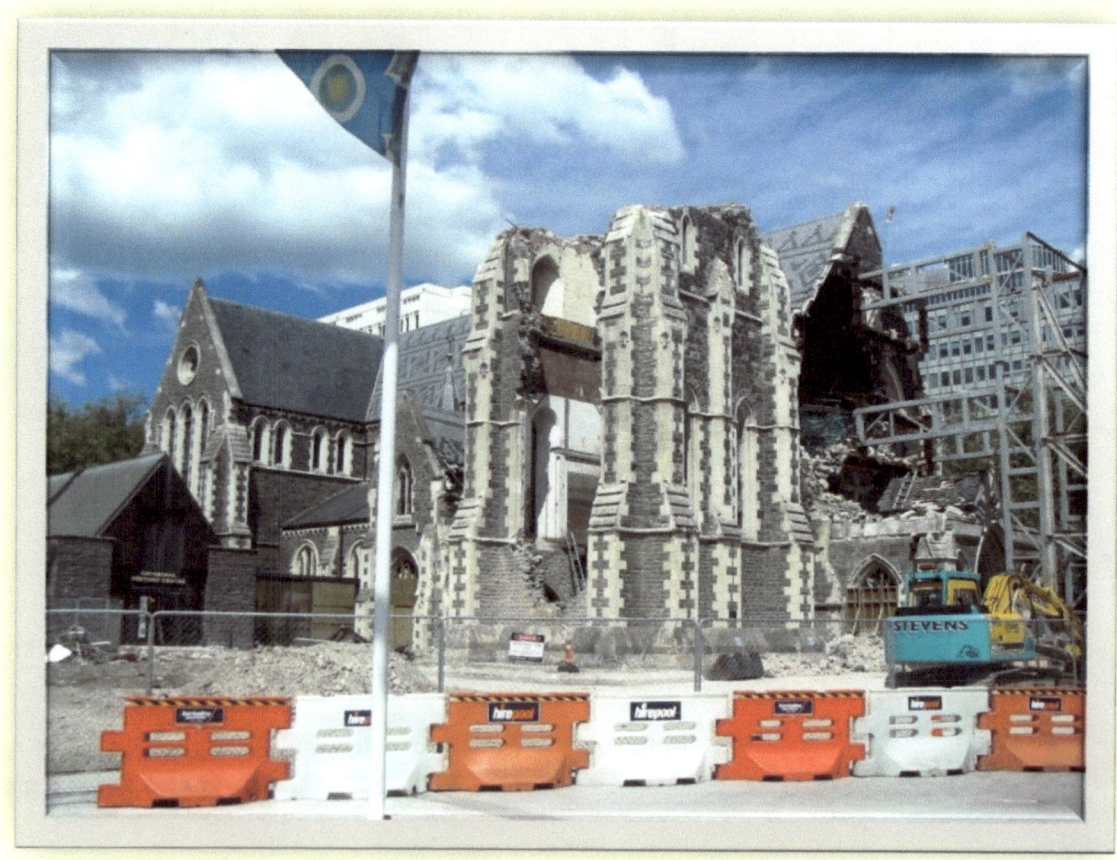

Cathedral Deconsecration 2011

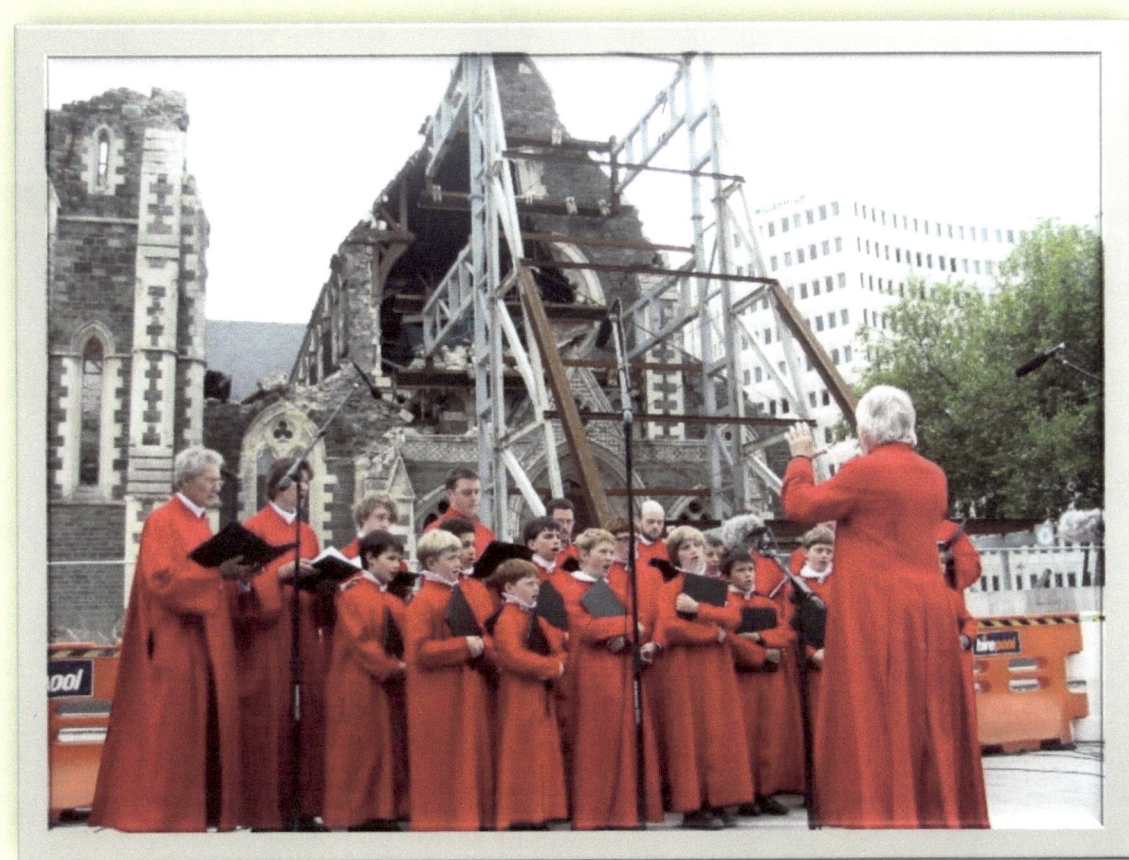

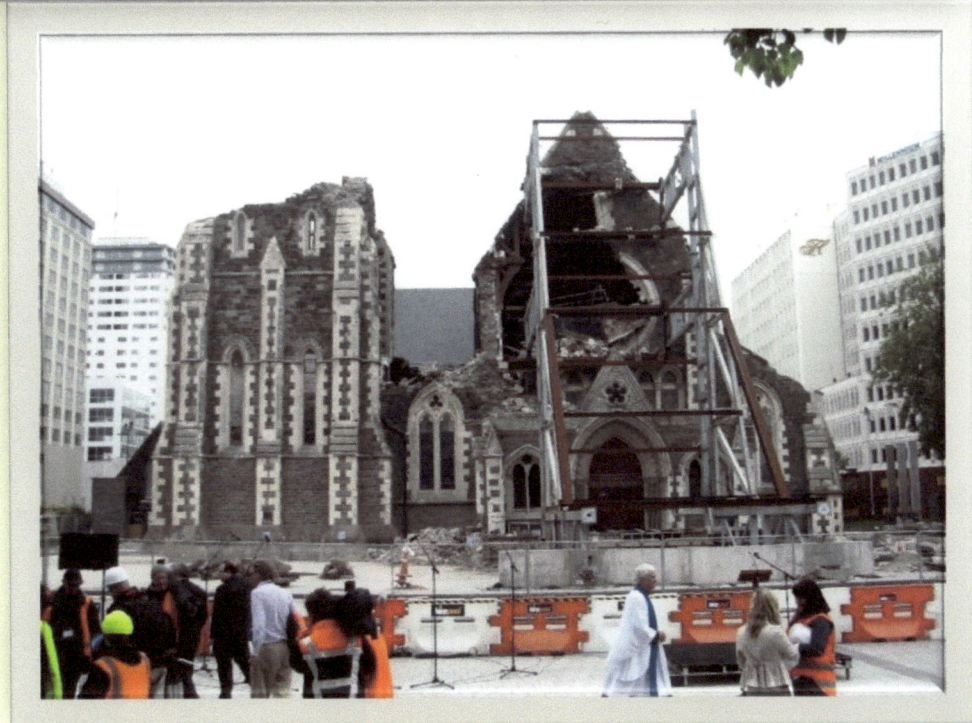

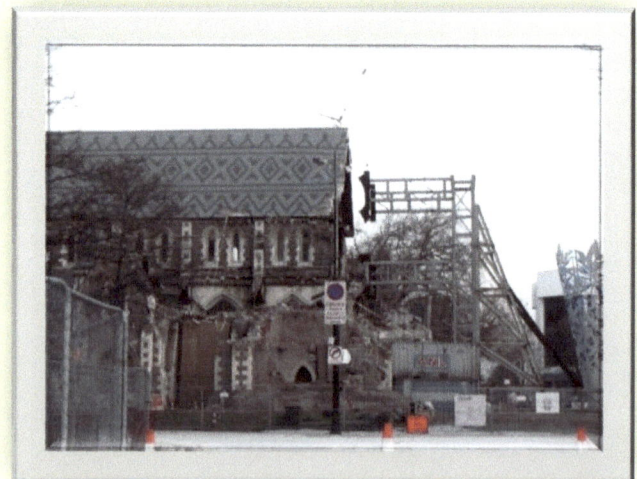
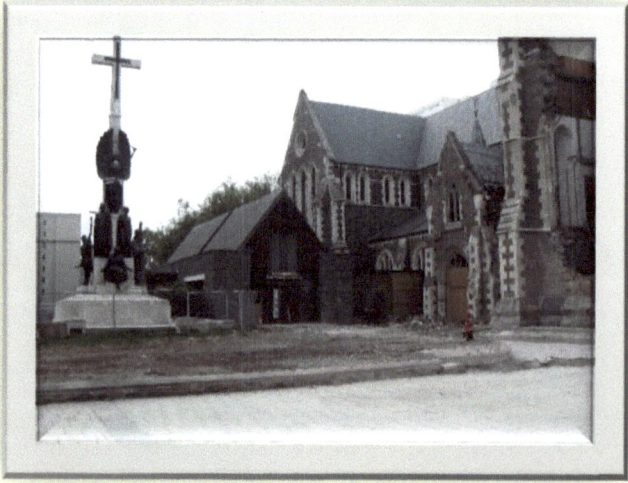

Early 2012 The Decline of the Cathedral

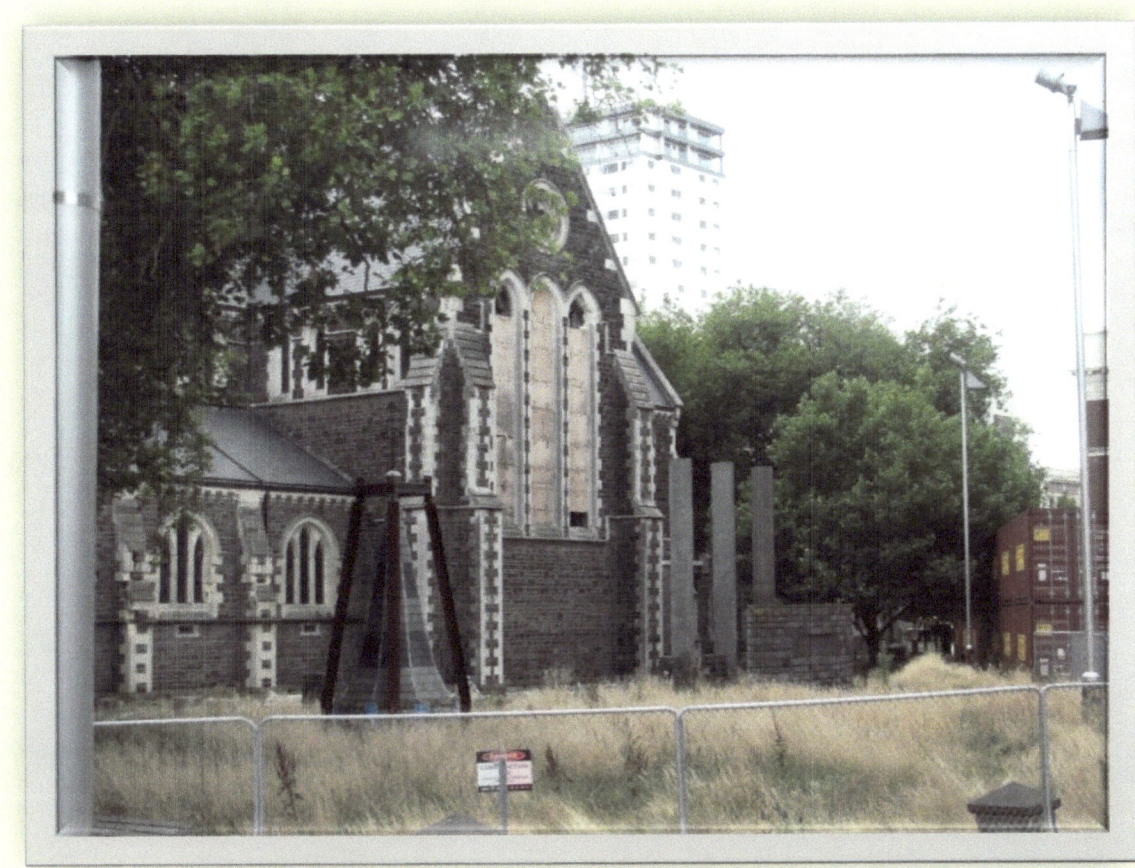

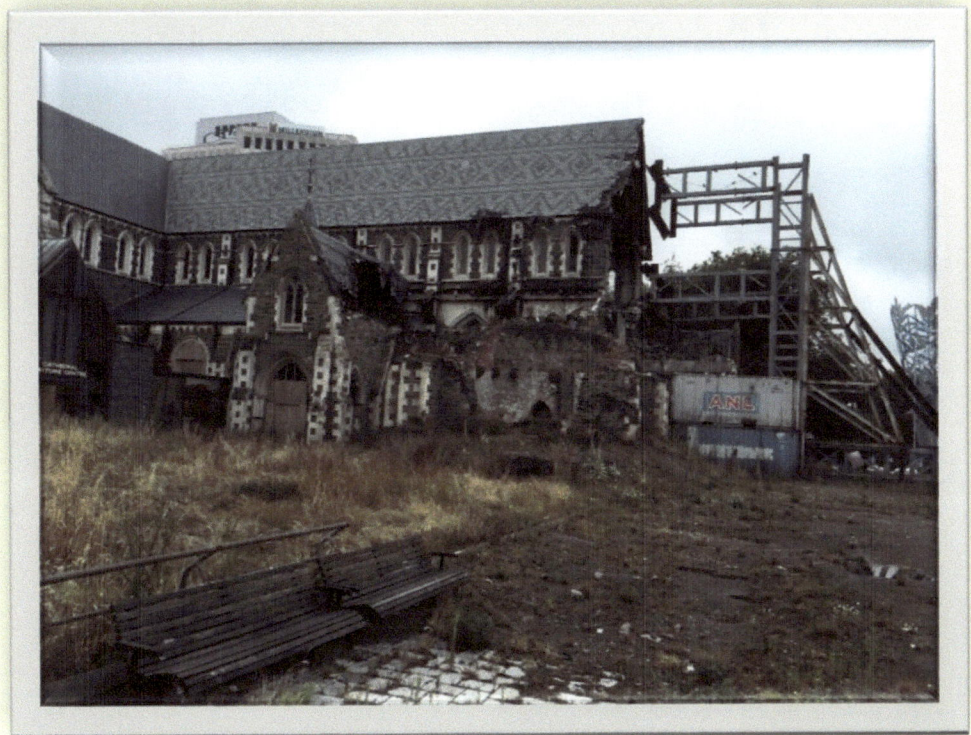

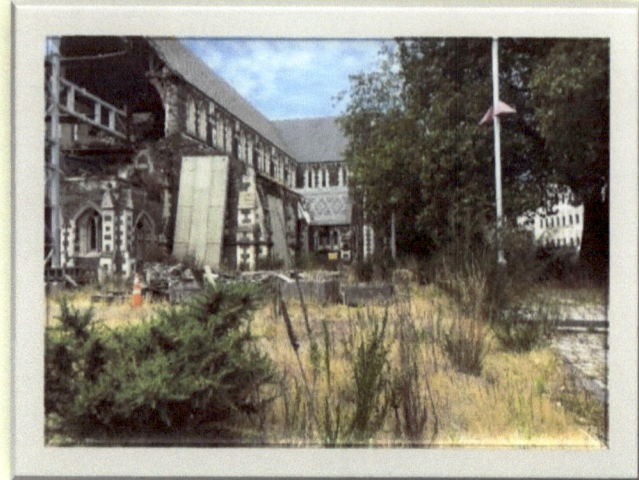
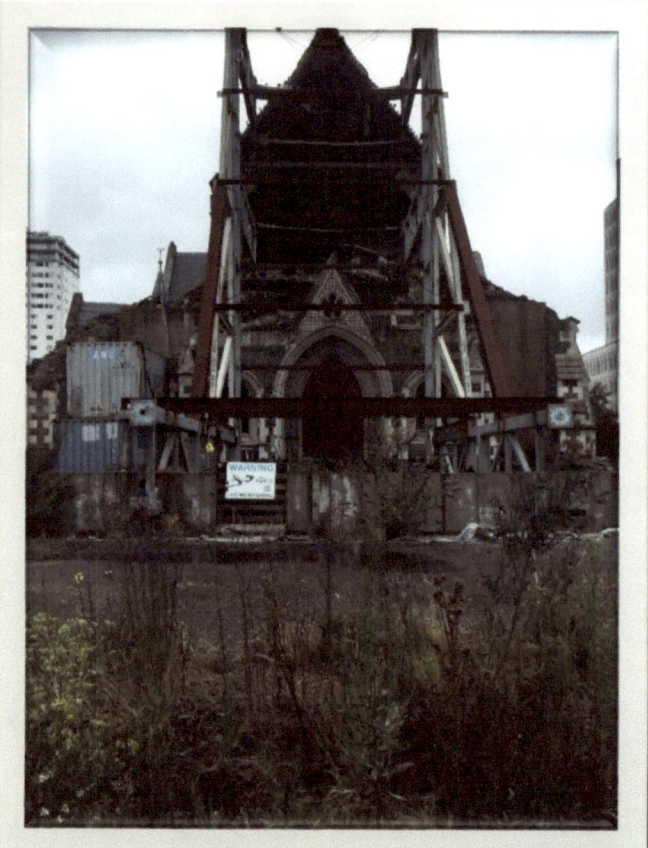
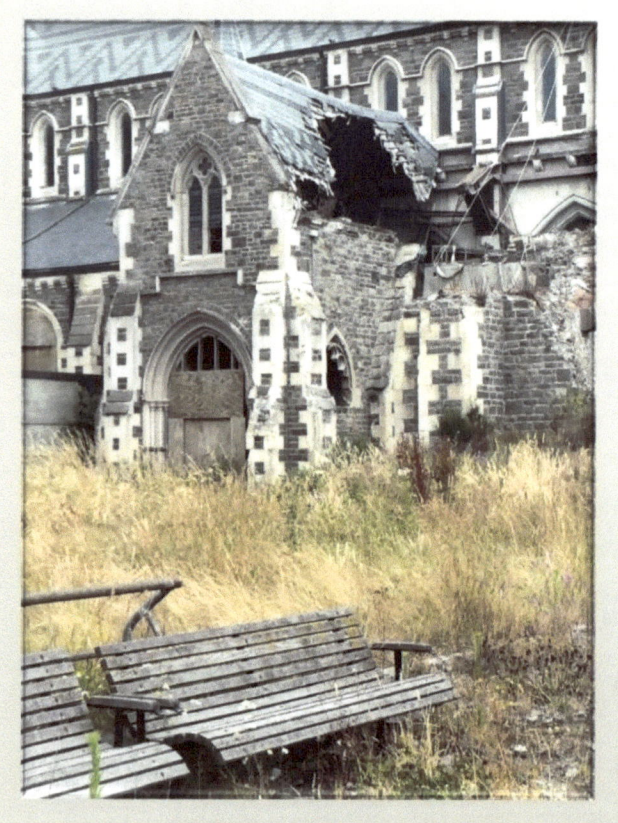
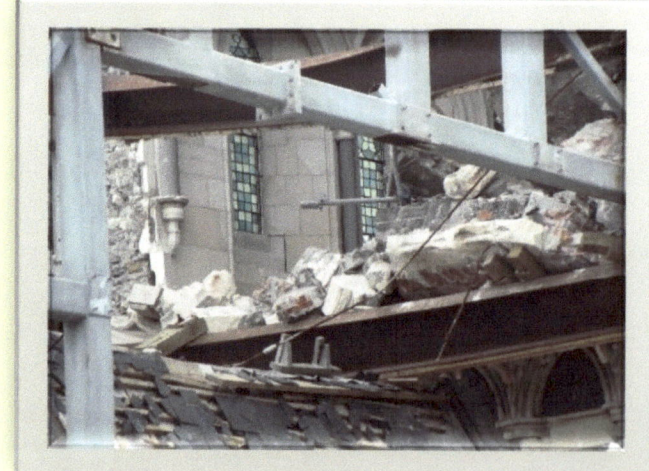

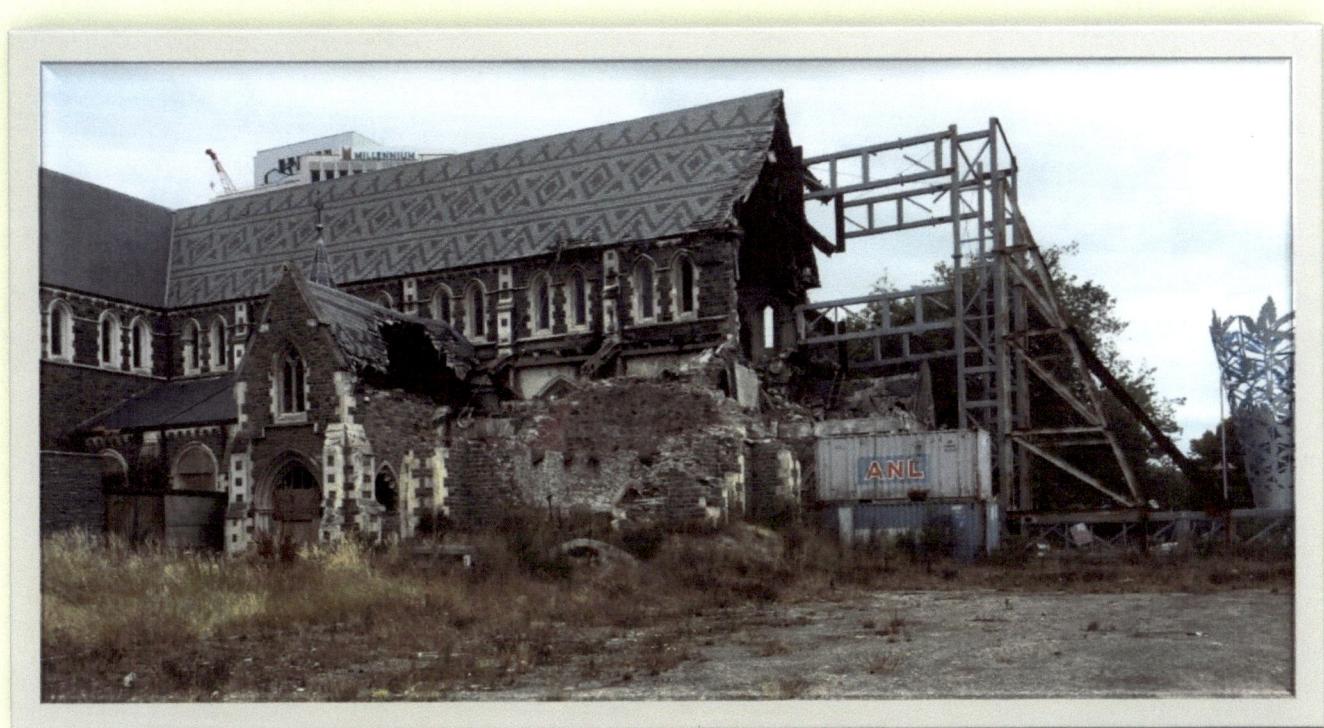

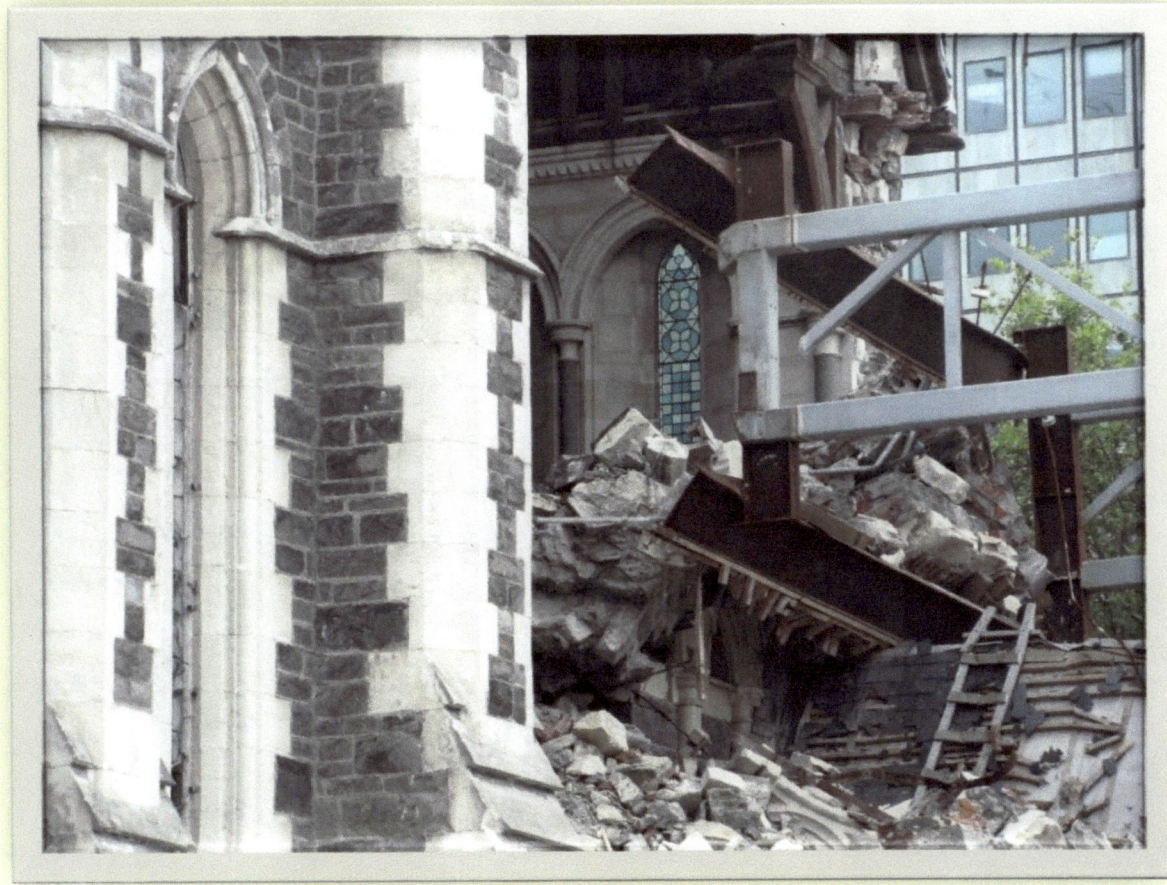

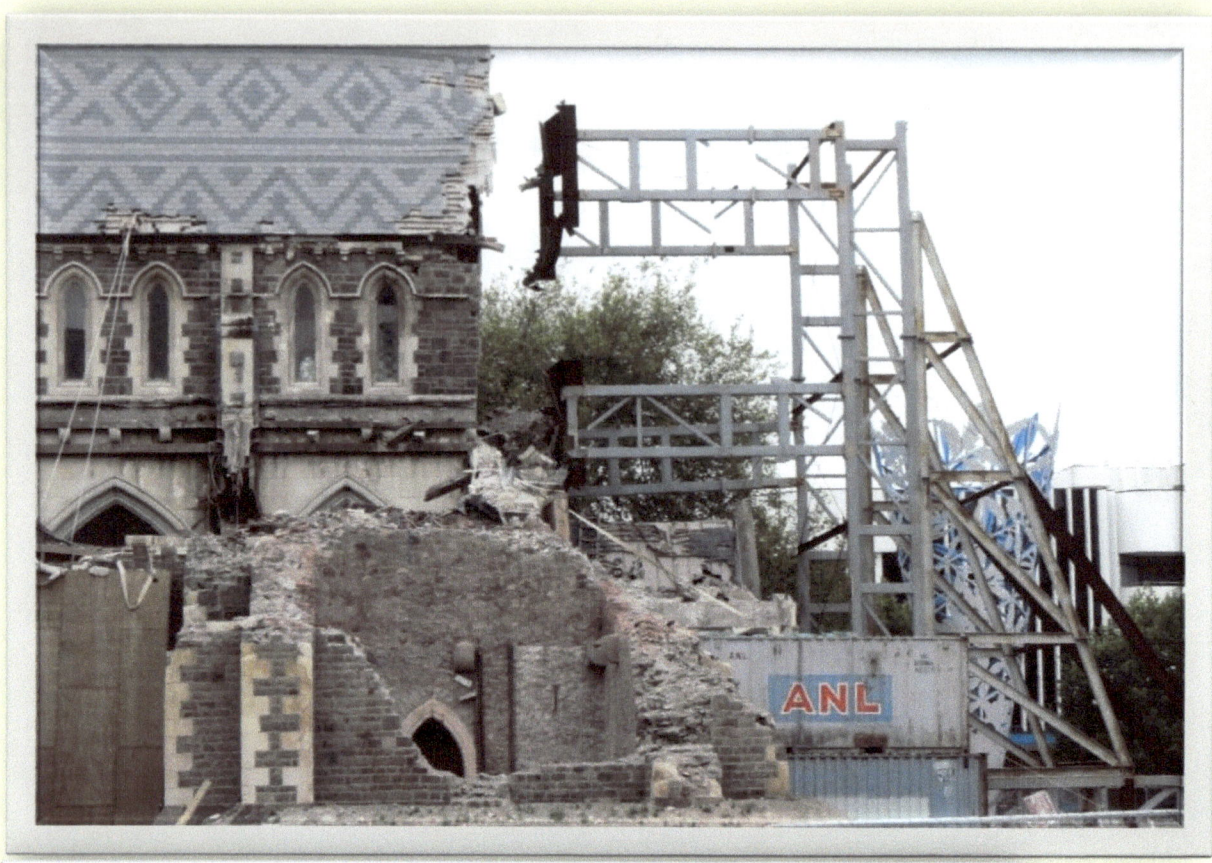
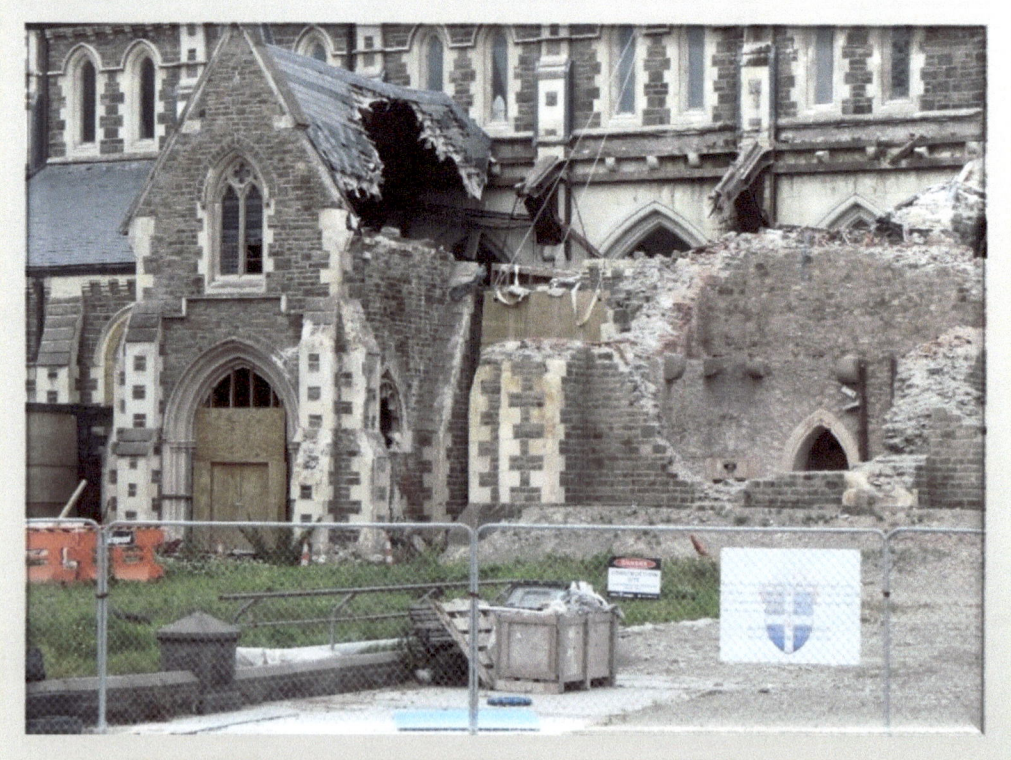

Mid 2017

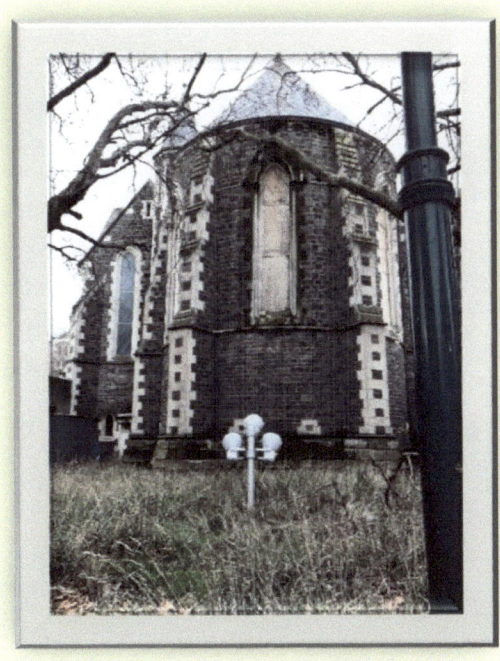
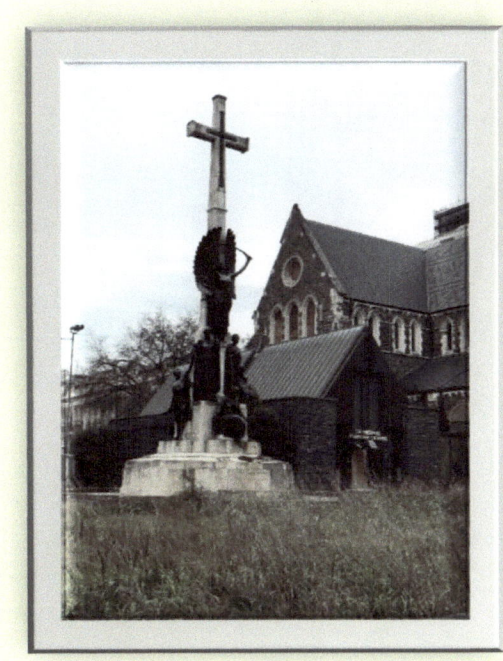

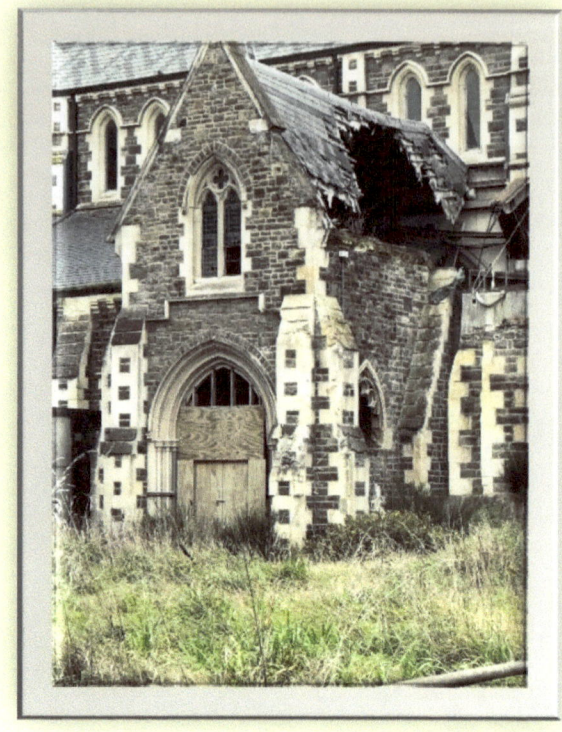
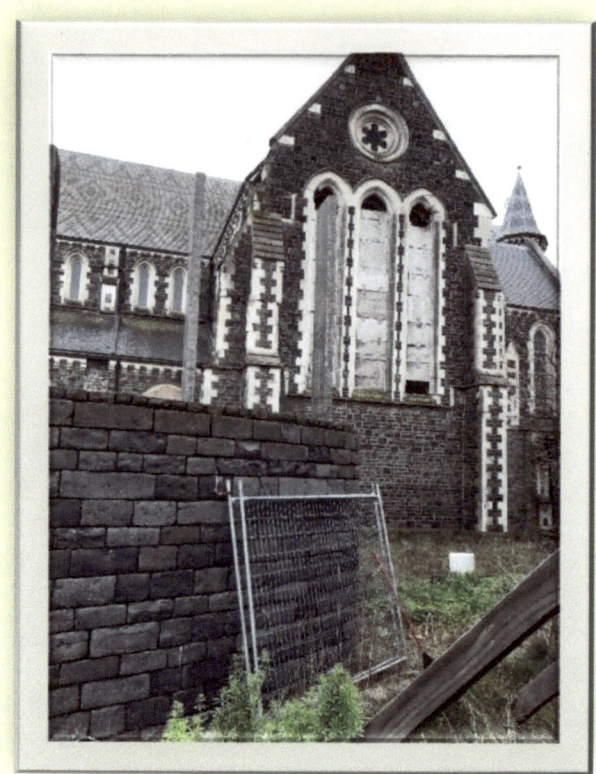
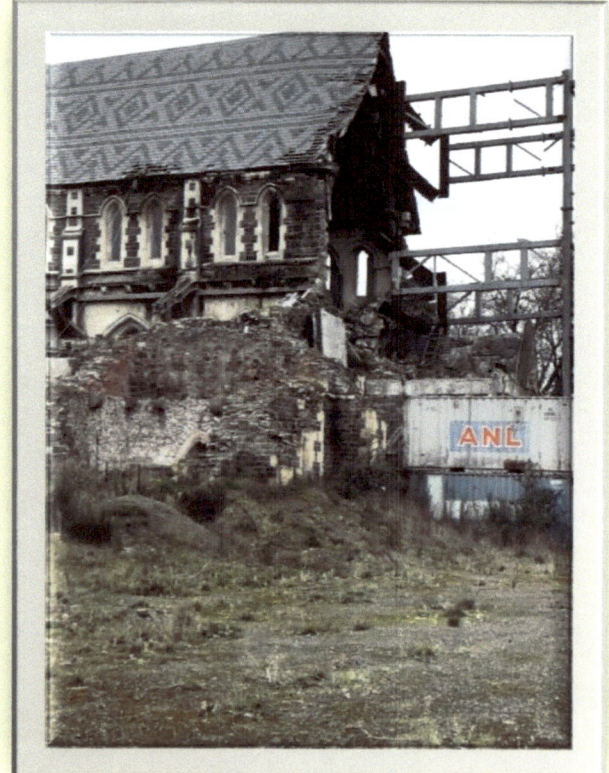
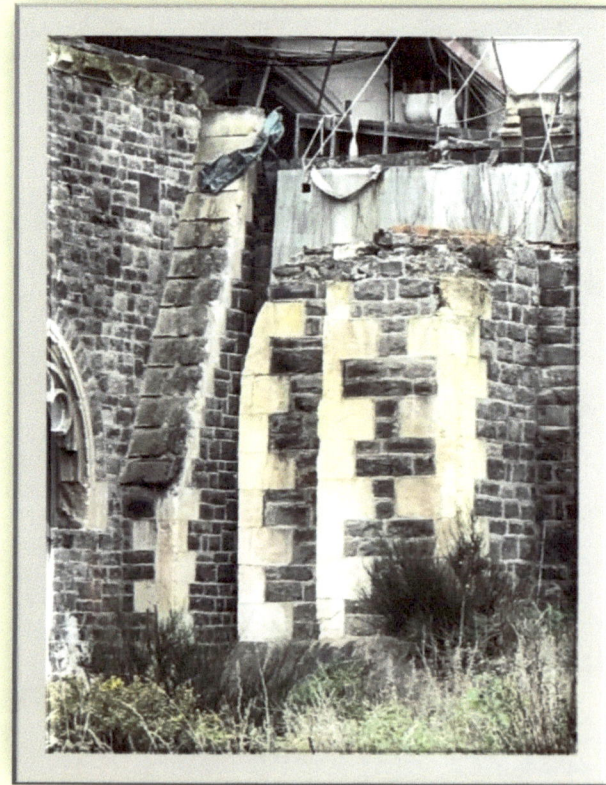

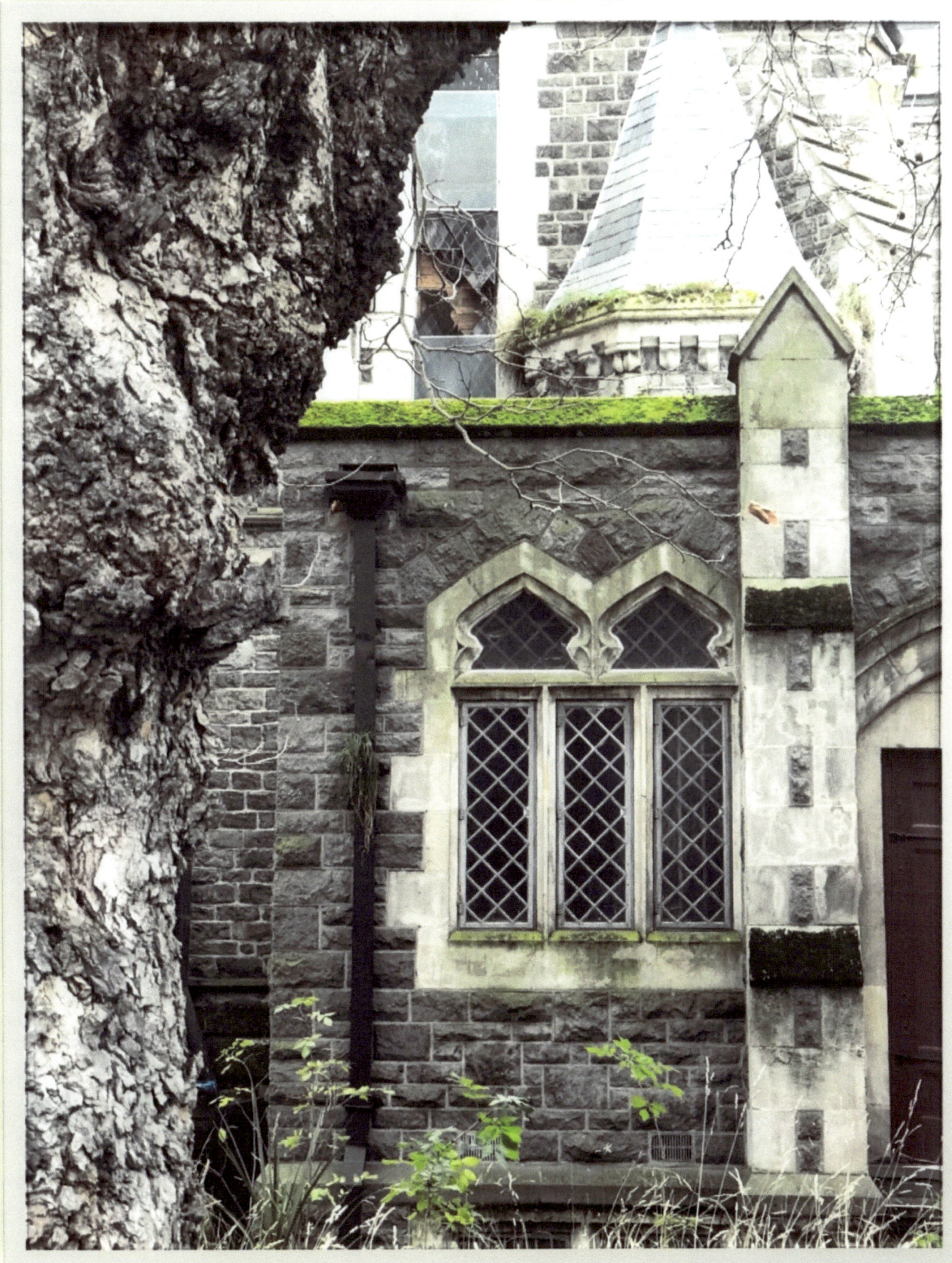

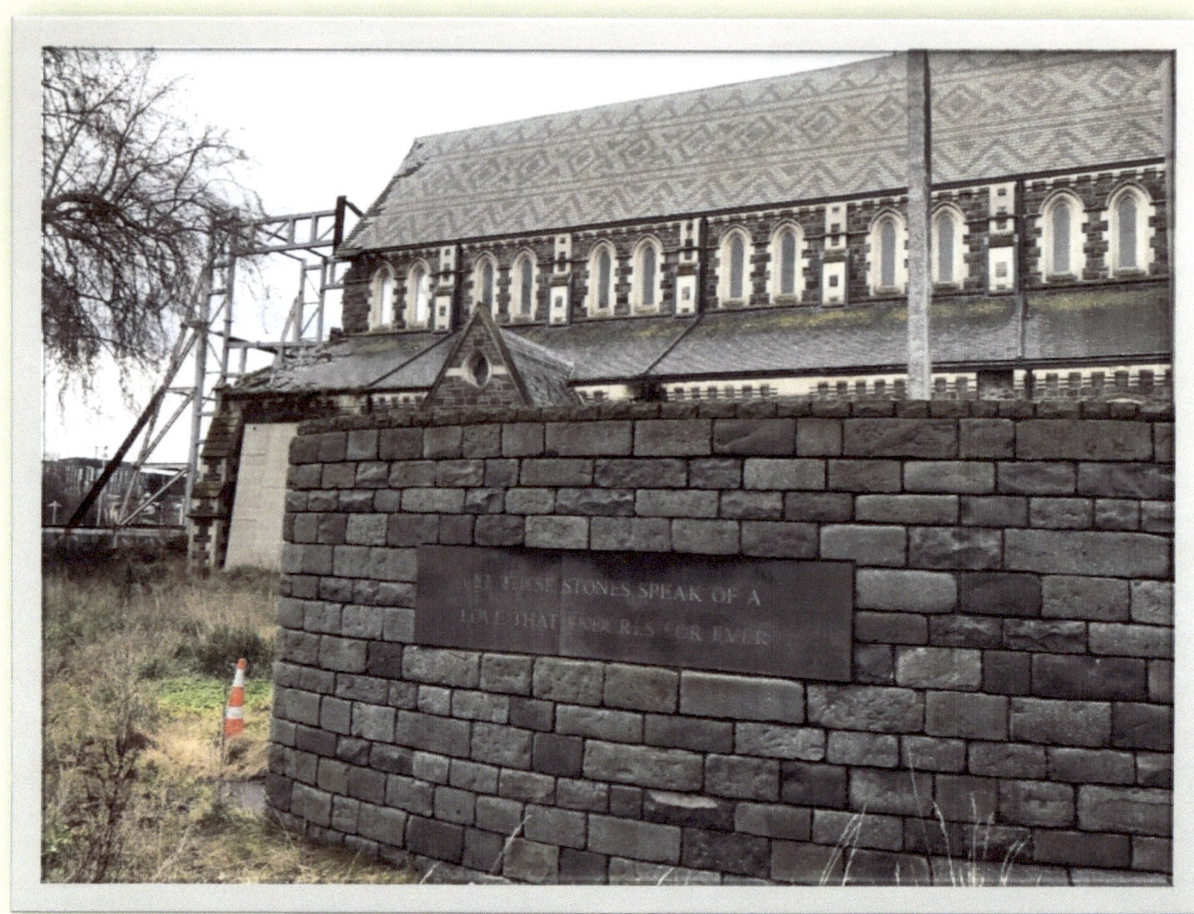
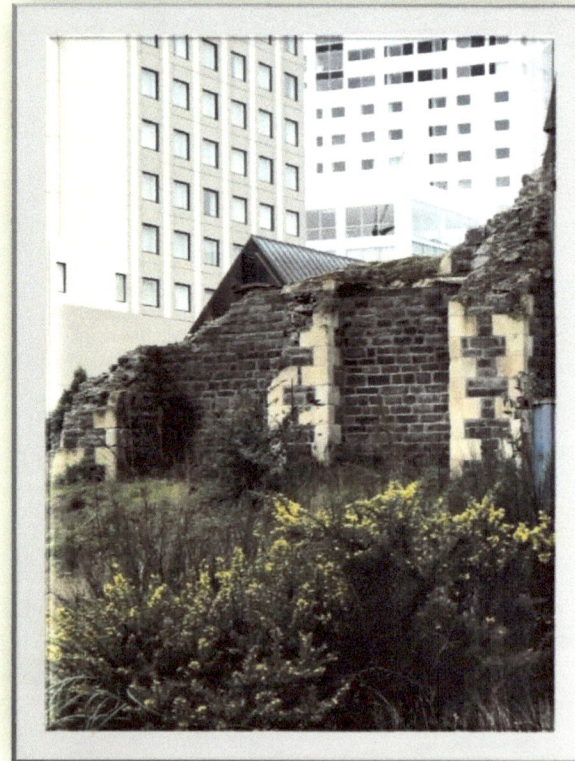
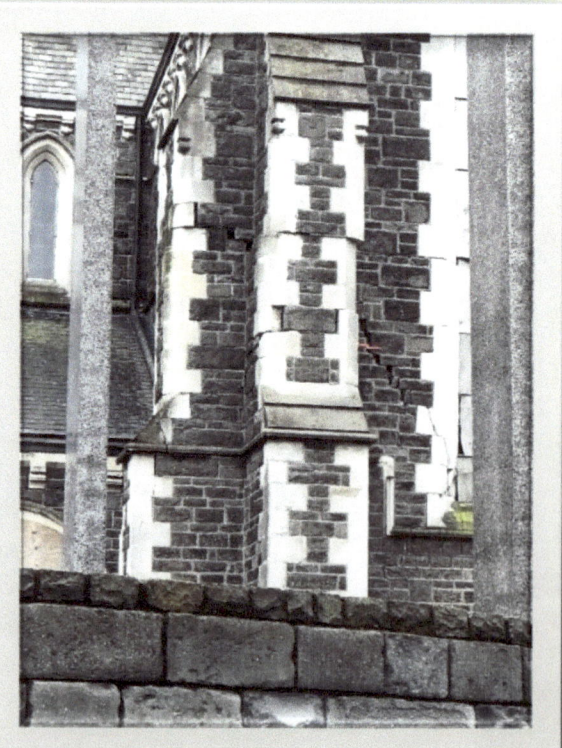

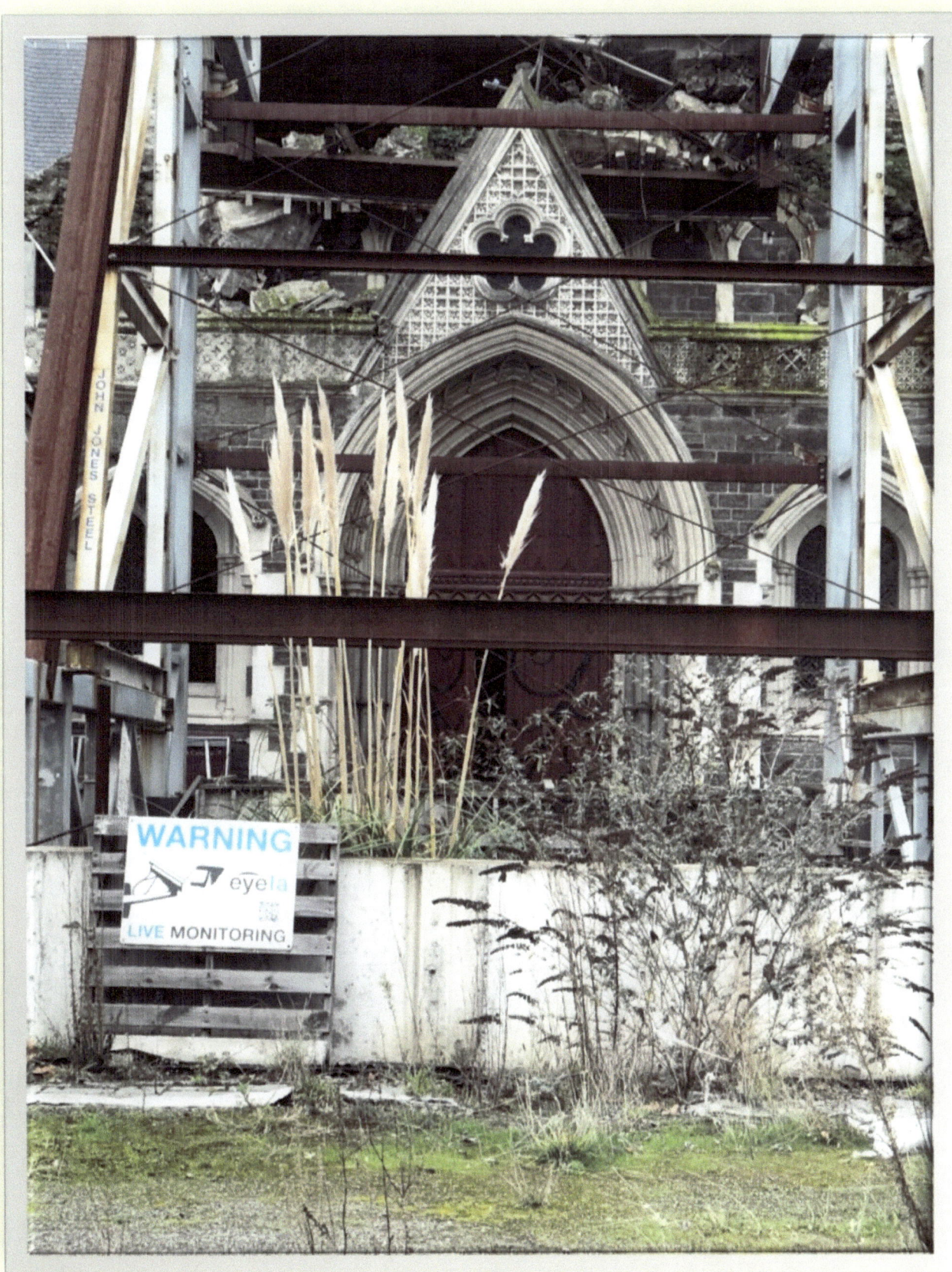

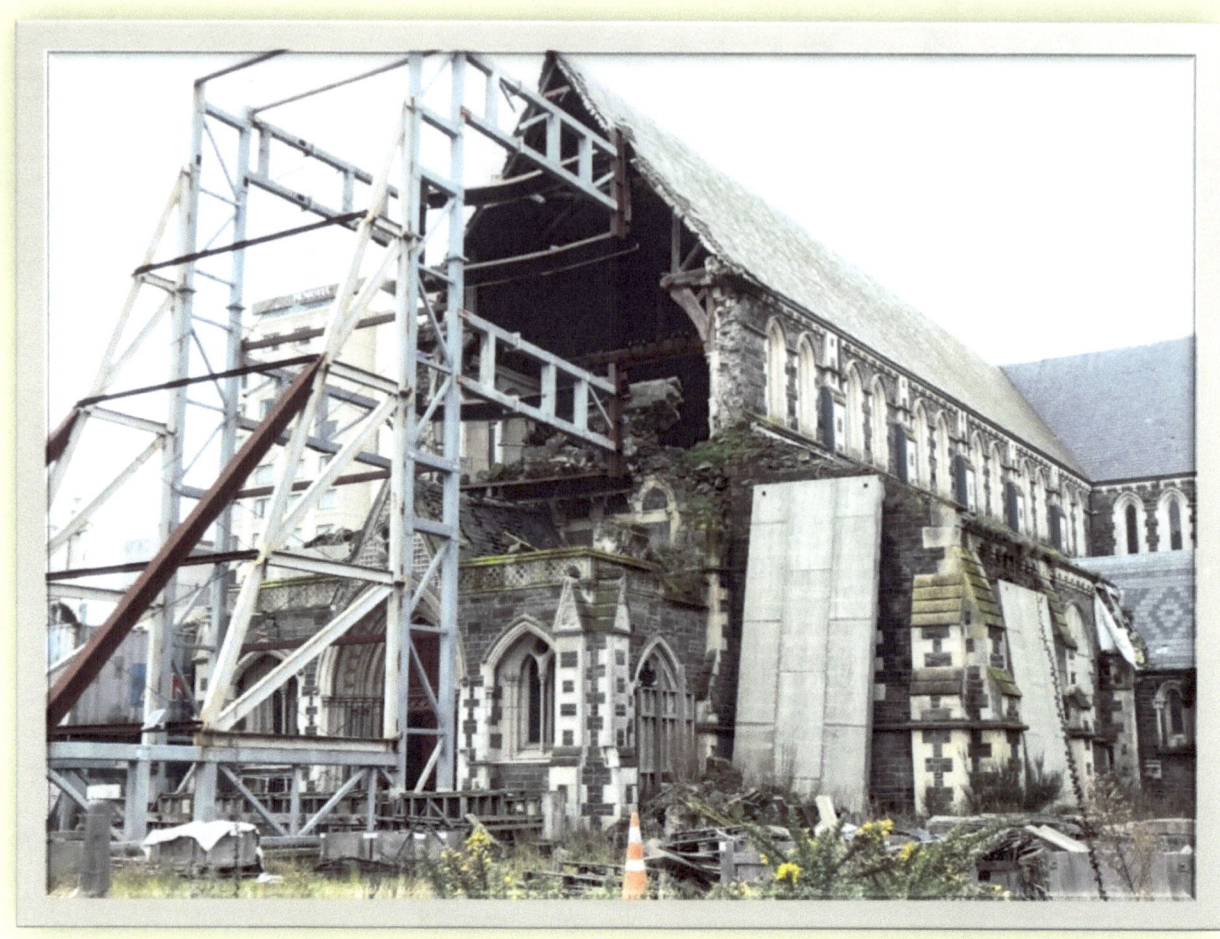
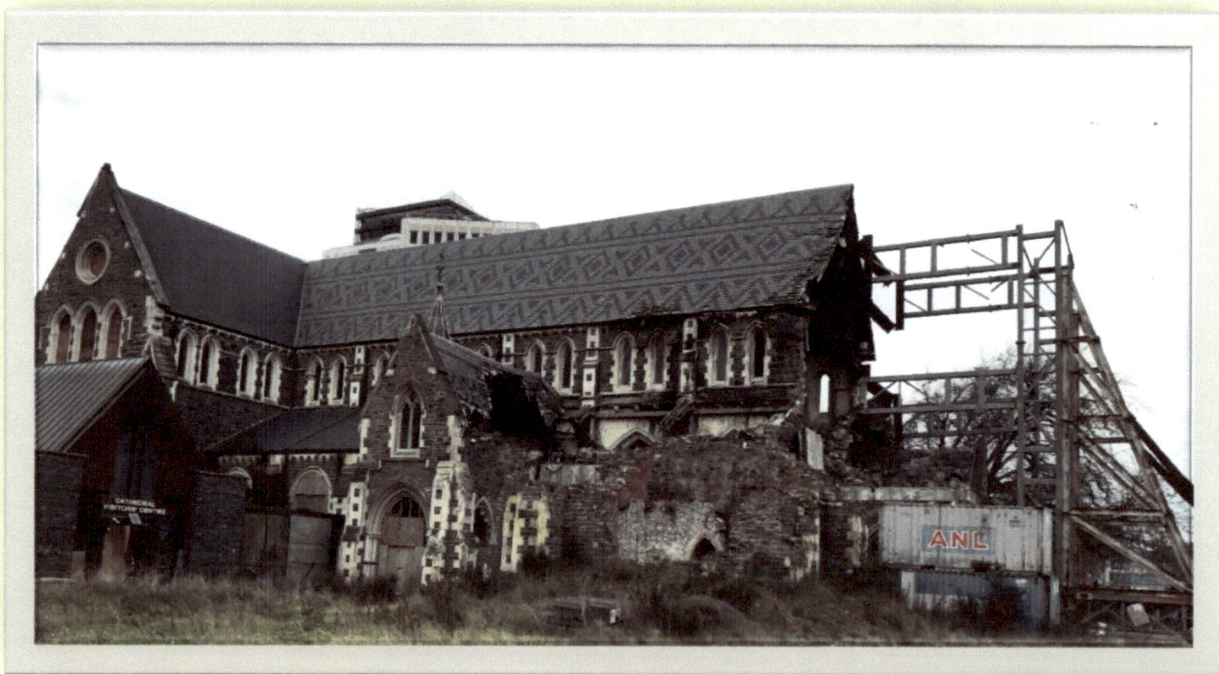

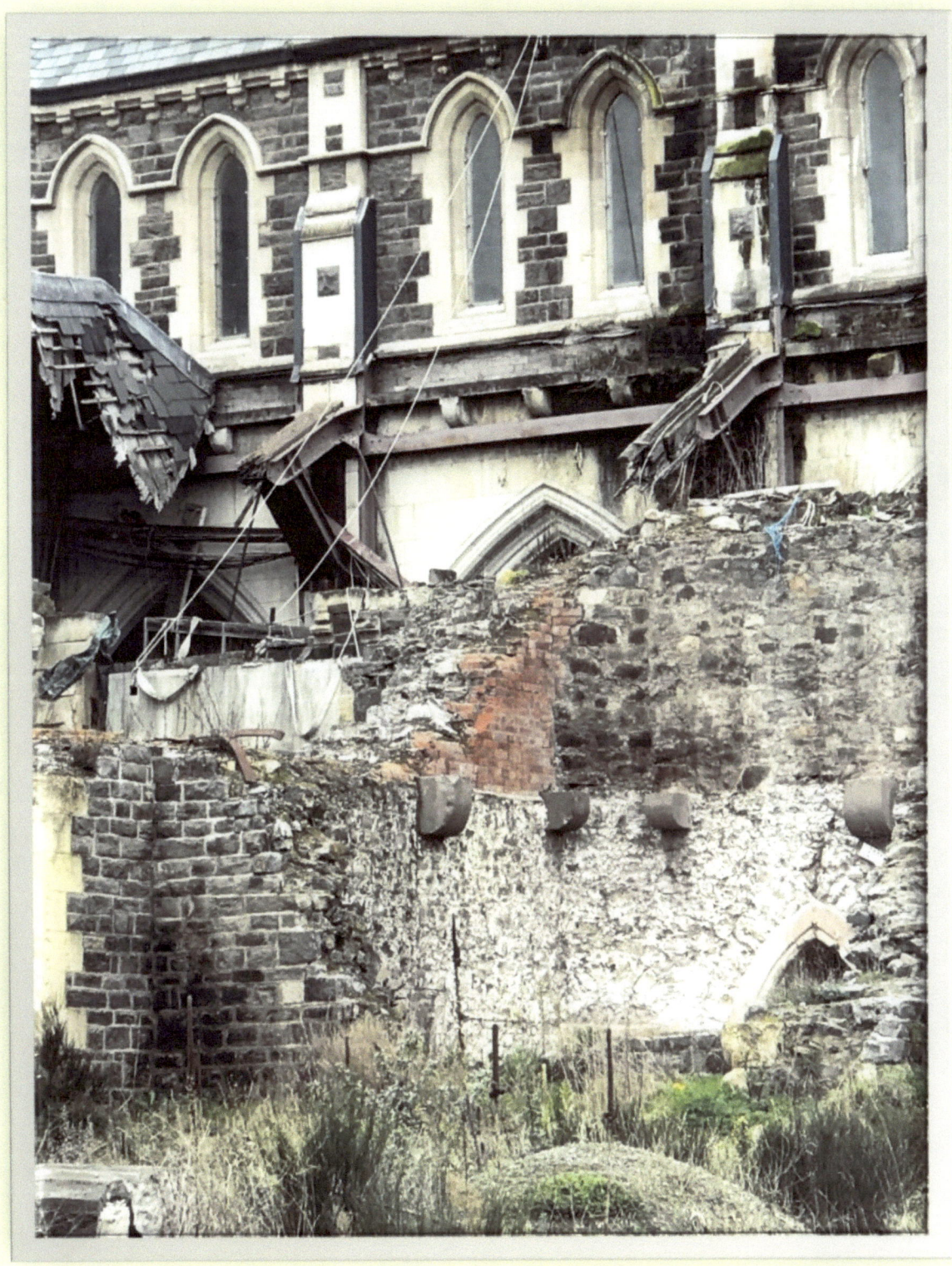